PHOTOGRAPHY, HUMANITARIANISM, EMPIRE

PHOTOGRAPHY, HISTORY: HISTORY, PHOTOGRAPHY

Series Editors: Elizabeth Edwards, Jennifer Tucker, Patricia Hayes

ISSN: 2398-3892

This field-defining series explores the inseparable relationship between photography and history. Bringing together perspectives from a broad disciplinary base it investigates what wider histories of, for example, wars, social movements, regionality or nationhood, look like when photography and its social and cultural force are brought into the centre of analysis.

Photography, Humanitarianism, Empire, Jane Lydon
Victorian Photography, Literature and the Invention of Modern Memory: Already the Past, Jennifer Green-Lewis
Further titles forthcoming

PHOTOGRAPHY, HUMANITARIANISM, EMPIRE

JANE LYDON

University of Western Australia

Bloomsbury Academic
An imprint of Bloomsbury Publishing Plc

B L O O M S B U R Y
LONDON · OXFORD · NEW YORK · NEW DELHI · SYDNEY

Bloomsbury Academic

An imprint of Bloomsbury Publishing Plc

50 Bedford Square
London
WC1B 3DP
UK

1385 Broadway
New York
NY 10018
USA

www.bloomsbury.com

BLOOMSBURY and the Diana logo are trademarks of Bloomsbury Publishing Plc

First published 2016

Paperback edition first published 2017

British Library Cataloguing-in-Publication Data
A catalogue record for this book is available from the British Library.

ISBN: HB: 978-1-4742-3550-1
PB: 978-1-3500-2743-5
ePDF: 978-1-4742-3551-8
ePub: 978-1-4742-3552-5

Library of Congress Cataloging-in-Publication Data
Names: Lydon, Jane, 1965- author.
Title: Photography, humanitarianism, empire / Jane Lydon.
Description: London; New York: Bloomsbury Academic, an imprint of
Bloomsbury Publishing, Pl, [2016] | Series: Photography, history |
Includes bibliographical references and index.
Identifiers: LCCN 2016003649| ISBN 9781474235501 (hardback) | ISBN
9781474235525 (epub) | ISBN 9781474235518 (ePDF)
Subjects: LCSH: Photography–Social aspects–Australia–History–19th
century. | Photography–Social aspects–Australia–History–20th century.
| Humanitarianism. | National characteristics, Australian.
Classification: LCC TR121 .L735 2016 | DDC 770.994–dc23 LC record available
at http://lccn.loc.gov/2016003649

Series: Photography, History: History, Photography

Cover design: Louise Dugdale
Cover photograph © Brook Andrew / Tolarno Galleries, Melbourne and
Galerie Nathalie Obadia, Paris and Brussels

Typeset by Deanta Global Publishing Services, Chennai, India
Printed and bound in Great Britain

CONTENTS

LIST OF FIGURES

ACKNOWLEDGEMENTS

This research was funded by the Australian Research Council under its Discovery and Future Fellowship schemes (DP110100278, FT100100064). It began at Monash University but was substantially conducted at the University of Western Australia. Since my arrival in 2013, my colleagues at the University of Western Australia have provided a welcoming and collegial environment, and patiently waited for me to complete this project.

I am deeply grateful to the four museum partners in our research project 'Globalization, Photography, and Race': Christopher Morton at the University of Oxford's Pitt Rivers Museum, Anita Herle at the Cambridge University Museum of Archaeology and Anthropology, Christine Barthes at the Musée de Quai Branly in Paris and Wonu Veys at the National Museum of World Cultures in Leiden, the Netherlands. Much of the thinking around this topic took place during a visiting fellowship at Clare Hall at the University of Cambridge during 2014, and I am especially grateful to Anita Herle, Nicholas Thomas, J. D. Hill, Jocelyne Dudding, Wendy Brown, Alison Clark, Chris Wingfield and Khadija Carroll for their interest.

At Bloomsbury I thank Davida Forbes, Ariadne Godwin and Molly Beck and series editors Elizabeth Edwards, Jennifer Tucker and Patricia Hayes for their enthusiasm. For research assistance at different stages throughout the project, I thank Sari Braithwaite and Donna Oxenham. At the Monash Indigenous Centre I owe Lynette Russell warm thanks for many years of collegiality – and numerous other colleagues, particularly in the former School of Journalism, Australian and Indigenous Studies.

Although specific acknowledgements are made throughout the book, in South Australia (especially for Chapter 2), I wish to thank Lynnette Wanganeen, Tom Gara, Pauline Cockrill of History SA, and Jackie Johnston, Secretary of Southern Eyre Peninsula Family and Local History Group and a custodian of Mill Cottage at Port Lincoln. Thanks to Hannah Lowery and Jamie Carstairs of the Special Collections of the University of Bristol Library, for their permission to reproduce selected photographs from the Papers of Matthew Blagdon Hale. I thank Gael Newton and Peggy Brock for reading an early draft of this chapter and offering expert comments. Chapter 2 is derived, in part, from an article published in *Photography and Culture*, available online: http://www.tandfonline.com/doi/abs/10.2752/175145215X14244337011126.

I thank Floriana Badalotti for translations of Italian source texts (Chapter 3). Thanks to Mario Mineo and Carlo Nobili at the Museo Nazionale Preistorico Etnografico 'Luigi Pigorini', Rome. Barry Cundy at AIATSIS Library assisted in identifying the translation by Dymphna Clark. I am grateful to Bunurong elders Sonya and Stephen Murray for their interest.

In researching Arthur Vogan (Chapter 4), I am grateful to Denis Gojak for his advice and for sharing his research materials with me: Denis's blog, *Secret Visitors*, presents episodes from his doctoral research, including a fascinating analysis of Vogan's later life as pseudo-archaeologist: http://secretvisitors.wordpress.com/about/ (accessed 8 August 2014). I thank staff at the Fryer Library at the University of Queensland and particularly Mark Cryle, former Manager of the Fryer Library. Mitchell Library at the State Library of NSW, and the National Library of Australia gave me assistance in obtaining Vogan's papers and images. Thanks to Fiona Paisley for sharing her research at the Anti-Slavery and Aborigines Protection Society with me, and for her patience. I thank Maxine Briggs of the State Library of Victoria, and Bundjalung/Gumbainggirr Elder Robyne Bancroft for cultural permission to use a photograph from Grafton, and Shauna Bostock-Smith for her advice. Chapter 4 is derived, in part, from an article published in *Australian Historical Studies*, available online: http://www.tandfonline.com/doi/full/10.1080/1031461X.2013.877503#. VXkcFtKqqko.

At the Pitt Rivers Museum I particularly thank Christopher Morton, whose intellectual curiosity and practical support have been greatly valued throughout our project (Chapter 5). I particularly acknowledge participants in our Australian history seminar including Jeremy Martens, Philip Mead, Tony Hughes-d'Aeth, Jenny Gregory, Jo Hawkins, Darren Jorgensen and Alison Bartlett, for comments on a version of Chapter 5. I also thank colleagues elsewhere for constructive engagement with my argument, especially Alison Bashford, and in Adelaide Deane Fergie, Rod Lucas, Richard Vokes and Amanda Nettelbeck. I thank Douglas Djalanba of Warruwi (South Goulburn Island) for his interest in his ancestor's story, and Glenn Auld for assistance in contacting Kunibidgi people now living in Maningrida.

Chapter 6 is derived, in part, from an article published in 2015 as 'H. G. Wells and a shared humanity: Photography, humanitarianism, empire', *History Australia*, available online: http://journals.publishing.monash.edu/ojs/index.php/ha/article/view/1237. Research regarding the 1951 UNESCO Exhibition on Human Rights was assisted by Katrine Bregengaard and Eva Prag of the *Visualizing Universalism: The Unesco Human Rights Exhibition, 1949–1953* project hosted by Columbia University's Institute for the Study of Human Rights, New York. The State Library of West Australia holds a copy of the UNESCO album.

For discussion and encouragement during work on this book, I especially thank Liz Conor, Ned Curthoys, Shino Konishi, Alice Gorman, Ann Curthoys, Alistair Paterson, Fiona Paisley, Philip Mead, Aileen Walsh, Krishna Sen and Donna Oxenham for their support and enthusiasm. And last but never least, thanks to my dear family – especially my mother, Mary Lydon, and Tim, Roy and Dash.

PREFACE

To learn to see the frame that blinds us to what we see is no easy matter. And if there is a critical role for visual culture during times of war it is precisely to thematize the forcible frame, the one that conducts the dehumanizing norm, that restricts what is perceivable, and indeed, what can be.

JUDITH BUTLER, *Frames of War: When is Life Grievable?*
(New York: Verso, 2010), 100.

Writing from Australia, I am very conscious of the ways that the ethos of humanitarianism and human rights has been applied in my country. The gap between theory and practice has often been wide here, despite the participation of many well-intentioned and often visionary Australians in conceiving, developing and disseminating these global principles. Our history as a settler colony has left legacies in the present that are most evident around questions of relations between Aboriginal Australians and mainstream society, sometimes termed 'reconciliation', and the concrete disparities in health, education and employment which continue to defy our best efforts at reform. In 2016, such problems appear more intractable than they have since the 1970s. Exploring the history of seeing human difference through an Australian lens reveals how photography has both incorporated Indigenous peoples into the category of the human, but has also excluded them from it.

For many years now I have been concerned about understanding the role of photography in shaping debates about Aboriginal Australians and their relationship to the nation and the wider world. My previous work has been conducted through collaboration with Aboriginal people in seeking to understand Indigenous views of photography and history. This has taught me the power of photography within Aboriginal communities, and impressed upon me the immense responsibility of working with these archives, still so fraught with emotion and trauma for many descendants. In this book I have taken a more self-reflexive stance towards this history, in order, as Judith Butler suggests, 'to learn to see the frame that blinds us to what we see'. This is not, I hope, a retreat to 'what the white photographer saw'. Instead I attempt to move beyond the limited and politicized ways that Aboriginal people have been represented to ask questions about whiteness and history: what schemes of humanity, justice and progress have shaped the ways humanity has been visualized through the camera's lens? What have been their limitations? How have the ideas and relationships created by photography entrenched white identity and privilege?

A powerful visual and narrative strategy of humanitarianism has been to create a sense of proximity between distant people, prompting what we now term empathy. Since its invention, photography has provided a vivid conduit between viewer and viewed.

However, while empathy is popularly considered a positive good in our society, intellectual critique has always focused on its *limits*, pointing out that such emotions are deeply implicated within power relations and entrenched inequality. Salutary as such arguments may be, they do not suggest what we should put in its place, unless it might be the dispassionate application of human rights principles. Yet in practice, the idealizing vision of human rights is also governed by cultural dispositions and political interest, and often distorted in its application.

As a white Australian scholar, I am wary of either distancing or appropriating the experience of Indigenous people through the identification afforded by photography, but I believe that photos provide a means for the radical interrogation of white privilege. In addition to understanding the evils of colonization, I believe we should acknowledge moments of compassion with the potential for change, lest we lose hope in the possibility of reconciliation and justice in the present. We need a way of looking at these photographs that is 'testimonial', rather than passive. Guiding questions for my research have therefore been: Who benefits from the production of empathy and in what circumstances? Who should feel empathy for whom? What change has such imagery brought about? Photographs insist on our obligation to the past, summoning it into our present and keeping it alive. Despite the difficulties of witnessing, in its performance, photographic history offers a means of remembering, and *continuing* to remember, which may prevent foreclosing or compromising the past.

The history of humanitarianism is not a simple story of progress. Some like to narrate Australia's story as one of improvement, from a brutal frontier to racial accommodation and pioneer achievement, along with a gradual process of reconciliation, to a proud national future. Linear histories such as these allow us to draw a line between past and present, to forget what happened *then* and ignore its legacies *now*. Linear histories feature evil colonists, overlooking evidence for ambivalence or moral uncertainty in the past; casting our forebears as long-departed 'villains' enables us to feel that we are better than they were and lets us overlook the ways historical precedents may live on in the present. Conversely, casting humanitarians as heroes renders them outside culture, somehow apart from their time and the broader society of which they formed a part. But violence and subordination was contested and condemned in the past – just as it continues to be now. Such acknowledgement implicates us in this story, and forces us to recognise that our history cannot be seen as progress while injustice lives on in our present.

NOTE ON IMAGE USE

In acknowledgement of the important role of photographs in constituting Indigenous identity in the present, and the moral right of Indigenous people to have a say in their current use, cultural protocols surrounding the viewing of colonial imagery have come to involve Indigenous control over representation. I have followed these protocols in obtaining copyright and usage permissions for all images reproduced in this book as required under Australian and international law and, in a procedure that is now standard ethical research practice in Australia, I have also sought in each case to obtain cultural or moral permission from the image's subject or his or her family or community.

MAP OF AUSTRALIA

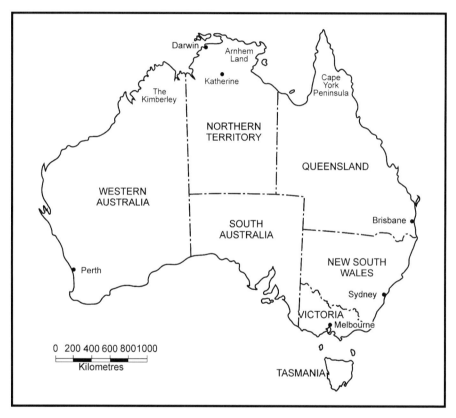

Figure 0.1 Map of Australia.

1

INTRODUCTION: PHOTOGRAPHY, HUMANITARIANISM, EMPIRE

This book is about how photography has been used to define humanity, in shaping ideas about race and difference, but also in helping to argue for humanitarian ideals and, ultimately, human rights. I examine the Australian experience during photography's first century, where discussion of colonization and nation-building often centred upon views of the humanity and capacity of the continent's Indigenous peoples. From the invention of this new visual technology around 1839 to the UN Declaration of Human Rights in 1948, photography became a part of debates about the nature of humanity, the treatment of Indigenous peoples and the responsibilities of British rule. Photographs became an increasingly important means of proving arguments, mobilizing audiences, sharing ideas and witnessing far-distant circumstances; but above all, they created relations between far-distant peoples, and prompted emotions such as compassion and empathy. This book maps the complex ways that photography has made arguments about who counts as human, and whom one should feel *for* or *with*. In exploring these diverse uses, I take issue with the current interpretive orthodoxy which claims that human rights can only be pictured in their *violation*. In this view, 'human rights' can only be imagined or depicted through the suffering of those who have been stripped of their humanity. As Susie Linfield argues,

> The philosophies that undergird ideas about human rights are … built around absence. And photographs, I would argue, are the perfect medium to mirror the lacunae at the heart of human rights ideals. It is awfully hard to photograph a human right … in fact, rights don't look like anything at all.[1]

In this book I wish to take a different approach. While I acknowledge the power of witnessing the *violation* of rights, I propose that our focus on suffering and atrocity imagery has displaced attention to other ways in which we may imagine humanity. Although powerful, there is nothing logically necessary about witnessing another's sorrow, rather than their happiness or contentment, in order to feel with them or understand them as human. As eighteenth-century moral philosopher Adam Smith noted, 'Neither is it those circumstances only, which create pain or sorrow, that call forth our fellow-feeling … Our joy for the deliverance of those heroes of tragedy or romance who interest us, is as sincere as our grief for their distress, and our fellow-feeling with their misery is not more

real than that with their happiness.'[2] Beyond the image of the suffering body, photography has prompted recognition of the diversity of the human condition in many different ways, ultimately asserting human rights under the umbrella of a universal humanity.

Over the last decade there has been an explosion of interest in the history of human rights. Lynn Hunt, in her influential account, *Inventing Human Rights*, argues that the psychological foundations for human rights emerged during the revolutionary period of the late eighteenth century in America and France, from a new humanitarian sentiment, entailing forms of subjectivity characterized by sympathy and autonomy. 'Sentimentalism', the moral expectation that one should care about others, was grounded in new ways to bring observers into proximity with the distant victims of suffering, such as in the epistolary novel.[3] In Hunt's account, the idea of human rights that emerged during the eighteenth century was succeeded by a period of relative 'silence' during the nineteenth and early twentieth centuries, which was finally broken at the conclusion of the Second World War.[4] In this analysis, the long nineteenth-century 'silence' about rights was caused by the emergence of nation states – so that debate occurred within 'specific national frameworks' – and by the challenge to a shared humanity constituted by racial science.[5]

More recently, others have pointed to the imperial and global proliferation of debates, processes and events entailing concepts of human rights across the nineteenth and early twentieth centuries. This research has begun to view the history of human rights as a process that developed dialogically between the Western metropole and the colonies, as debates about universal humanity were fought around race, slavery, colonialism and imperial rule. Rather than a 'silence' about human rights, this period witnessed a more complex story about the emergence of a global category of shared humanity formed in negotiations over the nature of empire and Britain's role in the wider world.[6]

What are human rights? Fundamental to the concept of human rights is its universality: all human beings have rights simply because they belong to this shared category, the 'human'. Also specific to the modern discourse of rights is the notion of the autonomous individual. As Duncan Ivison argues, rights are grounded in a concept of 'providing a boundary around an individual, or at least around certain crucial aspects of her freedom'. He also notes, however, that such boundaries may be exclusionary, and are inescapably political in their formulation and application, often serving as 'conduits for new forms of power and regulation'.[7] The category of the human and its limits has thus been linked both to the liberal and humane impulses deriving from an increasing sense of individual value and their implication in forms of power. In this historical study I take a broad view of these processes, acknowledging the close historical and intellectual relationship between human rights and humanitarianism, distinct and sometimes incommensurable as these concepts might be.[8] Humanitarianism is a term that passed into everyday use after 1800 and refers to a philosophy of advocating or practising compassionate action. This 'fundamental shift in public consciousness' signalled the emergence of the extension of concern for people beyond one's immediate community.[9] While rights are often secured through an appeal to the humanitarian principle of ending unnecessary suffering, these orientations may exist in tension, as exemplified by the slave-owner who campaigns for the kinder treatment of slaves or, conversely, the abolitionist who nonetheless submits to the apparatus of slavery in order to buy and free the enslaved. Here I am also concerned with moments of

acknowledgement of another's humanity, even at times when the oppressive apparatus of modernist racial science was most constrictive. Such encounters – exemplified by Italian Darwinist Enrico Giglioli's fieldwork, recounted in Chapter 3 – mark the fluidity of the boundary drawn around the human, as personal engagement struggled with imagined alienation. This ambivalence structured the humanitarian relationship across empire.

Eventually the expansion and stabilization of this notion, as it was extended to all humankind within a growing view of the human as a universal, global category, produced the twentieth-century system of principles and law that we now term 'human rights'. This book explores how that was enabled by new technologies of seeing and a sense of empathy with and responsibility for the suffering of others.[10] Two distinct strands of argument characterize historiographical debate on this question, one emphasizing changing subjectivities and an emerging ethos of compassion, or as Adam Smith termed it, 'fellow-feeling', and another focused upon the power relations and political contexts for humanitarianism. As we shall see these are, of course, linked, particularly through popular culture and the cultural forms that shape subjectivity.

Fellow-feeling

Fundamental to the practice of both human rights – at least in its ideal form – and humanitarianism is a concern for the suffering of other people. Such concern has taken the form of emotions defined variously over the last three centuries as pity, sympathy, fellow-feeling, compassion and empathy. Scholarly interest in emotions, sometimes termed the 'affective turn', has defined emotions, or 'felt judgements', as embodied feelings experienced in the context of cultural values and principles.[11] Emotions may be collective, historically created and locally contingent, and respond dynamically to circumstance, response or refusal in systems of circulation and exchange that Sara Ahmed terms 'emotional economies'.[12] Rather than focusing solely on the function of emotion in written texts, this study explores the *practices* of viewing and using photographs, attending especially to the images' affective properties. Such practices constitute humanitarian 'objects of feeling' – those towards whom we feel pity, anger or love.[13]

From the mid-eighteenth century a so-called 'cult of sensibility' arose in Britain, stressing a set of values that regarded sensation as a 'moral and emotional capacity', and that came to associate sensibility with refined feeling, discrimination and taste as well as an intense sensitivity to the suffering of others.[14] Adam Smith's landmark 1759 work, *The Theory of Moral Sentiments*, examined the human capacity for 'pity or compassion, the emotion which we feel for the misery of others, when we either see it, or are made to conceive it in a very lively manner'.[15] As I have noted, Smith argued that it is not just suffering that 'call[s] forth our fellow-feeling', but that with any 'passion' evinced from the object, 'an analogous emotion springs up, at the thought of his situation, in the breast of every attentive spectator'. Our joy for 'those heroes of tragedy or romance who interest us, is as sincere as our grief for their distress, and our fellow-feeling with their misery is not more real' than with their happiness.[16] And he explained that while 'pity' and

'compassion' signify our fellow-feeling with the 'sorrow of others', by contrast 'sympathy' denoted 'our fellow-feeling with any passion whatever'.[17] Smith's broad conception of sympathy encompassed what during the twentieth century increasingly came to be called 'empathy', a term only introduced to English in 1909 in translation of the German term *Einfühlung* (or 'feeling into').[18] In its earliest turn of the century usage, empathy referred to an aesthetic experience, such as a reaction to a work of art, as well as a bodily response.[19] During the twentieth century, empathy merged with and completely replaced the multidimensional concept of sympathy as it was used by earlier observers. I aim to use terms such as 'sympathy' within their historical context; however, in drawing on the extensive recent critical literature focused upon a broad and inclusive usage of 'empathy', I use this latter term to refer to the constellation of sympathetic emotions.[20]

Identifying the ultimate limit to such 'fellow-feeling', Smith pointed out that 'though our brother is on the rack, as long as we ourselves are at our ease, our senses will never inform us of what he suffers'. The viewer is limited by her own experience and remains unable to truly enter into another person's subjectivity; empathy can thus only be felt as an imaginative identification. In the end, 'it is the impressions of our own senses only, not those of his, which our imaginations copy'. Significantly, Smith grounded moral conduct in the experience of seeing and being seen; he considered sympathetic identification with others as a natural response to viewing their experiences, prompted by an inner spectator, 'the man within'. Twenty-first-century neuroscience has corroborated Smith's notion of sympathy – or as we now term it, empathy – as a process of mirroring the mental activities or experiences of another person based on the observation of his bodily activities or facial expressions.[21] The term 'mirror neuron' refers to the significant overlap between 'neural areas of excitation' aroused by our own experience as well as our observation of someone else's.[22] Our consciousness of this relationship – our bodily observation and awareness of our simultaneous separateness and identification – is central. Smith wrote, 'We suppose ourselves the spectators of our own behavior, and endeavor to imagine what effect it would, in this light, produce upon us. This is the only looking-glass by which we can, in some measure, with the eyes of other people, scrutinize the propriety of our own conduct.'[23] Smith's recognition of our innate disposition for motor mimicry anticipated a mode of sympathy, moral appeal and campaigns for reform designed to confront viewers with the plight of suffering victims in order to prompt empathy.

By the end of the eighteenth century, the cult of sensibility, along with its stereotype, 'the Man of Feeling', had become the object of parody and satire, suggesting its decline. However, a new culture of 'sentimentalism' emerged from this emotional regime, infused with a new power by evangelical Protestantism, and becoming a key element of nineteenth-century philanthropy and humanitarianism.[24] The rise of 'humanitarianism' has been closely linked to the antislavery movement and to a shift in perception towards the end of the eighteenth century which made slavery appear morally unacceptable to many. This new cultural orientation emphasized sympathy for suffering and revulsion from pain, uniting ethical witnessing with a moral universalism and a notion of necessary action to alleviate suffering.[25]

Humanitarian narratives were an integral aspect of the culture of sentimentalism and the growing moral expectation that one should care about others. Thomas W. Laqueur's

classic essay, 'Bodies, Details, and the Humanitarian Narrative', argued that the humanitarian narrative 'relies on the personal body, not only as the locus of pain but also as the common bond between those who suffer and those who would help', with detailed accounts of the suffering body eliciting 'sympathetic passions' that could move a person from feeling to action.[26] Laqueur observed that eighteenth- and early-nineteenth-century narratives came to speak in an extraordinarily detailed way about 'the pains and deaths of ordinary people', producing a literary 'reality effect' reliant upon detail as the sign of truth, and the body as locus of pain forming a common bond between sufferer and observer.[27] In many contexts humanitarians successfully deployed graphic scenes of distress as a powerful prompt to sympathy, expressing through visual means the liberal political philosophy of rights and contributing to the abolition of slavery.[28] In this vein, scholars such as Martha Nussbaum, Richard Rorty and K. Anthony Appiah have more recently argued for models of cosmopolitan reading that allow the reader to bridge difference: like Hunt, they advocate an empathetic imaginative identification with those unlike 'us' which expands the category of humanity itself.[29]

The limits of empathy

Mistrust, however, has always surrounded humanitarian narratives and the emotions they seek to excite: the very intensity of humanitarian images of suffering often became suspect for their titillating and anaesthetizing effects, serving to distance, rather than embrace, the victim.[30] Lauren Berlant has pointed out that emotions such as compassion merely imply a social relationship, with an emphasis on how the viewer feels and responds; yet in practice, it is clear that such emotions do not always lead to reform or progress, but may, in fact, maintain inequalities and foster division.[31] Wariness about empathy stems from three chief problems: that feeling is not necessarily linked to action, so that these emotions may simply reinforce the status quo; that representations of suffering may obscure the other's subjectivity, distancing and diminishing their humanity; and finally, and most unsettling, as Berlant suggests, perhaps 'compassion and coldness are not opposite at all but are two sides of a bargain that the subjects of modernity have struck with structural inequality'.[32] Such doubts have led some to conclude that humanitarianism itself relies upon a notion of the human that is partial, limited and exclusive.

Lynn Festa, for example, in exploring the eighteenth-century origins of sentimental literature, argues that emotion became an important means of social and cultural distinction in this mode, as the attribution of sentience and feeling helped to define who would be recognized as human.[33] By governing the circulation of feeling among subjects and objects, sentimentality allowed conquest to be portrayed as commerce and scenes of violence and exploitation to be converted into displays of benevolence and pity. Ultimately, Festa argues, 'The subject produced by sentimental antislavery is granted only a diluted form of humanity grounded in pain and victimhood, a humanity that lasts only as long as the recognition of the metropolitan subject who bestows it,' creating a divide between viewer and the imagined object of sympathy.[34] Such work suggests that humanitarian

narratives have acted as a potent mechanism for the distribution of power, including the power to justify when and where to intervene, and who is deserving of the 'gift' of rights.

Joseph Slaughter also points to certain literary strategies that produce troubling imaginative identifications 'with the suffering individual', in which the other's difference is masked or limited through the reader's own experience. For Slaughter, the dyadic model of empathetic identification revived by Nussbaum and Rorty does more to entrench than to dismantle the unequal relationship between those with rights and those without. This model of sentimentality, he says, 'is the cultivation of a *noblesse oblige* of the powerful (rights holders) towards the powerless (those who cannot enact their human rights) that ultimately reconfirms the liberal reader as the primary and privileged subject of human rights and the benefactor of humanitarianism'.[35] Instead, Slaughter argues for narratives that focus identification upon the humanitarian herself rather than the suffering subject. The introduction of a third actor – the humanitarian – into the 'humanitarian dramatic triangle' allows the reader to cultivate his or her own capacity for kindness through identification with the philanthropist. In this way, 'the sense of ethical obligation perhaps develops not in response to another's tragedy but as a sense of responsibility to the moral integrity of one's own class of humanity'.[36]

Such concerns are shared by visual theorists exploring the operation of empathy in photographic representation, and who have largely focused on identifying its *limits*. Although an enduring visual tactic has been to reveal the suffering and atrocity inflicted on others in order to spark action, a substantial amount of scholarly literature has been concerned to trace the ambiguities of empathy across racial, gender and class lines.[37] Images were deployed by the antislavery movement, for example, but Marcus Wood's analysis concludes that slaves were represented as passive beneficiaries of white compassion, reflecting abolitionist perceptions of black men and women as human, but not equals.[38] In the same way, Saidiya Hartman has argued that attempts to empathize with the slave through representation result in the occlusion of her subjectivity, as the white viewer's own experience determines the racial limits of imaginative identification.[39]

Such concerns raise important questions regarding the ethics of spectatorship and the implication of humanitarianism within political inequality. They demonstrate that empathy is produced within networks of power relations that enmesh both viewer and image – and I take up questions of ethical spectatorship throughout this book. I also pursue a number of related questions: How have photographs aroused empathy with Indigenous suffering and discrimination, and moved viewers to action on their behalf? What have been the limitations of these ways of seeing? How have they changed over time?

These ethical questions have only multiplied in an intensified global visual culture that places ever more weight upon photographic evidence for distant suffering, and the need for humanitarian intervention. Photos excite empathy. Photos bring their subject closer and allow the misrecognition of ourselves in another's suffering – a form of visual recognition that is central to a concept of humanity. Yet just as with humanitarianism itself, visual narratives of suffering may act to reduce and distance the sufferer or appropriate his or her pain. Many argue that such identification effaces racial difference, denies agency to the sufferer or gives the viewer a feeling of benevolent largesse which never actually changes anything. This critical tradition emerged in conjunction with poststructuralist

critiques of photography that emphasized the entanglement of knowledge, vision and power, and questioned the image's truth and authenticity.[40]

More recently, however, several scholars have emphasized the power of images to move us. Sharon Sliwinski's important study of photography and human rights represents a new approach towards historicizing human rights which demonstrates the crucial status of aesthetic judgement and the way images prompt emotional appeals and shape moral convictions.[41] Similarly, despite acknowledging photography's sometimes repressive functions, scholars of American slavery have recently revisited photography's 'democratizing potential' in exploring the ways that African Americans and their supporters used the medium.[42] A new interest in the medium's social – and emotional – effects has displaced analysis of the photo as sign and the photographer as author, perhaps best summed up as a shift from what photos *mean* to what they *do*.[43] In line with much thinking about affect which now considers It as constituted within culture, Judith Butler challenges a distinction Susan Sontag famously made between affect and understanding, image and prose, in arguing that sentiment does not forestall thought but that visual 'interpretation takes place by virtue of the structuring constraints of genre and form on the communicability of affect – and so sometimes takes place against one's will, or indeed, in spite of oneself'.[44] Echoing this emphasis upon one's embodied encounter with the image, Jill Bennett argues that an affective encounter can be a catalyst for critical enquiry, rendering what she terms 'heteropathic identification', an 'empathy grounded not in affinity … but on a feeling for another that entails an encounter with something irreducible and different, often inaccessible'.[45]

Empire and humanitarianism 1830–1850

In the following section I shift from exploring empathy itself to examine a broader ethos of humanitarianism within cultural and political frameworks: contests over the humanity of Aboriginal people were intensely politicized, as humanitarians sought to arouse sympathy for their plight against those who belittled their humanity in the defence of colonialism and conquest. Recent histories have explicitly focused upon the relationship between the 'extension of western concern for distant strangers and the expansion of western empires', arguing that humanitarianism is distinguished from earlier forms of compassion by its imbrication within imperial governance, with its orientation towards those in other lands.[46] However this was a battle fought over the boundary between the human and the non-human. Humanitarianism, I argue, is not merely an instrumentalist, action-oriented apparatus of policy and governance but also that which relies upon popular ideas and attitudes concerning who counts as human. In this inclusive usage, challenges to oppressive racial taxonomies are significant in defining the limits of contemporary acknowledgement of Indigenous humanity.

For many, the story of human rights begins with Britain's antislavery movement, typifying the symbiosis between imperial power and compassion.[47] This transnational movement, strongest between the 1780s and the emancipation of slaves in British colonies in 1834, gave rise to commentaries on morality, law and politics, humanity, natural rights and

human rights.[48] Although characterized by a concern for distant others, antislavery was also driven by new forms of social organization, such as the growth of capitalism and the beginnings of industrialization, suggesting its profoundly political as well as moral dimensions.[49]

So, why Australia? The colonization of Australia by the British from 1788 provided a kind of litmus test for theories about race, imperialism and progress. Increasingly over the course of the nineteenth century, British identity relied upon a sense of enlightened stewardship, as a civilizing force among the world's peoples. Australia, with its seemingly limitless potential as the inheritor of British achievements, yet already occupied by Aboriginal people, therefore precisely maps the tension between ideas of imperial progress and what was owed to the conquered. Quickly assigned by many observers to the border between human and animal, images of Australian Aboriginal people naturalized ideas about who counted as human and what this recognition meant for their rights. Australian Aboriginal people occupied an integral position within imperial schemes of identity and progress.

Since Britain's first plans to establish a colony in Australia, for example, ideas about its future were closely linked to contemporary debates about abolition. As Deirdre Coleman has shown, the American Revolution and the loss of Britain's North American colonies sparked an intense debate about the nature of colonization in the period 1770–1800, and the growing popularity of the antislavery movement gave a utopian cast to the debate about colonization.[50] Nineteenth-century observers argued for Australia's matchless potential to advance spiritual and scientific agendas, a perception grounded both in the utopian possibilities for its nascent society and in the seemingly primitive status of the continent's Indigenous peoples. The Australian head of the Church of England, Bishop William Broughton, saw the colonization of Australia as accomplishing a divine plan, declaring in 1829 that the 'exaltation of the English nation, and its gradual extension of power to the limits of the habitable world' was no accident, but marked 'the particular and evident providence of the Lord, for the fulfillment of His own purposes'.[51] Yet 'romantic', arcadian views that pictured the colonies as inheritor of the British Empire existed in tension with the need to exploit new forms of labour, and early ideals of a free society were tarnished by comparisons between transportation, the system of exporting convicts to the new penal settlements, and slavery.[52] In these utopian colonial visions, Australian Aboriginal people were slotted in to prior discourses of humanity and freedom. A celebrated sermon delivered by the Baptist minister John Saunders in 1838 declared that 'the New Hollander is a man and a brother'.[53] Such rhetoric evoked the emblem of the abolitionist movement – the kneeling slave in chains, surrounded by the words 'Am I Not a Man and a Brother?'[54]

The 1830s marked a high point of humanitarian public sentiment in Britain with the *Slavery Abolition Act 1833* that outlawed slavery throughout the British Empire. Following the end of slavery, prominent humanitarian leaders and organizations sought to redirect popular sentiment from abolition to the empire's Indigenous peoples, including the Khoisan and Bantu peoples of southern Africa, Australian Aborigines, New Zealand's Maoris and Pacific Islanders.[55] The 1835–6 'Select Committee on Aborigines' inquiry tried to define the principles of a system which would 'enforce the observance of their [Indigenous] rights' and concluded that 'the effect of European intercourse … has been, upon the whole, hitherto a calamity upon the native and savage nations'.[56] The evangelical critique framed colonization in terms of sin and redemption, and missionaries argued that it was

important for colonists to atone for their exploitation of Indigenous peoples by introducing Christianity and 'civilizing' them.

As Elizabeth Elbourne has pointed out, however, there is a basic paradox in the justification of British conquest through the language of liberalism and its simultaneous dependence on 'violence, coercion and property theft' to extend its control.[57] Just as Britain's campaign to abolish slavery reached its climax, the invasion of Indigenous country began on an unprecedented scale. Alan Lester and Fae Dussart trace the incorporation of amelioration policies into the apparatus of colonial governance, and especially the appointment of Protectors, as the British state accepted some responsibility for its colonized subjects.[58] These 'transimperial governmental experiments' were conducted in South Africa, Australia and New Zealand throughout the 1830s and 1840s, via the flows of imperial networks that were constituted by policies, the work of humane officials and their affective ideals, which came to function as an intrinsic aspect of their colonial governmentality.[59]

The colonial missionary movement and a concept of 'imperial trusteeship' drove Britain's transformation from Protestant nation to free Christian empire, prompting debates about the politics of racial difference and the ethics of imperial power.[60] A key feature of these developments was the connections and mutuality of relations between metropole and the colonial 'periphery', as expanded imperial networks of travel, and the exchange of ideas and culture constituted new social categories and knowledge across the globe.[61] Although the relationship between missionaries and imperialism has been complicated by historians who point out the resistance offered to missionization by many imperial officials and settlers, and the critical attitude of many missionaries towards colonization, it is clear that they were interlinked dimensions of a globalizing modernity.[62] Britain's foreign missionary movement was a means of shaping British ideas about empire, identity and society through the promotional strategies of the major churches and their offshoots, such as the Anglican Society for the Propagation of the Gospel (SPG), responsible for coordinating overseas missionary work.[63] The SPG participated intensively in the burgeoning print culture that emerged from new technologies of printing, including visual reproduction, distribution and correspondence.[64] Photography quickly became an important tool for these humanitarians, in showing foreign peoples to a domestic readership and arguing for their Christian and civilized potential.

But the optimism of the 1830s soon turned to doubt and pessimism: slavery in Africa remained a problem; the 1841 Buxton-sponsored expedition up the Niger River ended in disaster; and Indigenous resistance erupted in the Indian Mutiny, the Maori Wars and Jamaica's Morant Bay rebellion. By the end of the decade it was glaringly apparent that Australian humanitarians were ineffectual, particularly the Aboriginal Protectors appointed in the Port Phillip district (now the state of Victoria). In 1848 government superintendent Charles Joseph La Trobe reviewed their efforts and concluded that the protectorate had 'totally failed'. Bleakly, he wrote,

> The result of all this outlay may be stated in few words. Every one of these plans and arrangements for the benefit of the Aboriginal Native, with the exception of the last named, the Native Police, perhaps, has either completely failed, or shows at this date most undoubted signs of failure, in the attainment of the main objects aimed at.[65]

Douglas Kilburn's Kulin people

Humanitarian governance relied upon popular sentiment regarding the claims and capacity of Aboriginal people, and imagery provided a powerful tool in these debates. The climate of humanitarian failure and disillusionment regarding the capacity of Australian Aboriginal people framed their first photographs, produced in Melbourne in 1847 by professional photographer Douglas Kilburn. These were probably a commercial experiment to satisfy the curiosity of a British audience. The reception of these portraits exposes the limits of empathy and the reluctance to recognize Aboriginal humanity following a decade of invasion and conflict with Aboriginal people in the Port Philip District (Victoria).

Well before Darwinism, Aboriginal people had attracted strong scientific interest, yet early portraits of Aboriginal people are rare. Each of Kilburn's extant images shows a studio group of three people, presumably belonging to the Kulin Nations confederacy of central and southern Victoria, whose lands were rapidly overrun by white settlers from 1835. They wear a mix of traditional and European clothing and regard the camera directly and with gravity (Figure 1.1). Kilburn described their initial fear of the 'machine', perhaps enjoying the idea of himself as 'sorcerer'.[66] This scenario emphasizes the confrontation between black and white through the alien medium of photography, as the frontal, seemingly direct gaze of the Kulin appears to embody a stark racial opposition.

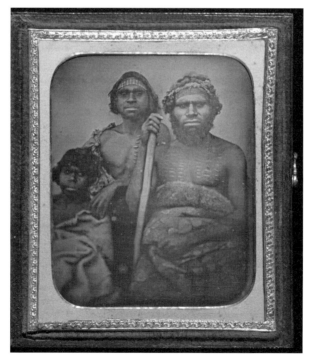

Figure 1.1 Douglas T. Kilburn, Group of Koorie men, c.1847. Daguerreotype. Courtesy National Gallery of Victoria, Melbourne.

They recorded people who had experienced a decade of white settlement, yet who remained visible within the landscape, walking the still-unpaved streets of Melbourne and camping on its fringes.

The modern viewer immediately recognizes the humanity and individuality of these three people and numerous signs of a rich cultural life: the older man's elaborately decorated possum-skin cloak, its skin incised with ancestral markings, his finely woven headband and the impressive ritual scarring across his chest all reveal him to be a senior member of his clan. These marks replicated the movements of the ancestral powers, or 'Dreamings', who created places, people and culture, and inscribed the signs of their activities into the earth.[67] Remaking these designs on the body, in sand or in ornament, reunites Aboriginal people with Dreamings and articulates relationships to people and place. A twined hair ornament has flicked across the senior man's shoulder during the exposure, a small gesture that blurred. The younger man stares challengingly at us, his scars shiny and only half-completed, while the young boy looks warily sidelong. It is easy for us, in our very different twenty-first-century visual culture, to view these people with respect, knowing of their sophisticated social world, the tribulations they were then facing and their survival, against the odds, into the present.

One hundred and fifty years ago, however, these images were used to measure Aboriginal people against contemporary standards of humanity and find them wanting. Well before the invention of photographic printing techniques, Kilburn's 1847 daguerreo-types circulated around the globe in the form of engravings, within an emerging cosmo-politan print culture.

Their distribution and reception within these new contexts, and the translations they required, reveal the malleability of visual meaning and its easy infusion with sentiment. Engravings based on Kilburn's Kulin featured prominently as the frontispiece of William Westgarth's 1848 popular guide for prospective settlers, *Australia Felix* (Figure 1.2).[68] Westgarth emphasized the colony's potential for settlers, but by contrast, characterized Aboriginal people as lazy, savage and doomed to extinction, in a 'fatal impact' formula that had been commonplace since the late eighteenth century.[69] With distaste, one reviewer noted that Westgarth's *Australia Felix* (1848) was 'a disagreeable subject, because so soon as our curiosity is gratified, every philanthropic hope is destroyed by the conviction, forced upon us by the failure of repeated attempts, that the race is incapable of elevation'.[70] In Westgarth's woodcuts of the Kulin, the specificity of the men's ancestral markings is lost; the cross-hatched lines of the engraver collapse all into a surface mesh and they have become primitive cartoons.

In 1850 a more sympathetic, 'soft primitivist' view was presented by the *Illustrated London News*, the world's first weekly illustrated news magazine (Figure 1.3). Kilburn's group photographs were skilfully rendered as individual engraved portraits, given meaning by the textual narrative. James Bennett Clutterbuck's account – another emigrant's guide – moved back and forth across the boundary between 'savage' and 'civilized', disgusting and admirable, in describing their lifestyle as 'dirty', yet deeming their appearance and especially their tattoos 'by no means inelegant in design' and suggesting that 'the Manchester calico-printers might derive some useful hints from the delineations of these simple people'. He declared their teeth so 'even, perfect and beautifully white' that they

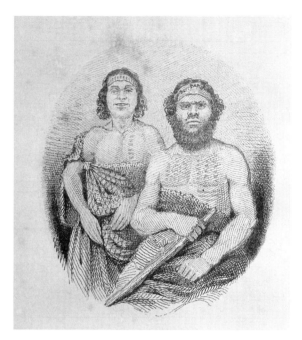

Figure 1.2 Frontispiece in William Westgarth, *The Colony of Victoria: Its History, Commerce and Gold Mining* (London: Sampson Low, Son, and Marston, 1864).

would be the envy of 'Cranbourne-alley dentists' and likened them to European children in concluding that their 'deportment' was

> far more dignified than artificial tuition could impart. Place a laboring man, or even some of the educated offspring of European parents, by the side of one of the aboriginal natives of Port Phillip, and the dignified, self-possessed carriage of the latter would be at once pronounced as belonging to the Chesterfield school than the artificial deportment of the former.[71]

Clutterbuck deplored the attitude of settlers who casually admitted to shooting Indigenous people for cattle-stealing, opining that 'our nominal brothers and fellow-subjects are thus practically treated as hostile aliens'.[72] The engravings present single or paired portraits drawn from Kilburn's daguerreotypes, rendered in a serious, almost neoclassical style that retains the subjects' dignity.[73] The text expresses a relativist notion of culture via its comparisons with metropolitan standards of dentistry and comportment. While the author deplores the 'savage whites' and argues for Indigenous humanity, he simultaneously deploys a major strategy of belittlement in relegating Indigenous people from the fully human to the lesser status of children.

The images were given an even sharper meaning when they subsequently appeared in the Assamese-language Baptist publication *Orunodai: A Monthly Magazine* (Figure 1.4). This was published from 1846 by the American Missionary Press in Sibsagar, Assam – a northeastern state of India that was occupied by the British after the first Anglo–Burmese

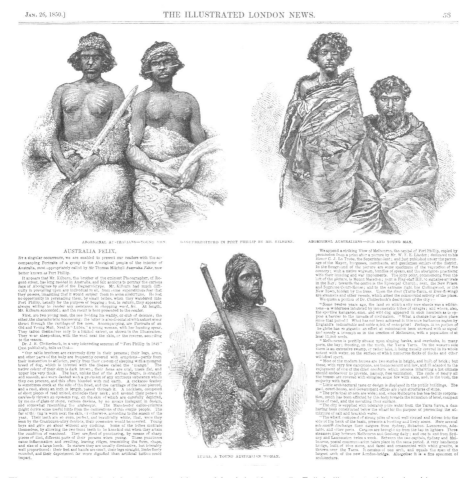

Figure 1.3 'Aboriginal Australians – Young Men', in 'Australia Felix', *Illustrated London News*, 26 January 1850, 53.

War of 1824–6.[74] *Orunodai* published articles designed for high-caste Assamese-speaking gentry, and addressed a wide range of current affairs, especially Christianity, science, astrology and history. Although it borrowed several key points from Clutterbuck's account, its description was significantly briefer and more disparaging than the London periodical's, and it claimed, uncompromisingly, that

> the aboriginal people of Australia are uncivilized; somewhat smaller than other humans, (they) do not know how to take-and-eat (i.e. conduct themselves), are more [primitive] than our Nagas; till now, the male and female do not feel any shame in entering and moving about the town naked. Some of them sleep in crevices of rocks or under trees, without building any houses.[75]

Designed for a local audience, this image reduces the Australian Aboriginal people even further, to the status of animals.[76]

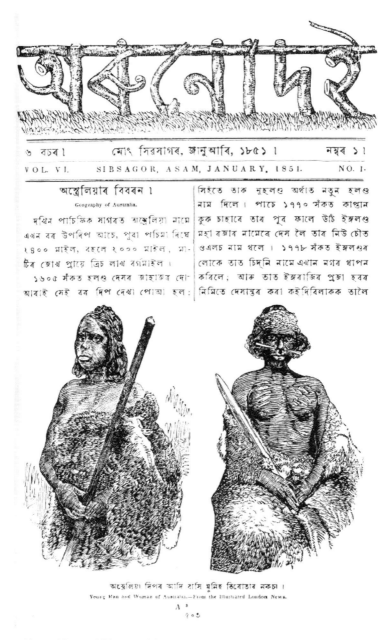

Figure 1.4 'Young Man and Woman of Australia – From the *Illustrated London News*, "Description of Australia"', *Arunodai* (Sibsagar, Assam), vol. 6, no. 1 (1851): 1.

At a time when humanitarian views of Aboriginal people were at their nadir, these three accounts of Kilburn's Aboriginal subjects used popular rhetorical practices to define them as less than human, and to justify invasion and dispossession. Even Clutterbuck's sentimental narrative, which constitutes Aboriginal people as objects of pity and condemns their cruel treatment by brutal white settlers, emphasizes difference rather than similitude.

They are simultaneously defined as human yet assigned to a separate class, allowing readers to recognize human likeness while maintaining key differences. The lived reality of encounter in the colony was forgotten, as visual and textual representations of Australian Aboriginal people that portrayed them as savage or subhuman circulated globally.

The following chapters take up this narrative from the late 1840s. Accounts of Aboriginal incorrigibility and missionary failure in Australia were seized upon in Britain, where popular views were increasingly informed by scientific arguments for a fundamental racial difference. In this way, boundaries drawn around the 'human' express power, dominance, inclusion and exclusion, underwriting territorial conquest. Increasingly during the nineteenth century, the measurement of bodies and visual 'data' became the basis for modernist notions of scientific race, in which Eurocentric criteria formed the basis for supposedly objective and relativist judgements. Yet what have been overlooked are the challenges to such categories and judgements posed by encounters – both photographic and embodied – with Aboriginal people.

During the 1840s, as Chapter 2 explores, a time when British pundits sought to constitute the white waif as the 'proper' object of pity, figured in opposition to the black 'savage', missionaries developed visual strategies of inclusion and equality. As foreign evangelization came under attack in Britain, Anglican missionaries created a vision of the Aboriginal people of Poonindie in South Australia as gentlemen. Picturing their black brothers as upper-class Christian gentlemen countered assumptions that Aboriginal people were primitive and subhuman. Dignified portraits sought to arouse feelings of respect and recognition within the civilized white viewer and to demonstrate Indigenous capacity, nobility and humanity to a metropolitan audience (see Chapter 2).

Perhaps most compelling for contemporaries was the view of Australian Aboriginal people as living relics of an earlier form of humankind. Following the publication of Charles Darwin's *Origin of Species* in 1859, the theory of natural selection quickly became scientific orthodoxy and was applied to humankind in a paradigm often termed 'social evolutionism'. Within this framework, Australian Aboriginal people occupied the lowest rung of a racial hierarchy believed to reflect temporal as well as cultural distance from European modernity. International interest in Australian Aboriginal people drew scientists from around the globe, for whom they constituted vital evidence for debates about human nature and progress. During the second half of the nineteenth century, in the wake of Darwinism, a widespread belief in the racial difference and inferiority of Aboriginal people underlay an acceptance of dwindling numbers and the demise of the race. The pitying cry of 'Povoretto!' signalled the privileged European viewer's acquiescence to conquest and destruction, camouflaged by sentimental narratives of a 'dying race'. However, encounters between scientists, photographers and Aboriginal people challenged these hardening biological theories, as exemplified by the uncertainties of young Italian Darwinist Enrico Giglioli during the 1860s and 1870s (see Chapter 3). Enrico Giglioli's experimental visual taxonomy aimed to transform Aboriginal portraits into an evolutionist schema that rendered them 'data'. His personal encounters, however, challenged this distancing stance and his photographic souvenirs remained in a private, domestic realm of memory.

Mid-nineteenth-century arguments regarding human difference between polygenists (who argued for multiple origins) and monogenists (a shared origin) were intensely

politicized, with significant implications for public debates about slavery and the American Civil War. The ascendancy of evolutionism from the 1860s onwards provided a means to explain a universal humanity, but it also legitimized racial hierarchies. The mid-century revitalization of the American antislavery debate following the publication of the bestseller *Uncle Tom's Cabin*, and the US Civil War, awoke sympathetic responses in Australia (see Chapter 4). However, increasingly over these decades, colonists had difficulty recognizing the suffering of Aboriginal people – Arthur Vogan's drawings of Queensland frontier mayhem had a limited reception. Humanitarians sought to awaken empathy through revealing atrocity and the suffering black body, but contemporary blind spots obscured empathetic recognition of the plight of Indigenous people.

Indeed, from the late nineteenth century, visions of Aboriginal assimilation masked the brutal reality of the Stolen Generations, as official policies of child removal are now termed. Notions of biological difference became increasingly rigid over the century's final decades, with the result that humanitarian campaigns were limited in their power to move Australian audiences. The invisibility of Aboriginal suffering over the last decades of the nineteenth-century maps colonial blind spots.

During the first years of Australian Federation (1901) relations between expert knowledge and government became intimately linked: young writer Elsie Masson's popular illustrated travelogue disseminated anthropological ideas about Aboriginal people to a wide audience. Masson participated in an anthropological–administrative network that harnessed material technologies, devices and techniques to govern colonial subjects (see Chapter 5).[77] These years mark the growing fetishization of whiteness, as Australia worked in concert with other countries in a global economy of 'people and ideas, racial knowledge and technologies' to exclude non-white peoples through restrictions on non-white migration and mobility.[78] Masson's account of life in the developing north of Australia reveals an apparatus of race that subordinated and governed Aboriginal people. At the same time, it conveys her sympathy and her acknowledgement of Aboriginal humanity. Masson deployed a range of visual strategies: echoing Baldwin Spencer's evolutionist approach, her dominant photographic narrative defined racial difference and primitivism and predicted the mournful end of the race. Other images, however, asserted a common humanity and pointed to white atrocity in pleading for the rights of Aboriginal people to be acknowledged. Masson's first-hand engagement with Aboriginal people demonstrates the ambivalence of racial categories and the role of visual imagery in codifying a relative understanding of culture, including customary systems of law.

Debates about race and human rights around the turn of the nineteenth century were linked to a transition from an evangelical tradition of antislavery to the rise of labour law and human rights protests under international government. In a visual humanist tradition that has often been overlooked, popular writer H. G. Wells reflected upon photographic evidence to condemn injustice and assert a cosmopolitan vision of humankind, the basis for his draft of a code of human rights (see Chapter 6). In Western Australia during the early years of Federation, the new nation was shamed by the revelation of violent coercion practised by white settlers in the state's northwest. A 1904 inquiry revealed brutal police practices, including neck-chaining, rape and slavery. Just at the time that lantern slide photographs of atrocity mobilized international censure against King Leopold

II's regime in the Congo, humanitarians failed to arouse such concern about violence against Indigenous peoples in Western Australia. Locally, such brutalities – represented by the enchained Aboriginal prisoner – were framed as evidence for upholding the rule of law and protecting white settlers. From an imperial perspective, such doings were shameful, reflecting poorly on British honour on the global stage, and a discreet veil was drawn across the whole affair. But H. G. Wells commented on Western Australia in advancing a transcendent vision of humanity that underlay his view of a new form of political community, and ultimately his vision of human rights. For Wells, even the forgotten Aboriginal deserved 'fair treatment, justice, and opportunity'; the photographic portrait gallery, *The Living Races of Mankind*, offered proof of a fundamental compatibility across the globe.

At the end of the Second World War, a new apparatus of human rights was articulated through the 1948 Universal Declaration of Human Rights (UDHR) of the United Nations, in a range of visual narratives that sought to create a sense of a universal humanity and a shared global culture (see Chapter 7). However, such utopian conceptions of global community have more recently been attacked on the grounds that they efface difference and inequality. The *Family of Man* exhibition and the UNESCO Human Rights Exhibition are among the most well-known postwar visual projects premised on a popular view of photography as a universal language of humanism. Critics of the *FoM* have focused especially on the exhibition's expression of American Cold-War ideals, as well as its exclusion and subordination of 'primitive' cultures.

In Australia, the application of this new apparatus of human rights to local issues was shaped by local politics and a state agenda, and the rights of Aboriginal people were again invisible in official formulations. It required the deployment of photographic evidence by Soviet powers, in a context of Cold-War debate, to expose the hypocrisy of state policy. As the example of Australian Aboriginal people illustrates, the fear of international shame caused by revelation of abuse was seemingly more effective than the idealizing rhetoric of humanism. Nonetheless, as I argue, the gap between the ideal vision of human rights and the ways such principles are actually applied by the state provides us with the grounds for critique, and for hope.

Over the long century explored in this book, photographs have been used to show Aboriginal people as the same as us, as different but inferior, and finally, as rights-bearing citizens. This is not a linear story of progress. Recognition has come at a cost. In order to be acknowledged by mainstream Australia, Aboriginal people have had to conform to popular notions of what to be and how to behave. Images revealing Aboriginal suffering have been used to suggest the need for intervention into Aboriginal lives, to shore up the status quo and to fuel 'benign whiteness' – the assumption that white identity and mainstream values are naturally the standard to which others should conform.

ONE BLOOD: THE NUCLEUS OF THE NATIVE CHURCH

*And hath made of one blood all nations of men for to dwell on all the face
of the earth, and hath determined the times before appointed, and the bounds
of their habitation.*

ACTS 17:26 (King James Version)

*The like feelings [of] ... Etonians and Harrovians at the cricket matches at
Lord's prov[e] incontestably that the Anglican aristocracy of England and the
'noble savage' who ran wild in the Australian woods are linked together in* one
brotherhood of blood.

AUGUSTUS SHORT, *A Visit to Poonindie: and Some Accounts
of that Mission to the Aborigines of South Australia*, 1872.

By the end of the 1840s, accounts of missionary failure in Australia were seized upon in Britain, where popular views were informed by scientific arguments for fundamental racial difference. In his 1853 novel *Bleak House*, Charles Dickens coined the term 'telescopic philanthropy' to argue that concern for those nearby – the waifs of London – should take precedence over humanitarianism towards distant Indigenous peoples on the other side of the globe, whom he regarded as 'savages'. Tenniel's cartoon represents this nationalist, anti-missionary stance, showing Britannia peering through a telescope at a distant Africa, where a missionary delivers a sermon to a crowd of Africans, while at her feet, three small street 'Arabs' crouch, one asking plaintively, 'Please'M, Ain't We Black Enough to Be Cared For?' (Figure 2.1).[1] Significantly, the comparison drawn between metropolitan London's black 'Arabs' and the foreign heathen is global in scale, as Tenniel adopts a distant view to express the vast gulf of geography and civilization between the British and Indigenous peoples. Historians have long acknowledged the nexus between ideas about race and class at this time, attributed to domestic social anxieties as well as colonial experience – although usually focusing upon their function for the British observers in managing domestic turmoil.[2] Susan Thorne, for example, traced the foreign missionary movement as a means of shaping British ideas about empire.[3] Yet these formulations also shaped the relations established between political rule and other techniques, objects and

TELESCOPIC PHILANTHROPY.

LITTLE LONDON ARAB. " PLEASE 'M, AIN'T WE BLACK ENOUGH TO BE CARED FOR ? "

(*With* MR. PUNCH's *Compliments to* LORD STANLEY.)

Figure 2.1 John Tenniel, 'Telescopic Philanthropy. Little London Arab. "Please 'M, Ain't We Black Enough to Be Cared For?"', *Punch*, vol. 48, 4 (March 1865): 89.

instruments in the field of colonial power.[4] Over the first half of the nineteenth century the claims to sympathy of both white waifs and black heathens were acknowledged, but their equivalence was increasingly challenged as notions of biological difference developed over following decades, gradually displacing sympathy for black people. Discussion of these changing views has tended to emphasize the dissemination of ideas of biological difference and modernist racial science, but the emotional economy created by popular narratives and visual cultures was at least as important.

Bleak House established an affective and moral opposition between the satirically drawn 'humanitarian', Mrs Jellyby, whose 'telescopic philanthropy' represents the improper expenditure of empathy for those in distant lands, and Jo the homeless

crossing-sweep, the novel's 'proper' and most powerful object of compassion. Dickens's explicit opposition between imperial evangelization and local urban reform emerges repeatedly within the novel – such as when Jo sits down to eat his 'dirty bit of bread' on the doorstep of the Society for the Propagation of the Gospel in Foreign Parts (SPG), an Anglican missionary organization founded to spread the gospel throughout the British Empire. Jo 'admires the size of the edifice, and wonders what it is all about. He has no idea, poor wretch, of the spiritual destitution of a coral reef in the Pacific, or what it costs to look up the precious souls among the cocoa-nuts and bread-fruit'.[5]

Dickens popularized the arguments of many prominent thinkers and statesmen. In his notorious 1849 'Occasional Discourse on the Negro Question', political theorist Thomas Carlyle challenged what he perceived to be a hypocritical philanthropic movement for the emancipation of West Indian slaves that overlooked more pressing problems facing the empire.[6] He contrasted 'beautiful Blacks sitting there up to the ears in pumpkins, and doleful Whites sitting here without potatoes to eat', and attacked Exeter Hall, the home of the British humanitarian movement, which he described as 'sunk in deep froth oceans of "Benevolence", "Fraternity", "Emancipation-principle", "Christian Philanthropy", and other most amiable-looking, but most baseless, and in the end baleful and all-bewildering jargon'.[7]

Within this imperial emotional economy, images of pathetic urban waifs became the affective counterpoint to degrading images of Indigenous peoples, whose inferior status was reinforced by contemporary scientific debate. Photography's verisimilitude enhanced the power of visual narratives to awaken pity, as in the work of Swedish-born Oscar Rejlander (fl.1855–75), one of the first photographers to address urban poverty. Rejlander combined his interest in pictorial effects, such as montage and retouching, with the theme of beggar children to create narrative vignettes reminiscent of literature and stage performances.[8] Of the fifteen 'urchin' portraits he made between 1859 and 1871, most were produced in London during the 1860s, and his most famous was *Homeless* (also known as *Night in Town* and *Poor Jo*), showing a boy slumped on a doorstep, head bowed to his ragged knees, sleeping or exhausted (Figure 2.2).[9] Victorian viewers immediately recognized this study as Jo, the homeless crossing-sweep, from one of *Bleak House*'s most famous passages, in which Jo is 'moved on' by the police, despite his desperate protestations that he has nowhere to go. In 1863, photography critic Alfred H. Wall praised Rejlander's portrait, which was 'powerfully painful' and 'full of the most eloquent pathos and expression'.[10] Wall expressed the prevailing contemporary belief in the morally improving effect of sympathy, arguing that the photo 'awakens pity, sets the imagination ajog, inducing one to think about the original lad, and the life he led, making one the better and more sympathetic for having seen it'.[11]

Rejlander retouched the upper part of the portrait to give the theatrical effect of a bull's-eye lantern beam – recreating the moment of discovery that became the focus of dramatized stage versions of Jo's pathetic death. His seeming revelation of the neglected boy was lent authority by the medium's factuality and veracity, invoking Jo's well-known story in order to arouse compassion for real urban waifs. Rejlander's images were highly effective among his contemporaries, as demonstrated by their use for publicity by the Shaftesbury Society and other philanthropic organizations.[12]

Figure 2.2 Oscar Rejlander, *Homeless*, c.1860. Albumen print. Courtesy George Eastman House, International Museum of Photography and Film, New York.

To an extent, Dickens's and his fellow domestic reformers' critique constituted a backlash against foreign philanthropy of the kind practised by the SPG.[13] By the 1840s senior church figures and their supporters recognized the limits of state assistance for the Church of England and initiated an independent programme of colonial church expansion, the Colonial Bishoprics Fund.[14] Yet this institutional and metropolitan enthusiasm for colonial missionary work was undercut by growing popular pessimism regarding the capacity of Australian Aboriginal people for conversion to Christianity. In 1842, Lord Stanley, Secretary of State for the Colonies, wrote to the governor of New South Wales, Sir George Gipps, to plead for

> some general plan by which we may acquit ourselves of the obligations which we owe towards this helpless race of beings. I should not, without extreme reluctance, admit that nothing could be done – that, with respect to them alone, the doctrines of Christianity must be inoperative, and the advantages of civilization incommunicable. I cannot acquiesce in the theory that they are incapable of improvement; that their extinction, before the advance of the white, is a necessity which it is impossible to control.[15]

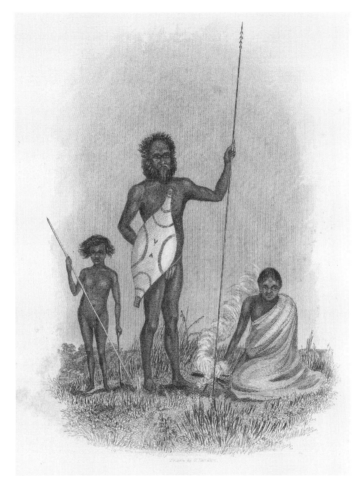

Figure 2.3 George Hamilton, 'Tenberry with Wife and Child'. Engraving. Frontispiece in Edward John Eyre, *Journals of Expeditions of Discovery into Central Australia, and Overland from Adelaide to King George's Sound*, vol. 1 (London, T. & W. Boone, 1845).

These idealistic metropolitan views were, however, contradicted by the testimony of such experts as explorer, Aboriginal Protector and colonial administrator Edward Eyre, who wrote in his 1845 memoir that

> many attempts, on a limited scale, have already been made, in all the colonies, but none have, in the least degree, tended to check the gradual but certain extinction that is menacing this ill-fated people; nor is it in my recollection that, throughout the whole length and breadth of New Holland, a single real or permanent convert to Christianity has yet been made amongst them.[16]

Eyre played a prominent role in the history of South Australia as explorer and, later, Aboriginal Protector stationed on the Murray River at a key site of colonial conflict and pacification. His memoirs opened with an engraving (Figure 2.3) based, in part, upon

a photographic portrait of 'King Tenberry', a greatly respected Elder and cross-cultural mediator during the 1830s and 1840s who symbolized the dignity and authenticity of tradition, untouched by Western culture. By romanticizing Indigenous 'Kings' as bearers of an authentic but disappearing tradition, Eyre dismissed the younger generation as lost.

Far more gentlemanly than many

These pessimistic narratives were challenged when in 1848 the new Anglican Bishop of Adelaide, Augustus Short (1802–83), arrived in the colony of South Australia with his Archdeacon, Mathew Blagdon Hale (1811–95).[17] They were supported by the Colonial Bishoprics' Fund, created in 1841 by the Church of England, backed by the Society for Promoting Christian Knowledge, the SPG and the Church Mission Society, as well as private donors. Marking its growing independence from the state, the Colonial Bishoprics constituted a new paradigm of imperial engagement and a turning-point for Anglicanism, as it expanded into a 'World Church'.[18]

Short and Hale were driven by an inclusive humanitarian orientation that encompassed both white settlers *and* Indigenous heathen, and Short in particular was later remembered as a demonstrative man, having 'all the warmth of manner, all the impetuosity of a boy'.[19] On arrival, Short reported that 'the native Australians have been very unduly underrated', and, drawing a direct comparison between white waif and black heathen, he stated of one Anglican school for Aboriginal children, 'It is our firm belief, that a consistent course of kind, equitable, and firm management would rescue many from barbarism and heathenism. But all persons have not the faith and love which have led your zealous missionary, Mr. King, to treat them as he would treat an orphan white child.'[20] Against those settlers who treated the Aboriginal people as 'little more than vermin', for example, clergy such as Hale argued, 'Being *men*, it cannot be *impossible* that that these natives should come to the knowledge of the truth and obtain eternal life.'[21]

As a young man, Hale was inspired by the antislavery movement, which ultimately led to his career as a missionary to Australian Aboriginal people.[22] A youthful attempt to become a missionary to the West Indies was thwarted by an unsympathetic clergyman at the SPG, and by his family, but he clung to his ideal, and 'from time to time, I said to myself, "It is one thing to stand on a platform and to hold forth about the duty of going to the heathen; but it is quite another thing to go oneself"'.[23] In 1847 he met Short and was persuaded to join him in journeying to Australia. Later in life, he would explain, rather apologetically, how his attention to his white settler constituents had been diverted to Aboriginal people and told of his belief in 'the great responsibility that rested upon us, as a nation, with reference to those heathen races, which, in various parts of the world, had become subject to British rule'.[24] In late 1852 he contracted with the colonial government for £1,000 per year to make their 'experiment' permanent. He claimed he was 'moved to this work by feelings of pity and compassion toward that unhappy race', professing that 'I believe from my heart that I cannot in any other way so effectually promote the glory of God' as by performing 'these works of mercy'.[25]

Short's privileged social background strongly shaped his view of the colonies, and it was later remembered that 'when one or other of his clergy complained of the rough and often menial work which falls to the lot of the colonial missionary', Short would retort, 'You ought to have been a fag at Westminster' – referring to his old school, the Royal College of St Peter in Westminster, established in London in 1179.[26] Among his attempts to recreate familiar institutions and Christian subjects in the colonies, Short was to establish St Peter's College for boys in Adelaide in 1847.[27]

With the local Protector Matthew Moorhouse's support, Short and Hale proposed the establishment of a 'training institution' at Poonindie on the southern Eyre Peninsula, where children and young adults could be further educated and Christianized, away from the 'corrupting' influence of their parents.[28] In 1850 Hale applied for land north of Port Lincoln, the traditional country of the Barngalla-Nauo [Barngarla] people and the site of numerous violent clashes throughout the 1840s.[29] Poonindie was founded on the principles of isolation and practical skills, and, under Hale's direction, the Aboriginal residents helped to construct buildings at the new site, to clear and fence the paddocks, and to plough the land and sow crops.[30] By early 1853 the clergymen were delighted with their small flock: at that time there were fifty-four residents, including eleven married couples, the rest children, including thirteen from the Port Lincoln district.[31]

But its real success came in February 1853, when eleven Indigenous residents were baptized, the first Australian Aboriginal people ever to convert to Christianity. Bishop Short described how, 'After hearing them, and asking them questions, I agreed with the Archdeacon that there was good ground for admitting them by baptism into the ark of Christ's Church, believing them to be subjects of God's grace and favour.'[32] His narrative drew much of its power from the contrast he drew between the newly transformed constituents and the 'wild' Australians, whom he asserted were alone among the peoples of the world in possessing 'not the slightest implements or arts of civilization'. He emphasized

the peculiar nature and difficulties of a mission to the Australian aborigines, which, not having been sufficiently provided against, have caused the failure of every attempt hitherto made in this and the neighbouring colonies to reclaim, civilize, and convert these interesting though degraded relics of our common humanity.[33]

As scholars such as Susan Thorne and Anna Johnston have argued, one of the primary tools of evangelical missionary effort was mastery of imperial print cultures.[34] Throughout the colonial period, missionary and Bible societies generated a 'vast publication machine' that involved hundreds of societies, auxiliaries and committees churning out annual reports, sermons, journals and tracts.[35] Even before halftone photographic publishing was invented in 1880, engraved images based on photographs became an integral aspect of this genre. Short and Hale were diligent in reporting progress to their financial supporters, in the form of popular accounts written for a wide audience – especially for the senior missionary societies of the Church of England, the SPG, and the Society for the Propagation of Christian Knowledge (SPCK), which had sponsored Poonindie. Such accounts took on particular significance in an imperial climate of scepticism towards

'humanitarians', symbolized by Dickens's satirically drawn character Mrs Jellyby, and confirmed by field reports such as Eyre's.[36]

In attempting to counter ideas of essential otherness, the 'conversion narrative', contrasting a former state of savagery with a subsequent elevated Christian state, was widely deployed. Short wrote to the Secretary of the SPG to describe this momentous event, in an account also published in the Adelaide *Register*, and subsequently in an illustrated SPG pamphlet and memoir.[37] Hale too later published a memoir focused on this event. For Short, Poonindie's gratifying results were demonstrated 'under the heads of Civilization, Moral Training, and Christian Attainment'.[38] In a highly revealing passage that conflates the converts' appearance, measured in terms of their clothing and personal grooming, with their spiritual transformation, he wrote of the ten baptized young men:

> I was agreeably surprised to see them nicely dressed in the usual clothing worn by settlers; cheque shirts, light summer coats, plaid trowsers, with shoes and felt hats – articles mostly purchased with their own earnings. They were better dressed than the labouring class in general at home. They had brought their blankets, blacking, brushes, &c, making the broad verandah of a wool shed their sleeping-place, and cooking their meals at a fire in the yard. Not far off was a small native camp, and the contrast between these two groups would have convinced any candid observer of the truth for which the Archdeacon has always steadily contended, viz. that the Aborigines are not only entitled to our Christian regard, but are capable, under God's blessing, of being brought out of darkness into light, and from the power of Satan unto God.[39]

Their visible transformation as signalled by clothes and other personal possessions revealed the progress made on the road to civilization, and Short concluded that there was 'now a small body of trained Christian natives, the nucleus of the native Church'.[40] This first group of converts was frequently compared with the flower of English aristocracy – especially on the sporting field. In February 1854, star pupils Sam (Conwillan), 'Sam junior' and Charlie were in Adelaide, and were invited to play cricket with the pupils of St Peter's College. The Adelaide *Register* reported, 'The Port Lincoln natives from Archdeacon Hale's establishment are very fine fellows. They speak pure English, without the slightest dash of vulgarism and are in truth far more gentlemanly than many.'[41] Short lauded the gallant behaviour and principles of Christian fellowship expressed through the noble game of cricket.[42] In these narratives, Short attempted to create a contrast between the 'before' and 'after' states of these potential Aboriginal Christians to manifest their progress, but his central strategy was predicated on their full humanity, in accordance with the biblical catch cry that God 'hath made of one blood all the nations of men for to dwell on all the face of the earth'.[43] Such strategies were common within missionary 'propaganda' as a substantial body of scholarship has shown.

But the Anglicans' vision of Indigenous transformation was unique in defining the Indigenous subjects as gentlemen.[44] Short argued that 'the like feelings [of] … Etonians and Harrovians at the cricket matches at Lord's prov[ed] incontestably that the Anglican aristocracy of England and the "noble savage" who ran wild in the Australian woods [were] linked together in *one brotherhood of blood*'.[45] Such acknowledgement was particularly

rare in Australia, where, by contrast with other races, Aboriginal people were often ranked as inferior.

In one sense, this perspective was rooted in the Anglican's own upper-class background, shaping his account in important ways. By stressing their changed appearance, and material and bodily habits, Short sought to show how *similar* these people were to those watching, and reading, at home. As moral philosopher Adam Smith had noted in his masterly analysis of the age's moral economy, one's own experience and world view provides the only means of entering into another's situation: 'We suppose ourselves the spectators of our own behavior, and endeavor to imagine what effect it would, in this light, produce upon us. This is the only looking-glass by which we can, in some measure, with the eyes of other people, scrutinize the propriety of our own conduct.'[46] For Short, the Poonindie men's appearance – mimicking his own – clearly proved their inner worth.

But Short was also echoing a discourse of noble savagery, as old as classical Greece, which praised the natural morality, simplicity or social harmony of Indigenous peoples. Although it often alternated with negative accounts of 'primitivism', the trope of the noble savage provided by accounts by Western explorers tended to relativize European culture, offering comparisons that could challenge Old World certainties.[47] Short's view was specific to his class, recalling the romantic views of early-nineteenth-century aristocratic travellers such as Alexis de Tocqueville, who lamented the deficiencies of contemporary civilization and mourned its disappearing refinements. It was more usual for nobility to be discerned within the highly stratified societies of the Pacific, such as Fiji, where the governor's wife, Lady Gordon, commented upon her 'curious feeling of equality with the ladies of rank … such an undoubted aristocracy'.[48] From early contact, the title of 'King' was conferred upon many senior Aboriginal people across Australia, such as Eyre's companion and advisor Tenberry, or the Wurundjeri leader, 'King' William Barak, who had witnessed the first encounter between his people and white settlers at what became Melbourne. While such labels bore no relationship to traditional social organization, white observers frequently described these men with respect, noting their dignified comportment, upright carriage, or power to command. Of Tenberry, it was remarked, 'The old fellow is a fine specimen of the former lords of South Australia, and is said to be the only real chief among the natives.'[49] Such observations were predicated upon the disappearance of people assumed to be passing away, and were usually contrasted with the 'degraded' state of the younger generation. But assertions of affinity with Indigenous people were also a challenge to those who argued against Aboriginal humanity. The application of the trope of nobility to the 'transformed' young Christians of Poonindie was unique. Here, the opposition between savage yet authentic and civilized yet inauthentic Aboriginal was dissolved.

Visual proof

The Anglican clergymen's faith in the power of visual proof to communicate the humanity and capacity of Poonindie's Aboriginal people emerges from their intensive programme of portrait-making. Short himself was an enthusiastic collector of portraits and visual records of colonial landscapes and works, commissioning at least three portraits of himself during

his episcopacy. As a group, the Anglicans frequently commissioned colonial artists and photographers to produce portraits of themselves and their Indigenous constituents, and the extensive programme of building works they oversaw. In early 1854 when three star pupils, including Samuel Conwillan, were sent to Adelaide to play cricket at St Peter's College, Conwillan's portrait was painted by John Crossland, an accomplished portrait painter who had made his name with a series of portraits of famous explorer Charles Sturt in 1853 (Figure 2.4).[50] Another portrait, of a Poonindie cricketer shown holding his bat aloft, was painted later that year.[51]

Conwillan was often mentioned as a committed Christian and leader of his community, and Short was not the only one to tell the following story of Conwillan's moral virtue:

> The natives were moral in their conduct, and able to resist temptation when sent with drayloads into Port Lincoln. It is remembered how 'Conwillan' on one occasion having loaded his own dray with goods from a coasting vessel according to orders, was found by the Archdeacon rendering the like service to a settler, whose teamster was lying intoxicated on the beach.[52]

The Anglicans actively commissioned several series of photographs of the Anglican Church's Indigenous congregation as part of a sustained programme of documenting

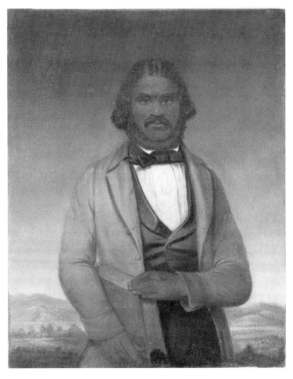

Figure 2.4 John Crossland, 'Portrait of Samuel Kandwillan, a pupil of the natives' training institution, Poonindie, South Australia, 1854'. Courtesy National Library of Australia, Canberra. Rex Nan Kivell Collection NK6294.

the church's work during the 1850s and 1860s.[53] Some of these remained private mementoes, for example, within Hale's own papers, while others were circulated in order to demonstrate missionary success. Hale retired in March 1885 and returned to England where he continued to promote the church's mission to the Australian Aboriginals through writing and lecturing until his death in Bristol in 1895.[54]

I believe the man portrayed in Figure 2.5 to be Conwillan, also painted by Crossland, and one of the most highly regarded Aborigines at Poonindie until his death in May 1860.[55] Another of Hale's Bristol mementoes shows a man holding a flute: the subject was probably either Conwillan or Tolbonco. The Rev. Hawkes noted of the two in 1858,

> My old friends Konwillan and Tolbonco (of St. John's Sunday school) knew me at once, and appeared glad to see me. They always lead the hymns with their flutes: both of these young men read and conduct the services of our church by turns on Sunday morning, when Mr. Hammond is absent celebrating divine service at St Thomas's, Port Lincoln.[56]

These 1850s portraits witness the mission's success and a more generalized capacity for Indigenous civilization and Christianization (Figures 2.6 and 2.7).[57] In their pose, dress and studio setting, the Poonindie photographs conform closely to contemporary mainstream conventions of studio portraiture. They echo contemporary Australian photographic

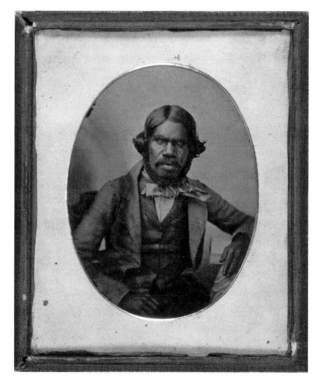

Figure 2.5 Aboriginal man of Poonindie. Ambrotype. By permission University of Bristol Library, Special Collections, Papers of Mathew Blagden Hale. DM130/239.

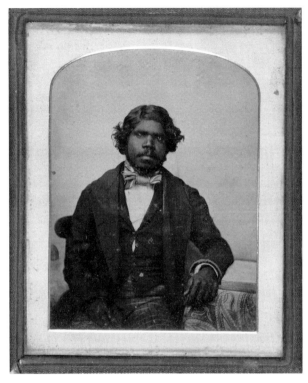

Figure 2.6 Aboriginal man of Poonindie. Ambrotype. By permission University of Bristol Library, Special Collections, Papers of Mathew Blagden Hale. DM130/238.

portraits of well-to-do settlers, dressed and posed in virtually identical ways to the Poonindie portraits.[58] Fashion curator Margot Riley identifies Conwillan's garb as a hand-made silk suit. The nearby book, probably a bible, signifies education and religious faith. They are remarkable individual studies that celebrate the achievements and standing of the Aboriginal subjects, yet from a peculiarly upper-class perspective that was unique in the Australian colonies.[59]

Engravings based on these portraits circulated within missionary accounts such as Hale's book, *The Aborigines of Australia*, published by the Society for Promoting Christian Knowledge in 1889. An engraving of Crossland's portrait of Conwillan appears beside a head-and-shoulders portrait of a young woman, captioned 'natives educated at Poonindie, 1858' (Figure 2.8).

Visual evidence became increasingly important during the 1850s, as the Church of England lost authority and a climate of scepticism developed about their claims for their Aboriginal pupils. The withdrawal of state aid to religion in 1851 compelled the Anglican Church in South Australia to devise a voluntary system of maintaining itself. Short himself was a proponent of independence, and oversaw the transfer of episcopal authority to the colonies, but failed to secure a leading policy role for religion. By 1860 the church had been marginalized as a moral force within colonial politics.[60] At the same time, there are indications that the public could be sceptical regarding what many now call 'missionary propaganda'. In 1859, for example, after Hale's departure, a South Australian

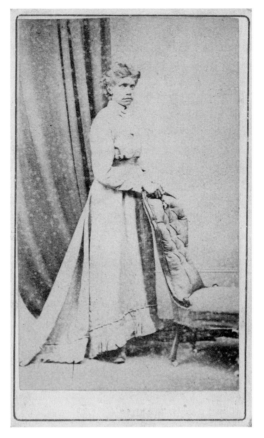

Figure 2.7 Young woman. By permission University of Bristol Library, Special Collections, Papers of Mathew Blagden Hale. DM130/233.

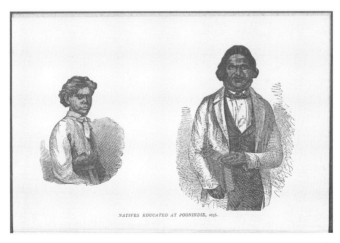

Figure 2.8 'Natives educated at Poonindie, 1858', Frontispiece in Mathew Hale, *The Aborigines of Australia: Being an Account of the Institution for Their Education at Poonindie, in South Australia: Founded in 1850 by the Ven. Archdeacon Hale, a Missionary of SPG* (London: Society for Promoting Christian Knowledge, 1889).

official wrote of Poonindie: 'The Superintendent agreed with me in thinking that much of the strong disbelief existing in the Public mind as to the possibility of Christianizing the Aborigines *at all* was excited by the reactionary feeling resulting from a perusal of those very enthusiastic reports put forth by the founder of the Mission.'[61]

No doubt the terrible mortality rate at Poonindie between 1850 and 1860 due largely to tuberculosis and rendered by the missionaries as 'happy deaths', undermined the public's perception of their success. In 1853 Hale reported on the 'sickness and mortality' that had plagued the mission, but had 'the happiness of being able to state' that 'the last hours of the sufferers were so cheered by the peace and hope which they derived from their belief' that his sorrow was 'turned into joy, and our mourning into gladness'.[62] Such accounts of mingled grief and joy were typical – for example, Methodist John Brown Gribble wrote in 1883 of the death of a young Wiradjuri girl who died at his mission, Warangesda, in New South Wales: 'It was my sad duty to prepare the coffin, and to place the little wasted black form therein; but amid my tears, joy filled my heart to overflowing at the thought of this precious gem, the glorified spirit of our dear little Waradgery girl, shining in beauty in the Saviour's crown.'[63]

Yet more important than local approval was the support of far-distant benefactor Angela Burdett-Coutts. Bridging the vast space of geography and culture that lay between the donor and South Australia, Short diligently provided her with photographic mementoes – of both missionaries and Indigenous people – as proof of the good work her philanthropy sponsored at Poonindie and elsewhere. For example, when Burdett-Coutts endowed the bishopric of Adelaide, Short sent her an engraved portrait with the inscription, 'To Miss Burdett Coutts, through whose munificence the See of Adelaide was founded', in a personalized visual 'thank you' that was to be a memento of his distant labours.[64] On his return to England in 1866 Short used visual evidence to prove to Burdett-Coutts the material progress she had made possible. As his biographer recounts, 'The baroness must have felt a deep satisfaction in hearing his own graphic account of the prosperity which had attended the see of which, under God, she had been the foundress. She looked with great interest at the photos the bishop showed her of the various edifices reared by the Church in Adelaide, remarking, "I had no idea how forward everything is."'[65] Burdett-Coutts continued to fund Short's programme of missionization in South Australia into the late 1860s.[66]

James Wanganeen

Another series of portraits, of James Wanganeen, was treasured by the Poonindie missionaries Hale, Short and Hammond, and other collectors, expressing his status in colonial society and especially the mission community as a success story.[67] Wanganeen was a Barkindji ('Maraura') man from the Upper Murray who had attended the Native School in Adelaide in the late 1840s and was then transferred to Poonindie in 1850. He was baptized in 1861, after Hale's departure, and during the 1860s rose to prominence as an evangelist among his own people.[68] The Rev. F. Slaney Poole recalled of Poonindie

in 1867: 'One of the members of the choir, named Wanganeen, was a handsome and intelligent aborigine, and he used to read the service on occasions when the superintendent or myself was not present.'[69] They include several daguerreotype portraits similar to those already discussed, and a *carte de visite* showing Wanganeen with his third wife, Mary Jane, produced after 1867 and before his death in 1871 (Figures 2.9 and 2.10).[70]

Wanganeen's colonial status can also be gauged through his appearance within a novel, Mary Meredith's 1871 *Koorona,* set in 1860s Adelaide.[71] Conventional literary narratives depicted an empty colonial landscape or depicted Aboriginal people as brute-like: in one rare mention, as historian Margaret Allen notes, a character exclaims, 'and then to think that these beings are really of one blood with us! Does it not seem strange? They have souls; and yet how near they seem to approach the lowest order of animals.'[72] However, the treatment of Aboriginal people was central to *Koorona*, and 'Wanganneen' is described as a 'man, born and reared on the wilds of Australia' who 'was one of nature's gentlemen … the untaught Australian had God's own patent of nobility'.[73] Meredith was also a devoted proponent of the Church of England and shared the Anglican clergymen's sympathy for Aboriginal people. With Short's encouragement, she was active in establishing the Point Pearce mission on the Yorke Peninsula for the local Narungga people.[74]

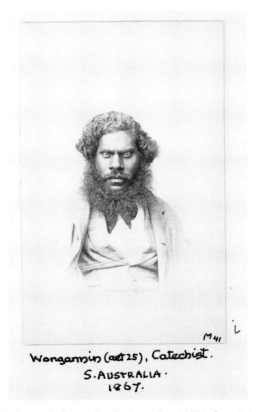

Figure 2.9 'Wongannin (aet 25), Catechist. S. Australia. 1867', Copyright Pitt Rivers Museum, University of Oxford. PRM1998.249.33.9.

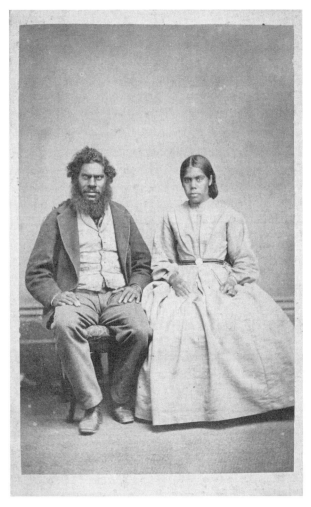

Figure 2.10 Townsend Duryea, Portrait of James and Mary Jane Wanganeen, c.1867–1870/1. *Carte de visite*. By permission University of Bristol Library, Special Collections, Papers of Mathew Blagden Hale. DM130/231.

Mrs Smith's little tribe

During the 1860s Short deployed photographic portraits to secure funds from Burdett-Coutts for a home and school for Aboriginals at Mt Gambier in South Australia.[75] Lay-missionary Christina Smith managed the school between 1865 and 1867 with Short's support, and in 1865 Short commissioned several studio portraits of Smith's protégés from professional photographer Walter William Thwaites (who had also produced portraits of the Bishop himself). Three now held in the Pitt Rivers Museum in Oxford show 'Caroline, a half-caste. Mt Gambier S. Australia 1867' and two girls in their teens (Figures 2.11 and 2.12). These young women feature in Smith's thirty-one-page pamphlet, *Caroline and Her Family: With, The Conversion of Black Bobby*, published in Mt Gambier in 1865, telling

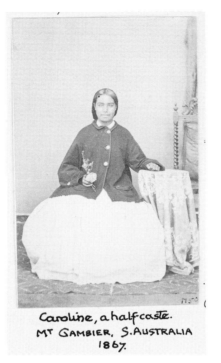

Figure 2.11 'Caroline, a half-caste. Mt Gambier S. Australia 1867'. Copyright Pitt Rivers Museum, University of Oxford. 1998.249.33.10.

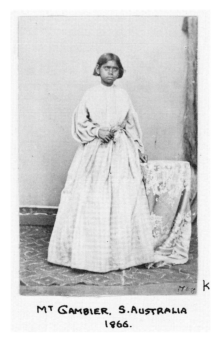

Figure 2.12 Portrait of two girls. 'Mt Gambier, S. Australia, 1866'. Copyright Pitt Rivers Museum, University of Oxford. 1998.249.33.11.

the sad story of how the dying Caroline, or Mingboaram, asked Smith to care for her two daughters.[76] The local newspaper suggested that these 'capitally executed photographs of the aborigines of Mount Gambier, embracing more particularly Mrs Smith's little tribe, Annie Coutts [Anne Burdett-Coutts] and Johnny Short make capital pictures. The photographs would form excellent souvenirs to send home to friends, and we have no doubt Mr Thwaites will have a large demand for them.' Another child was named Helen Bishop. Anglican lines of patronage and obligation are indicated by naming these young people after Short and his benefactor the Baroness Burdett-Coutts.[77]

Smith's ethnography, *The Booandik Tribe of South Australian Aborigines: A Sketch of Their Habits, Customs, Legends and Language* (1880), told the story of her encounter with the Bunganditj people.[78] Centred upon 'a few short memoirs', it belongs to the genre of conversion narratives popularized by evangelists such as John Wesley, which feature a deep spiritual transformation. Often, these stories concluded in the person's 'happy death'. Twenty years afterwards, the pathos of Caroline's tragic passing softened into nostalgia as again and again, Smith's Aboriginal pupils are converted to Christianity but then die – with their deaths narrated as being inevitable but glorified by their new faith.[79] Like the discussion of the 'happy deaths' at Poonindie, or at Gribble's mission Warangesda, Smith's encounters with the Bunganditj were structured by this narrative of loss and redemption.

Conclusion

It is revealing to compare the 'happy deaths' of the Christian Aboriginal children with the death of the homeless London waif, Jo the crossing-sweep. For Victorians, belief in God ensured ascension to the afterlife, and sustained a widely shared view that only Christian faith rendered a life worthwhile and meaningful. Dickens showed Jo's pathetic – if fictional – death as a heathen to be a tragic waste and the outcome of life-long neglect. Dickens sheeted home the blame for Jo's death to the Church of England: in his last moments, Jo remembers the 'genlmen' who had prayed in his slum who had 'all mostly sounded to be a-talkin to theirselves, or a-passin blame on t'others, and not a-talkin to us'. His last words are a broken attempt to repeat the Lord's prayer after his friend, Allan Woodcourt, but the scene concludes with the narrator speaking directly to the reader, including Anglican Bishops: 'Dead, my lords and gentlemen. Dead, Right Reverends and Wrong Reverends of every order. Dead, men and women, born with Heavenly compassion in your hearts. And dying thus around us every day.'[80] Victorian audiences found this scene exquisitely affecting.[81]

By contrast, the real and frighteningly high mortality rates of Australian Aboriginal children were narrated in church texts as 'happy' deaths, completing lives reclaimed from savagery.[82] Missionary narratives claimed black deaths as evidence for their *achievements* in the field, as they 'rejoiced' in the 'translation to a better world'.[83] Black Christians were equal in God's eyes, and their ascension to heaven and everlasting life was assured.

If we return to Rejlander's *Homeless* and compare it with the portraits of the young Poonindie Christians or 'Caroline', the doomed mother, it is clear that both seek the

viewer's sympathy, but deploy countervailing visual strategies: the first emphasizes difference, picturing the child as other and savage in order to shock the viewer; it shows the violation of the child's rights in order to mobilize assistance. The Aboriginal portraits assert the young men and woman's sameness to demonstrate their essential humanity and equality. This humanist vision challenged prevailing attitudes towards Aboriginal Australians that emphasized their animality and intractability, justifying violent ill-treatment and dispossession. Visual imagery disseminated such ideas in representing Indigenous tradition and difference, framing Indigenous people as abject, incapable of change, or as relics doomed to extinction. Within an imperial context, such depictions underwrote British arguments for focusing sympathy upon the poor white child. Locally, these derogatory views reinforced the logic of dispossession. Against this pessimistic vision, Anglican missionaries in South Australia asserted the humanity – and more, the nobility – of Aboriginal Christians. While their view was limited in practical and conceptual ways, their vision of the essential unity of humankind shaped a distinctive aspect of the colony's visual culture. In commemorating the achievements of Christianized Indigenous farmers, these portraits from Poonindie mark a radical departure from contemporary accounts of Indigenous Australian people. They offer a view into a rare moment of humanitarian optimism and idealism, showing the Aboriginal subjects as dignified, cultivated and well-educated – in short, as equals.

3
VERITABLE APOLLOS: BEAUTY, RACE AND SCIENTISTS

In May 1867 a young Italian scientist set out in search of 'authentic' Indigenous Australians. Aged twenty-two, Enrico Giglioli (1845–1909) was travelling around the world on the diplomatic and naturalists' expedition of the Italian warship, *Magenta*. When his teacher, Filippo de Filippi, died in Hong Kong, Giglioli was forced to take over as ship's naturalist, arriving in Melbourne, Victoria, a little more than thirty years after its invasion by the British. Giglioli was already an enthusiastic follower of Charles Darwin's theory of natural selection and, like his English mentor Thomas Henry Huxley, was eager to apply this schema to humankind. Giglioli was keen to see Indigenous Australians for himself, whereupon local ethnologist Robert Brough Smyth warned him that 'the aborigines, of whom I had seen only a couple of miserable individuals in the streets of Melbourne, had almost disappeared from the neighbourhood of the city and the other centres of settlement'. Brough Smyth advised him to visit Coranderrk Aboriginal station, near Melbourne, as well as the regional towns of Sandhurst [Bendigo], or Echuca on the River Murray (the border between Victoria and New South Wales), where Aboriginal people might be seen 'still in an almost independent state'.[1]

Giglioli first went to Moama, near Echuca, where he 'had the pleasure … of running into a family of aborigines who had kept their native appearance'. He described the scene and their camp, including their spears, skin cloaks and gunyahs, concluding that 'the scene was highly typical and amply rewarded me for my long journey'.[2] Excited and impressed by his first *bona fide* encounter with Indigenous people, Giglioli obtained a series of *cartes de visite* by Melbourne-based travelling photographer Thomas Jetson Washbourne which he mounted on boards within his collection (Figure 3.1).

Today these photographs have assumed new meanings in the context of descendants' pursuit of native title: this woman (right) belonged to the 'Barwidgee Tribe', now known as the Dhudhuroa. Indigenous Elder Gary Murray explains how these portraits have been drawn into the process of mapping connections to land and kin in the pursuit of native title. The cultural performances of this photograph over 150 years, in its transformation from scientific datum to activist tool, both complicate and destabilize totalizing notions of the colonial archive.[3]

In this chapter I examine Giglioli's encounters with Aboriginal people, beginning with his direct, embodied meetings in 1867, and then tracing his indirect engagement over following decades via his vast collection of photographic portraits from across the continent and

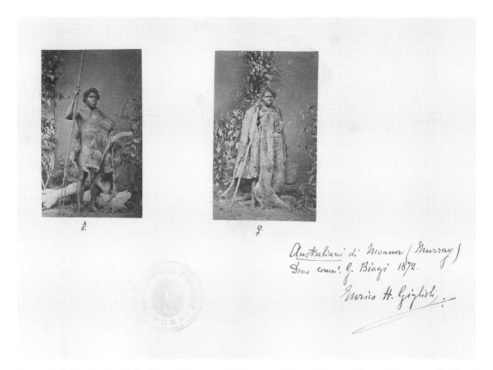

Figure 3.1 'Australiani della tribu di Moama & Echuca sul fiume Murray. Dono del comm. G. Biagi 1872 ed acq. a Melbourne Maggio 1867. Enrico H Giglioli' ['Australians of the Moama and Echuca tribes, on the river Murray. Donated by Consul G. Biagi 1872, acquired in Melbourne May 1867']. Courtesy Museo Nazionale Preistorico Etnografico 'Luigi Pigorini' [National Museum of Prehistory and Ethnography 'Luigi Pigorini'], Rome.

their uses as anthropological 'data'. Until recently scholars have emphasized the power relations that shaped scientific photographs of colonized peoples, yet ethnographies of the archive have now begun to focus interest on practices of collection, collation and classification, and the diverse effects they exert. As Elizabeth Edwards and Christopher Morton have argued, as well as exploring the photograph's multivalency in different cultural contexts, we should also attend to the ways that the archive constitutes and is constituted by 'a history materially performed by things', including the institutional structures around objects and their dynamic social lives.[4] Giglioli's archival practices in managing his vast collection of photographs worked to establish meanings over time, and against a single or dominant reading, as the photograph's 'infinite recodability' is activated by shifting relations of the material object.[5]

Encounters between Europeans and Indigenous people have great analytical significance, for 'even in the midst of massacre and revenge', in such meetings 'pre-existing understandings, preconceptions from both sides of the encounter, were engaged, brought into confrontation and dialogue, mutual influence and ultimately mutual transformation'.[6] In his landmark 1960 study, *European Vision in the South Pacific*, art historian Bernard Smith argued that European perceptions were altered as a result of eighteenth-century voyagers' encounters with Oceanic peoples.[7] In the same

way, the choices made by photographers in recording Indigenous peoples depended on culturally specific relationships: Christopher Morton, for example, has argued that differences within the photographic work of anthropologist Edward Evans (E. E.) Evans-Pritchard in Central Africa may be attributed to the interests and reactions of his subjects, rather than to disciplinary frameworks.[8] Similarly, Anita Herle's study of John Layard's 1914–15 photographs from Vanuatu suggests a participatory form of fieldwork and the complex intersubjective relations involved in their production.[9] Giglioli's encounters with Indigenous Australians in the nascent settler colony were a dialogical process of mutual transformation, as he sought to reconcile his preconceptions with sometimes challenging or confounding experience.[10] As Judith Butler has argued, sentiment is bound up with but does not preclude thought; visual interpretation may take place in spite of oneself. Giglioli's recognition of humanity ruptured prevailing notions of racial inferiority: despite the rapidly increasing force of contemporary scientific notions of difference over these years, such moments mark the ambivalence of the boundary drawn between human and non-human. In his personal encounter Giglioli noted what was shared and universal despite his professional drive towards emphasizing difference.

In May 1867 Giglioli travelled fifty kilometres northeast from Melbourne to Coranderrk Aboriginal Station, one of the region's six Aboriginal reserves. Coranderrk then numbered around 100 residents, of whom he noted: 'They occupied one good house (for young adolescents) and fairly well-maintained shacks, the inside walls of which were in most cases papered with cuttings from English and Australian illustrated journals, and photographs, greatly prized by these people.'[11] He was not the first photographer to visit Coranderrk, and the residents were well aware of the medium's power. As well as amassing 'a vast collection of photographs of Indigenous people from various parts of Australia', Giglioli also secured his own photographs of Coranderrk.[12] He collected a number of portraits of the residents, and botanist Ferdinand von Müeller later sent him a series of 104 Coranderrk portraits by photographer and botanical collector Charles Walter.[13] He treasured remarkably intimate photographic portraits of Bunurong man Tommy Hobson (c.1833–68) and his family, and wrote of his encounter with warmth:

> One of these aborigines with whom I spoke, Tommy Hobson by name, had in the past been a great drunkard, but since he settled at Coranderrk, he had not only succeeded in dressing decently himself, his wife and three sons, but had been able to acquire with his own money a horse and harness. I found him in his shack with his wife Maggie and his younger son Thomas Harris. I was moved by the happy and prosperous appearance of this little family. Tommy is no more; and two years after my visit ten other aborigines whom I had found there had died, apart from poor Hobson. Among the Australian aborigines I saw he was one of the most typical, and his wife could be called the local beauty.[14]

Giglioli's portrait of Hobson is informal and relaxed, as though taken in the course of Hobson's normal daily round – unlike the more formal sitting in his Sunday best, made one year earlier by Charles Walter.[15] He holds a riding crop and wears a medal (unidentified) around his neck (Figure 3.2). Another photo shows a man and a woman posed with

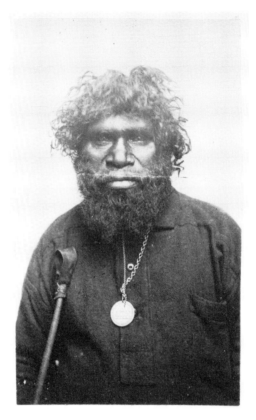

Figure 3.2 Unknown photographer, Portrait of Tommy Hobson. Courtesy of Michael Treloar Antiquarian Booksellers, Adelaide, and Josef Lebovic Gallery, Sydney.

Hobson, his hand placed affectionately on the woman's shoulder, establishing this image as a family group. Hobson was a widely travelled and worldly man whose life story reflects the turbulence of the colony's early decades. His English name was taken from squatter Edward William Hobson, who took up a run on Bunurong country, on the southeastern shores of Port Phillip Bay in 1837. Tommy would have been around four years old then, and grew up on traditional country, working for the pastoralist. He may have been among the crew of the *Sea Gull,* which sailed the waters of California during the 1849–50 gold-rushes.[16] By the 1860s Hobson and his family were living at Coranderrk, and in 1866 it was reported by a manager that 'Tommy Hobson has bought a good mare, and a saddle and bridle. A few years ago I could not prevent him from spending all his money in drink; but now he has always money on hand, and he keeps himself, his wife, and three children, always well clothed.'[17]

As Giglioli noted, Tommy and his wife both died from tuberculosis within a few years of his visit. Despite the warmth and interest the young Giglioli showed in this encounter, testifying to being 'moved by the happy and prosperous appearance of this little family', his subsequent writing about Aboriginal people reveals an ambivalence regarding their status. Giglioli's published work, including his experimental use of photography, shows

how he inserted his personal encounters and impressions into a framework determined by inherited preconceptions and the fashionable scientific theories of his day.

Giglioli and photography

On his return to Florence, Giglioli wrote up the zoology of the voyage of the *Magenta*, and in 1869 began to lecture in this field. Giglioli was to enjoy a long and distinguished academic career, becoming director of the Royal Zoological Museum in Florence in 1876. Like his mentor, fellow Darwinist Thomas Henry Huxley, Giglioli's central research interest was marine vertebrates and invertebrates, but he was also a noted amateur ornithologist and photographer, and continued his research in the developing discipline of anthropology, amassing the world's largest collection of stone tools as evidence for global 'stone age' culture. In 1892 Frederick Starr of the University of Chicago surveyed the international anthropological scene and singled out the 'founder' of Italian anthropology, Paolo Mantegazza, and Giglioli as the two foremost Italian anthropologists of the day.[18] Giglioli was immersed in British as well as Italian scientific networks, having been born in London to an English mother and a father in exile from Italy. Between 1861 and 1863, from the age of sixteen, he attended the Royal School of Mines in London, studying natural science with Charles Lyell, Richard Owen and Huxley.

Throughout his career Giglioli worked within an evolutionist framework, which he had imbibed in the heady years following publication of Charles Darwin's *The Origin of Species by Means of Natural Selection* in 1859.[19] Darwin's theory built upon arguments about evolution that had been developing throughout the nineteenth century, his key contribution being the idea of 'natural selection' to provide an overarching explanation for the mechanism of transformation. Throughout the 1860s, *The Origin of Species* was hotly debated, quickly becoming scientific orthodoxy, and over the final decades of the nineteenth century, Darwin's ideas were applied to humankind in what was often termed 'social evolutionism'.

For many, Darwinism provided an explanation and justification for colonization and its effects. Arguments that Australian Aboriginal people represented a primitive form of humankind dated from the beginning of British colonization, and Aboriginal 'data' in the form of bodies, images and ethnographic information was consequently collected from the earliest years of colonization.[20] The scientific paradigm of natural evolution only strengthened notions of biological difference between so-called 'races of men' and the perception that Aboriginal Australians were a survival from the stone age that were doomed to extinction following contact with whites.[21]

Two books remain the major sources for Giglioli's Australian experiences and research: his 1874 *The Tasmanians: The History and Ethnology of an Extinct People*, and his work published the following year, *Voyage around the Globe on the Magenta 1865–68*, with an ethnological introduction by Mantegazza.[22] These heavily illustrated works contributed to Darwinian debates about race and humankind and participated in the extensive contemporary scientific interest in Australian Aboriginal people.

As Giglioli was a zoologist, his research relied upon the comparative method, an investigative philosophy that was well-established by the early nineteenth century and which was an important plank underpinning Darwin's theory of evolution. What was distinctive about Giglioli's account of mainland Aboriginal people in *Voyage around the Globe* was his innovative use of photographic imagery to argue against more senior colleagues, such as French anthropologist Paul Topinard and his theory of several distinct sub-groups of Aboriginal people. Giglioli's early application of the comparative method to the new medium argued for homogeneity within the Australian mainland population, as well as its distinctiveness, seeking to identify the race's essence. As he explained, he began to collect portraits of the Indigenous peoples of each country visited by the *Magenta*, which he systematically added to over the following decades, drawing upon his extensive scientific networks, so that by 1911 it numbered more than 10,000 images and represented 'all living peoples'.[23]

Although an early adopter, Giglioli was not alone in attempting to deploy photography in the service of scientific debates about humankind, nor in applying the comparative method to humanity. From the medium's earliest years, anthropologists had seen the potential of this new, seemingly objective means of comparing human beings. Visual appearance was believed to reflect racial essence, and scientists sought to define and isolate distinct attributes of human species by recording uniform and comparable aspects of the body. In 1845, for example, in response to philosopher Johann Gottfried Herder's call to establish a gallery of human races, Etienne-Renaud-Augustin Serres, president of the French Academy of Arts and Sciences, appealed for a Photographic Museum of Human Races, hoping to compare human types.[24] By the early 1860s calls for the systematic collection of photographic data were underlined by the seemingly imminent disappearance of peoples in Brazil, North America and Tasmania. Various experimental photographic projects were mounted during this decade that sought to draw upon Australian data, such as Huxley's 1869 initiative to record 'the various races of men comprehended within the British Empire', which met with little success.[25]

In Britain, two methods for the collection of anthropometric photographs devised by Huxley and John Lamprey emerged in the decade following publication of *Origin of Species*. Neither, however, became established as a standardized method.[26] Huxley was Giglioli's former teacher and famous as a comparative anatomist well before he wrote the first book devoted to the topic of human evolution, *Evidence as to Man's Place in Nature* (1863), in which he reviewed the evidence for the evolution of man and apes from a common ancestor.[27] In 1869, as President of the Ethnological Society of London, Huxley called for a photographic record of the races of the British Empire. Facilitated by the Colonial Office, this project set forth a detailed system showing subjects naked, frontal and sideways within precisely measured parameters in relation to both the camera and a measuring rod. As Elizabeth Edwards shows, many of the 'successful' sets of portraits that were produced and sent back to the Colonial Office were made within prisons, and the subjects' distress is palpable. However, although Huxley's scheme was framed by an oppressive apparatus of race, its execution was marked by points of 'ambiguity, fracture and resistance' as few of his respondents followed his instructions, and many ignored or rejected his request.[28] At the project's point of origin, Colonial Office administrators

referred to the project as 'something filthy' and the resulting images as a 'hideous series', and 'horrors', to be filed away.[29]

Why do these photographs still seem 'dehumanizing' to most observers and especially today's Aboriginal people? The worst experience I have had as an academic was during a public lecture in 2012, when I showed a South Australian photograph from Huxley's project. A Victorian Aboriginal woman expressed her outrage and shock at seeing an image of this kind displayed, shaming me and reminding me of the powerful identification photography affords across time and place – but also pointing to the ways this series' visual conventions challenge our ideas about human dignity. One repellent element in these images is the overt context of measurement: tools such as the measuring rod, and sometimes calipers, undermine the individuality of the person photographed and turn her/him into a biological specimen, laid bare to scientific appraisal. Even more confronting is their nakedness, which, as Philippa Levine has argued, has long been associated with primitive savagery in the British mind, stemming from the foundational biblical narrative of the fall from grace.[30] For Victorian-era viewers, a lack of clothes signified savagery and immorality and marked the limits of civilization.

Many colonial officials rejected Huxley's request – as was the case in Victoria, where protector Brough Smyth explained that the Christian Aboriginal people of Coranderrk would not take off their clothes for such a purpose, being 'careful in the matter of their clothing' and likely to take offence.[31] Already experienced photographic sitters, as Giglioli had noted, and well aware of the significance of clothing, the self-respecting and politicized residents of Coranderrk would not willingly perform their retrogression from humanity to primitivism for the camera. They refused other requests for such data, such as French scientist Désiré Charnay's attempt to apply Huxley's scheme in 1878, with the result that he grumpily 'sent them to the devil'.[32] There are no naked photographs of Coranderrk people, demonstrating the way that an Indigenous agenda significantly governed the form of the resulting photographic record.

It is not merely the array of 'types' or representatives that 'dehumanizes': 'galleries' of humankind have sometimes served to challenge racial categories and to underline what is shared by humankind. Edward Tylor, for example, despite his commitment to a stadial framework of progress, found such a 'gallery' confounding and thought-provoking. Tylor was curator of Pitt Rivers Museum and a central figure in the establishment of anthropology at Oxford University in the early 1880s. In reviewing the magnificent German photographic album, Carl Dammann's 1873–6 *Ethnological Photographic Gallery of the Various Races of Man,* which assembled photographs of Indigenous people from around the world, Tylor suggested that its accuracy and detail would check 'rash generalisation as to race' through revealing 'the real intricate blending of mankind from variety to variety'.[33]

Photographing sameness and difference

Nonetheless, there was widespread agreement that Aboriginal bodies would provide evidence for 'ancestral relations' between races that had come to look different over time.[34] Giglioli shared many of Huxley's interests in social evolution, and in 1865, at

the age of twenty, he wrote to Huxley of the reception of Darwinism in Italy, and of his own forthcoming translation into Italian of Huxley's *Man's Place in Nature*.[35] Giglioli's photographic collection project began in 1867, two years before Huxley's. In *Voyage around the Globe* Giglioli aimed to demonstrate 'ethnic unity', and so 'reproduced pictures of Australian aborigines living at outlying and widely separated points of the continent', which he argued showed there was 'over the whole extent of the island continent a rare homogeneity of type, and this type is original, unusual and singular as is the character of almost all the creatures which live in this country'.[36] As an evolutionist, Giglioli considered variations between the 'various strains of Australian Aborigines [*genti*]' to be determined by adaptation to environment, suggesting, for example, that good nourishment produced a fairer skin.[37] He argued that polygenist theories such as Topinard's were flawed by reliance on 'extreme' examples rather than considering the range of types to be found across the continent, and was highly critical of Topinard's method, especially his diverse and 'inaccurate' visual sources. In 1872 Topinard had suggested multiple Aboriginal origins, arguing,

> So can be explained the diversity of portraits that have been made of the Australians, why navigators have depicted them in different ways, why travelers in the centre have found them to be better built, more handsome than those on the coast, why for such a long time they have been considered as the most hideous beings in creation, while today, through over-reaction one is inclined to take them as models for statuary.[38]

Giglioli refuted this theory, scrutinizing the empirical reliability of observer accounts:

> The shape and proportions of the various parts of the body and limbs do not present anything remarkable, and the contradictions to be found in the reports by various observers are due to the common tendency to choose extreme types for the descriptions. Thus we find some, like Pickering and Leichhardt, who assert that the aborigines are veritable Apollos, while others have depicted them as the most wretched of humans in their physical aspect. Of these let us cite Dumont D'Urville, whose pictures representing aborigines of the West coast, after a horrible famine, were later repeated in all the ethnological works, spreading a sad caricature of this poor people.[39]

Instead, he advocated the application of the comparative method using the 'portrait type'. Fundamentally, Topinard and Giglioli's disagreement centred upon their explanation of Australian diversity as either homologous or analogous types, the basic unit of comparative morphology. Types permitted classification through an underlying structural plan revealed by the study of many individuals, rather than to superficial resemblances. Measurement, especially of skulls, was seen as an objective means of classification and comparison. Through the photographic 'type', an abstract sense of human variation was made observable and real: as Elizabeth Edwards argues, the photographic type revealed 'the parameters of divergent variation, which could nonetheless be contained within this taxonomic device'.[40]

In a more general sense, Giglioli shared the widespread belief in physiognomy – the doctrine that character was revealed by the forms of the face, head and body that became almost universal by the Victorian era.[41] Italian scientists, such as Giglioli's mentor, Paolo Mantegazza, applied ideas of physiognomy to the new science of man. Perhaps unsurprisingly, Italian scientists were also prominent around this time in the emerging school of anthropological criminology, based on perceived links between criminality and the physiognomy of the offender, led by Cesare Lombroso – who succeeded Giglioli's father Giuseppe as Chair of Anthropology at Pavia in 1862. Hence Italian science offered a receptive milieu for theories correlating anatomical form with racial difference, both within and without its new borders.[42]

Picturing Aboriginal people in the mid-nineteenth century

At the time of Giglioli's Australian visit in 1867, photographic images of Aboriginal people were still relatively rare, and except for display in albums and exhibitions, were known chiefly through engraved versions in newspapers, magazines and books. As discussed in Chapter 2, some of the earliest daguerreotypes of Indigenous Australians had been produced in Melbourne from around 1847, forming the basis for interpretations by artists who illustrated accounts of the young colony, while during the 1850s a handful of *plein air* (outdoor) experiments recorded the traditional and changing lifestyle of the original occupants.[43] From the early 1860s, however, such photographs became increasingly available through *cartes de visite* produced by studio photographers in all the major colonial centres.

Experiments with photography in scientific publications began to be made around this time – such as Darwin's 1872 *Expression of the Emotions in Man and Animals*, which was the first book to include photographs.[44] Giglioli, in suggesting that his own photographic portrait series countered the 'extreme types' of his predecessors, implicitly argued for its objectivity. Giglioli's use of Australian portraits, many 'ready-made' *cartes de visite*, was innovative in systematically assembling Indigenous 'types' from across the continent. This method had no photographic precedent, but echoed in visual form the textual strategy adopted by many ethnographers in reviewing native customs Australia-wide. This assemblage was both more limited and more thorough than Huxley's contemporary photographic scheme, in focusing solely upon Australian Aboriginal people, and in providing examples from each Australian colony. Where other projects aimed to identify difference, as evidence for global human variation, Giglioli's goal was to establish the unity of a single 'race'.

Significantly, Giglioli discussed his published visual evidence, based on his *carte de visite* portrait collection, as if it belonged to the same epistemological register as the range of contemporary images available in the pages of scientific accounts – that is, engravings based upon drawings and watercolours – and as if there were no significant difference between them. Of course, Giglioli's published images were also engravings based on

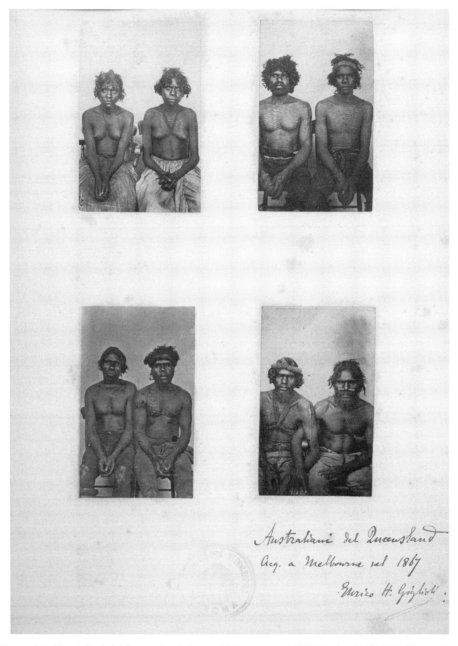

Figure 3.3 'Australiani del Queensland, Acq. a Melbourne nel 1867. Enrico H. Giglioli' ['Australians of Queensland, acquired in Melbourne in 1867. Enrico H. Giglioli']. Courtesy Museo Nazionale Preistorico Etnografico 'Luigi Pigorini' [National Museum of Prehistory and Ethnography 'Luigi Pigorini'], Rome.

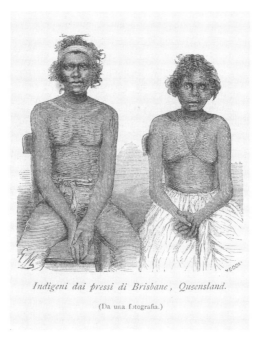

Indigeni dai pressi di Brisbane, Queensland.

(Da una fotografia.)

Figure 3.4 'Indigeni dai pressi di Brisbane, Queensland. (Da una fotografia)' ['Indigenes from near Brisbane, Queensland (from a photograph)']. Enrico Hillyer Giglioli, *Viaggio intorno al globo della r. pirocorvetta italiana Magenta negli anni 1865–66–67–68* [*Voyage around the Globe on the Magenta 1865–68*] (Milano: Maisner, 1875), 778.

his photos, and so, to the reader, virtually indistinguishable from the published images included in the accounts he cited. Nor were Pickering and Leichhardt or Dumont d'Urville themselves directly responsible for producing the imagery that conveyed their travels and findings to a wide audience. In each case highly-trained artists produced the illustrations, whose views more-or-less coincided with those of the authors of the text.

Through the engraver's methodical interpretation, the portraits reproduced in *Voyage* elide cultural and physical differences. Comparison with the original photographic models for the Brisbane portraits (Figure 3.3) indicates the ways the engraver has smoothed out their complexity, bringing disparities of scale, dress and form into alignment. The actual, asymmetrical features of the man and woman (themselves brought together from two separate photos to create this seeming couple) have been altered, the engraver enlarging their eyes, lightening their expressions and omitting small irregularities (Figure 3.4). This is, in part, due to the technical requirement of an impressionistic rendition of the photograph's indexical particularity, but in each case the shift was towards classicizing the subject's appearance. The individuals recorded in the photos are forgotten, becoming ideal types in the engravings (Figures 3.5–3.6). Despite Giglioli's stated goal of realist accuracy, and his claims for a uniquely broad and representative sample, these manipulations confine the detail of the photographic portraits within the conventional framework of Western art.

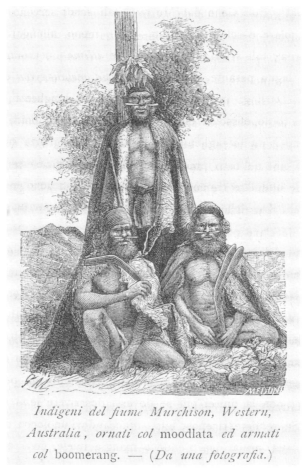

Figure 3.5 'Indigeni del fiume Murchison, Western Australia, ornate col *moodlata* ed armati col *boomerang*. – (Da una fotografia)' ['Indigenes of the Murchison River, Western Australia, decorated with moodlata and armed with a boomerang. – (from a photograph)']. Enrico Hillyer Giglioli, *Viaggio intorno al globo della r. pirocorvetta italiana Magenta negli anni 1865–66–67–68* [*Voyage around the Globe on the Magenta 1865–68*] (Milano: Maisner, 1875), 784.

Stephen Bann has reminded us of the 'parallel lines', or shared involvement of printmaking, painting and photography in image-making during the first half of the nineteenth century. By showing these media 'coexisting in closely parallel planes', he has 'attempted to configure a space of *troc* [barter] that existed simultaneously with the emerging codes of modern visuality'.[45] This 'intervisuality' clearly structures Giglioli's and others' account of Aboriginal people during the 1860s, a decade of great visual ferment in the Australian colonies, as photography was used to great effect in catering to European popular and scientific demand for Indigenous 'data' from the expanding frontier. Photography was a means of naturalizing ideas about race and culture, although much older visual conventions governed ideas of the medium's value, established by pre-photographic forms of representation such as voyagers' accounts.

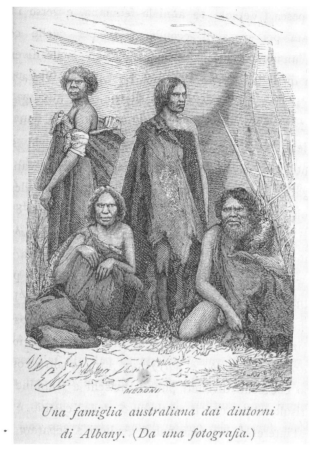

*Una famiglia australiana dai dintorni
di Albany. (Da una fotografia.)*

Figure 3.6 'Una famiglia australiana dai dintorni di Albany. (Da una fotografia)' [An Australian family from around Albany. (From a photograph)]. Enrico Hillyer Giglioli, *Viaggio intorno al globo della r. pirocorvetta italiana Magenta negli anni 1865–66–67–68* [*Voyage around the Globe on the Magenta 1865–68*] (Milano: Maisner, 1875), 787.

Aboriginal 'Apollos' and 'Caricatures'

While accuracy of observation was certainly highly valued in visual representations by this time, it is important to acknowledge the profound influence of longstanding Western aesthetic ideals, particularly those derived from Greek prototypes. Classical female portraits had always tended towards idealization, as within this tradition beauty was considered to be their subjects' most salient feature.[46] As for many Western observers, for the young Italian Giglioli the most obvious personification of the ideal of male beauty was the Greek god Apollo, exemplified by the world-famous Apollo Belvedere, displayed behind the Vatican Palace in Rome. From the mid-eighteenth century, this sculpture embodied Western ideals of aesthetic perfection, made famous by neoclassicist German art historian and archaeologist Johann Winckelmann, to whom it appeared 'the highest

ideal of art among all the works of antiquity', and becoming fundamental to Western consciousness through reproduction and exegesis.[47]

For physiognomists, anthropologists, artists and popular audiences, elements of classical physiognomy coexisted comfortably with modern science – particularly in Italy. Anatomists such as Robert Knox had recommended the study of Greek sculpture, available through Roman copies, as the epitome of racial and physical perfection, and in 1854 Josiah Clark Nott and George Robins Gliddon's *Types of Mankind* compared the profiles of the Apollo Belvedere, a Negro and a monkey in arguing their polygenist theory.[48] In 1850, Louis Agassiz commissioned photographs of slaves and mixed-race Brazilians that were juxtaposed with classical statuary in support of his polygenist theories.[49] Such techniques of comparison became common, and continued to shape scientific imaging even as new media were incorporated into illustrative practices.

Giglioli positioned his own supposedly objective and accurate photographic study between 'some, like Pickering and Leichhardt, who assert that the aborigines are veritable Apollos' and those who portrayed them as 'the most wretched of humans', thereby mapping the contemporary visual field. Charles Pickering was an American naturalist who accompanied the United States Exploring Expedition of 1838–42 under the command of US Navy Lt Charles Wilkes. The expedition was of major importance to the growth of science in the United States, and much of the data collected helped form the basis of collections at the new Smithsonian Institution. Two striking engravings, both produced by the expedition artist, engraver and illustrator Alfred Thomas Agate, appeared in Pickering's *The Races of Man; and Their Geographical Distribution*[50]: 'Australian Race, Willilnga. A Native of the Interior of Australia' (Figure 3.7) and 'Bamboro-kain'. Combining symmetry of feature with a dignified pensiveness, Agate's portraits were indeed sympathetic to his Aboriginal subjects, a view coinciding closely with Pickering's text, which noted that some Aboriginal people they encountered

> contrary to all anticipation, had the face decidedly fine; and several of the young women had a very pleasing expression of countenance. The general form, though sometimes defective, seemed, on the average, better than that of the Negro; and I did not find the undue slenderness of limb which has been commonly attributed to the Australians. Strange as it may appear, I would refer to the Australian as the finest model of the human proportions I have ever met with; in muscular development combining perfect symmetry, activity, and strength; while his head might have compared with an antique bust of a philosopher.[51]

Pickering's text also challenged the relegation of Aboriginal people to the 'bottom of the scale of humanity', noting that 'a child educated at a school in Sydney showed intellectual capacity equal in every respect to that of his European companions'.[52]

Giglioli also referred to Prussian explorer and naturalist Ludwig Leichhardt's depictions of Aboriginal people as 'veritable apollos'. These were in fact Charles Rodius's drawings of two Aboriginal members of his first 1844–5 expedition: Harry Brown of Newcastle and Charley Fisher of Bathurst, who had been a native policeman and tracker.[53] Rodius is better known for his two series of lithographed portraits produced between 1831 and

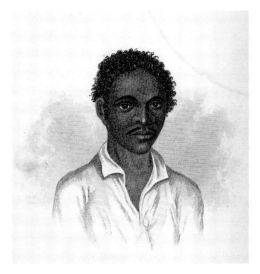

Figure 3.7 'Australian Race, Wililnga. A Native of the Interior of Australia', Charles Pickering, *The Races of Man; and Their Geographical Distribution* (London: H. G. Bohn, 1851), 138.

1840, which, at the time, were considered faithful likenesses and desirable souvenirs of Sydney. His Sydney series verges on caricature, but his portraits of the Aboriginal explorers are indeed romantic and dignified.

At the other end of the spectrum, for many contemporary as well as later observers, were the most extreme caricatures provided by Dumont d'Urville's visual and textual accounts.[54] His observations contributed to the growing clarity of racial distinctions in the Pacific, as his division of Oceania into Polynesia, Micronesia and Melanesia was adopted by later writers.[55] His draughtsman Louis Auguste de Sainson's drawings and Dumont d'Urville's textual narrative have often been perceived as mutually reinforcing in denigrating the Australian Aboriginal people they encountered, particularly by contrast with the Maori of New Zealand, whom they regarded as the archetypal romantic savages.[56]

Some of de Sainson's engravings – such as those based on drawings produced at King George's Sound – were considered by contemporaries to be cartoonishly unrealistic, as indicated by Giglioli's criticism, made on the basis of fifty years of hindsight and his personal field observations. Scepticism over de Sainson's blatant hyperbole was also expressed by the journal accounts of the French officers Gaimard and M. M. Quoy, who noted that the 'characteristic emaciation' was not 'peculiar to these people' but was caused by lack of food, as shown by the change in appearance of sealers' women as a result of their improved diet. They defended de Sainson's depictions as accurate, although acknowledging that they seemed 'peculiar and quite extraordinary at first sight and the drawing that M. Sainson made of a child looks like a real caricature; one would say that his lower limbs are nothing but a femur and tibia covered with skin'.[57] Yet despite these qualifications, his monkey-like faces and absurd gestures are harder to excuse: clearly for Giglioli, as for us, these were 'caricatures'.

As a proponent of the comparative method, Giglioli developed his own visual taxonomy in the form of wide-ranging photographic portrait types. Using the new medium, he

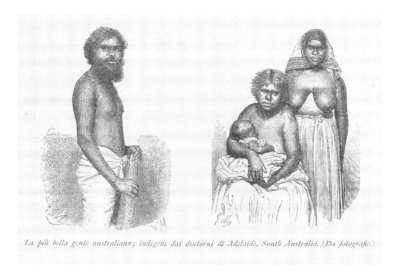

La più bella gente australiana; indigeni dai dintorni di Adelaide, South Australia. (Da fotografie.)

Figure 3.8 'La più bella gente australiana; indigeni dai intorni di Adelaide, South Australia. (Da fotografie)' ['The most beautiful Australian people. Indigenes of the environs of Adelaide, South Australia. (From photographs)']. Enrico Hillyer Giglioli, *Viaggio intorno al globo della r. pirocorvetta italiana Magenta negli anni 1865–66–67–68* [*Voyage around the Globe on the Magenta 1865–68*] (Milano: Maisner, 1875), 776.

located himself in relation to these more 'extreme', pre-photographic interpretations so that he could claim to have identified the truly 'typical' Australian.[58] Giglioli conflated social organization and Western notions of beauty in claiming that the 'most beautiful people', 'probably by reason of their easier conditions of life', came from the Adelaide region, as shown in a portrait of a man and two women (Figure 3.8).[59] As Darwin had argued just a few years before, relativist perceptions of beauty were a key aspect of sexual selection, which was a fundamental mechanism for racial and sexual evolutionary divergence. Implicit in Darwin's theory was the equation of Western conventions of beauty with European progress.[60]

Giglioli's project defines the contemporary reliance upon physical appearance as the basis for scientific evaluations of racial status. Like Darwin, Giglioli's conception of Indigenous intellectual and physical faculties was constrained by his own neoclassical taste, revealing the imbrication of everyday cultural predispositions with supposedly objective scientific methods. Visual representations of Aboriginal people were contested: in positioning himself objectively between 'Apollos' and 'caricatures', Giglioli's visual analysis maps contemporary debates concerning ideas of race and Indigeneity, but also demonstrates the close dialogue that persisted among mid-nineteenth-century visual media; experiments in applying photography owed perhaps as much to inherited classical ideals as they did to new scientific methods.

Throughout his text, Giglioli moved between acknowledgement of Aboriginal humanity, even admiration for Aboriginal demeanour and culture, and the strict qualification of such assessments. His pity for the reserve residents and pleasure at their 'cleanliness, good health and apparent contentment' contrasted with his distancing, totalizing ethnological

description. Despite rejecting his colleagues 'extreme' views, he concluded that 'the Australian aborigines are still in that primitive stage in which man leads a wandering and adventurous life without ever taking thought for the morrow', and that their 'inconstancy' was due to 'an incomplete development, I might say to an arrest of the psychic faculties'.[61] This ambivalence signals the tension between his own observations, including his interpretation and deployment of his photographic project, and his commitment to the evolutionary paradigm. Significantly, Giglioli did not illustrate his scientific account with any of his Coranderrk portraits, either the six he made himself or Walter's 106 portraits. This visual absence may be explained by the clothed, and therefore non-primitive, status of the Coranderrk residents, who seemingly disrupted the principles governing the larger assemblage. Giglioli kept these portraits of Coranderrk to the end of his life as private mementoes of a personal encounter across cultures.

The brutal realities of colonization, such as the diseases that ravaged Indigenous populations, were authorized by a belief in inevitable extinction. Evolutionism provided an explanation for such perceptions, at the same time permitting sympathy with the victims. Giglioli's views were infused with sentiment: from his empathy with Hobson's domestic happiness (which he was later to emulate when he married in 1876) to his sorrow at the family's sickness and death; yet ultimately these emotions simply naturalized his views of progress. Giglioli and his wife Constanza visited Australia in 1891, and she wrote to their children left behind in Italy, reasserting Giglioli's view that the race was almost 'exterminated'. 'Poveretti!' (Poor things!), Costanza exclaimed. 'They are mendicants in the estate that once was theirs and now wear their ancient ornaments only for the photographer.'[62] For European observers, this pity seemed the appropriate moral response to direct towards the doomed race, entailing a passive sentimentalism that masked complicity in establishing the racial hierarchies of colonial governance.

Understanding the thought of scientists such as Giglioli works to undermine modernist scientific concepts of race by tracing the concept's normalization and the ambivalence of visual meaning during the mid-nineteenth century, with the effect of revealing the contingency of such racial categories.[63] As Edwards concludes of Huxley's contemporaneous project, which ultimately petered out, its totalizing intentions and sometimes oppressive execution were undermined by internal fractures, resistances and dissonances. During this experimental phase of representing Indigenous Australians, it is important to acknowledge the diversity of contemporary ways of seeing, including admiration for Aboriginal people. In demonstrating the extent to which his 'scientific' arguments were underwritten by aesthetic judgements, and personal encounter in the 'field', Giglioli's work complicates monolithic interpretations of colonial photography. His photographic project demonstrates that many mid-nineteenth-century observers admired the appearance of Indigenous Australians and acknowledged their humanity.

4

BLIND SPOTS OR BEARING WITNESS: ANTISLAVERY AND FRONTIER VIOLENCE IN AUSTRALIA

In December 1853 the Tasmanian steamer *Culloden* made a 'pleasure trip' from Hobart to the Aboriginal settlement at Oyster Cove, where the day-trippers were greeted by 'the Queen', Mary Ann, aged about thirty. Mary Ann Cochrane, daughter of Tarenootairer, and her husband, Walter George Arthur, were active campaigners for improved conditions for their people. The Hobart pleasure-seekers observed that 'Mary Ann, it appears can read with fluency, and asked for books. She wanted "something lively." She had read "Uncle Tom's Cabin" and pronounced it "very much true." Books were promised her.' When Mary Ann spoke of the 'truthfulness' of *Uncle Tom's Cabin*, she showed that she participated in a global community of readers, gripped by the sentimental narrative of slavery in the United States. She herself was deeply familiar with ideas about rights and freedom, and along with white humanitarians, sometimes drew an analogy between slavery and the treatment of her people. Of the abduction of Aboriginal women by sealers in Bass Strait, for example, the Aboriginal Protector George Augustus Robinson declared, 'Surely this is the African slave trade in miniature, and the voice of reason as well as humanity calls for its abolition.'[1] The Arthurs themselves had effectively protested against the management of the tyrannical superintendent Dr Henry Jeanneret by drawing on the language of rights and slavery: they argued that they were a 'free people', and Mary Ann complained of Jeanneret in June 1846 that 'we do not like to be his slaves nor wish our poor country to be treated badly or made slaves of'.[2] The novel's theme of the evils of separating families must also have resonated with Mary Ann, whose people had been forcibly dispossessed and dispersed. Although she remained in contact with her family, even if relocated across the colony's settlements, her husband, Walter George Arthur (c.1820–1861), the son of Rolepa, a senior man of the Ben Lomond tribe in northeastern Tasmania, had a 'half-caste' mother, and he was separated from his kin 'in unknown circumstances'.[3] Surely, more than most readers of the American novel, when Mary Ann declared its tale of oppression and violence 'very much true', she was speaking from her experience as a black woman.

This chapter explores the important yet overlooked phenomenon of the influence of antislavery discourse in Australia over the course of the nineteenth century. After its 1830s climax the power of antislavery debates gradually faded, only to be revitalized by

reference to the American struggle, and especially Harriet Beecher Stowe's novel, *Uncle Tom's Cabin; or, Life among the Lowly* (hereafter *UTC*), published in 1852. This novel had an enormous impact on the abolitionist debate in America leading up to the American Civil War – expressed in the apocryphal story that when President Abraham Lincoln met Stowe he said, 'So this is the little lady who started this great war.'[4] The book sold 300,000

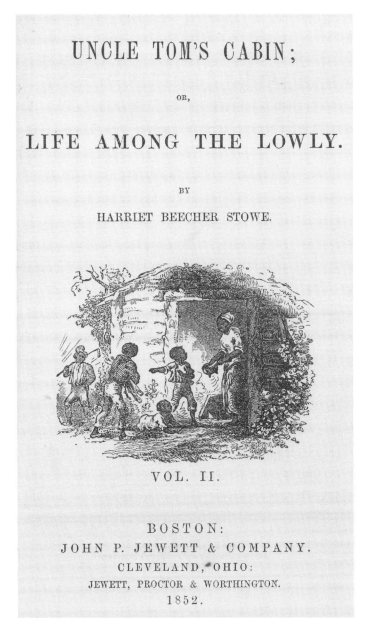

Figure 4.1 Hammatt Billings, frontispiece in Harriet Beecher Stowe, *Uncle Tom's Cabin; or, Life among the Lowly*. A 1852 .S76 U4 v.2. Special Collections, University of Virginia, Charlottesville, VA.

copies in its first year, and became the most famous novel of the nineteenth century. The visual culture that sprang up around the novel shaped public perceptions through prints and paintings, illustrations in various book editions, advertisements for stage productions, paintings of favourite scenes, and even sheet music for Tom-inspired songs.[5] For Australian audiences, *UTC* acted to share Anglophone narratives, language and cultural dispositions, and was reworked to engage with local circumstances.[6] Australian readers were first given a taste of the book at Christmas-time 1852, through an extract in which a mother was cruelly separated from her only remaining child at a slave auction.[7]

One early review, published by the conservative *Times* of London, savaged the novel for its exaggerations, arguing against abolition and for gradual and voluntary reform from within.[8] Stowe's Boston publisher, John J. Jewett, had, unusually for the period, included six full-page engravings and a small cover vignette, and the *Times* reviewer considered the author's 'extreme views' to be signalled by Hammatt Billings's introductory image, writing that 'the object of the work is revealed in the pictorial frontispiece. Mrs. Harriet Beecher Stowe is an abolitionist, and her book is a vehement and unrestrained argument in favour of her creed.'[9] The illustration in question depicted a scene of domestic harmony within the humble but cosy slave cabin where Aunt Chloe and three small children wait for their father, Tom, to return home from the fields (Figure 4.1). It is revealing that this familial vignette crystallized opposing views of slavery: for the *Times*, this was romanticizing, 'audacious trash', but for Stowe and her sympathizers, family was sacred.

Most readers disagreed with the *Times*, as indicated by the novel's tremendous and lasting popularity around the globe.[10] In Australia, nineteenth-century audiences retained considerable sympathy for *UTC*'s depiction of slavery, even as satirical and burlesque versions proliferated in America.[11] Australian audiences rarely likened the treatment of Australian Aboriginal people to *UTC*-style slavery, instead expending their sympathy upon safely distant American slaves by preference to local Aboriginal people. However, the moments when *UTC* was invoked signal outrage and scandal, as white observers registered the local presence of horrors they had only imagined to exist elsewhere. These moments define contemporary notions of humanity and rights, mapping the border between recognition and disavowal of Aboriginal people. At these significant moments humanitarians attempted to bring the treatment of Aboriginal people into public scrutiny and censure by linking colonial frontier violence with transatlantic slavery as the canonical form of oppression.

'Inhuman White Savagery'

Over the second half of the nineteenth century, as the southern colonies of Sydney, Melbourne and Adelaide forgot their own, more distant, histories of violent settlement, the Queensland frontier became a key battleground for public opinion. Following the colony's independence from New South Wales in 1859, conflict was condoned by many settlers and the government as a 'cruel necessity' in what historian Jonathan Richards has termed a 'secret war'.[12] Violence was institutionalized through the Native Mounted

Police, a body of Aboriginal troopers headed by a white officer, who were able to move easily across rugged terrain, their terror premised on traditional enmity between Aboriginal nations.[13] The native police were a fearsome means of pacifying Indigenous resistance across the British Empire, and were frequently accused of taking Aboriginal women as sexual hostages.[14] For two decades public disquiet grew, culminating in a sustained campaign against frontier violence in 1880 by the Brisbane weekly newspaper, the *Queenslander*. This series of anonymous articles and editorials prompted tremendous controversy, and was issued as a booklet titled *The Way We Civilise*. One authoritative contributor termed the Native Police system as 'slavery, pure and simple, and on a scale the most gigantic perhaps the world has ever witnessed'.[15] Humanitarians expressed a view of Aboriginal people that recognized but qualified their humanity:

> If we, by common consent, punish those who torture an animal, what plea have we to urge for the horrible brutality with which we assert our mastery over creatures lower in the scale of humanity than ourselves, but still men and women able to feel and suffer in the same manner as we do? In the form that our cruelty assumes, in our vices, we acknowledge their humanity, and yet we deny to them the plea for immunity from unnecessary suffering which we admit on behalf of the brutes.[16]

Historian Henry Reynolds terms this small booklet 'one of the most influential tracts in Australian history': although it did not trigger a Royal Commission, it prompted two extended Queensland parliamentary debates and ultimately circulated among humanitarians across the British Empire to inform imperial policy. It is credited with British Prime Minister William Gladstone's decision to veto Queensland's annexation of New Guinea in 1883.[17] The pamphlet's reception, as it circulated from local to imperial readers, reveals the tensions between the grim intimacy of the frontier and its tolerance of atrocity, and imperial humanitarian condemnation as represented by the Anti-Slavery and Aborigines' Protection Society. These different perspectives allowed local campaigners to leverage their critique through appeal to international outrage.

Another, less successful, attempt to unite these diverse strands was the 1890 novel *The Black Police*, by young English-born journalist and artist Arthur James Vogan. As a journalist and newspaper artist, Vogan was an active participant within an imperial global network of newspaper narratives and engraved illustrations that expanded tremendously in the late nineteenth century.[18] In 1889 Vogan travelled through the Channel Country of Queensland for the Royal Geographic Society of Australasia, where he witnessed many brutalities, including a terrible flogging.[19] He attempted to publish an illustrated article 'depicting what I had seen of the atrocities committed upon the aborigines', but it was rejected as 'unsuitable for our columns'. He then decided to adopt 'the form of a novel, as being a more popular form, likely to command a larger and more sympathetic audience' than other genres.[20] However, he complicated the novel's fictional status with this explanation: 'In the following story I have endeavoured to depict some of the obscurer portions of Australia's shadow side. The scenes and main incidents employed are chiefly the result of my personal observations and experiences; the remainder are from perfectly reliable sources.'[21]

The book follows the adventures of proud New Zealander Claude Angland, as he travels to north Queensland on the trail of his dead uncle, a miner. Angland encounters and defeats the cruel squatter, Sir Wilson Giles, his evil niece, Lileth Mundella, and her (white) suitor, Inspector Puttis of the Native Police. Mark Cryle notes the novel's combination of a wide-ranging and diverse series of narrative modes, including 'frequent diversions from the main story during which Vogan employs a range of narrative devices' including 'flash-backs; stories told by incidental characters; letters written by Angland to his friend in New Zealand; and the reproduction of actual newspaper articles, some of which Vogan himself had authored'.[22] Typical of much late-nineteenth-century popular literature that took enjoyment from 'toying' with narrative modes, Vogan's collage of voices and types of 'evidence' positions the reader as judge, or virtual witness to a range of testimonials.[23] The narrator-hero, a thinly disguised Vogan, is lent insight and a sense of moral perspective by his outsider status, and he appears as a man of sentiment, shocked by the spectacle of injustice and inhumanity.

Vogan's novel aimed to challenge local injustices via the internationally recognizable language of antislavery as well as imagery and references specific to *UTC*.[24] Throughout Vogan's novel, Aboriginal people on pastoral stations are referred to as 'slaves' living in 'a state of bondage' and in constant fear of flogging.[25] In particular, Vogan made frequent and explicit comparisons between Queensland circumstances and the mid-nineteenth-century culture of American slavery, as popularized by *UTC*. Angland wrote to a friend that 'one feels as if he had somehow descended into the slave countries of Mrs Beecher Stowe', and that 'all the horrors depicted by Mrs Beecher Stowe, all the sorrows sung of by the immortal [abolitionist American poet John Greenleaf] Whittier, are rampant around me as I write'. He quoted from Whittier's 1850s abolitionist poems including 'Randolph of Roanoke' which concerns a kind, remorseful slave-owner.[26]

Most powerfully, Vogan made central use of an immediately recognizable abolitionist visual symbol in an image that stems directly from British versions of Stowe's novel: the flogged black woman. Within Vogan's gendered moral universe, sexualized violence against black women signals the moral turpitude of his villains, and is opposed to his hero's impulse to protect female weakness.[27] Both his lurid cover and an engraving within the text depicted a naked Aboriginal woman, Dina, being whipped by an Aboriginal man. In Vogan's account of the whipping of Dina, he transformed an actual event that affected him profoundly into a sensational, iconic image of slavery. Vogan later described how in 1889 he 'saw a native girl tied to a verandah post at Sandringham Station (Acres & Field) and flogged with fencing wire'.[28] Dina's fictional flogging occurs on the ominously-named 'Murdaro' station, where she is introduced as the sole surviving member, 'caught as a child', of a tribe annihilated by the Black Police. She is a 'house gin, or unpaid native woman', terrified of her mistress who 'established her authority by having the house-gins flogged for the slightest misbehavior, till they were thoroughly "broken into her ways"'.[29] The cruel squatter Wilson Giles makes unstinting use of the whip and oversees the flogging of Dina and another maid, Lucy, in 'Dina's Flogging', an engraved scene that would have been immediately familiar to late-nineteenth-century viewers from the popular imagery prompted by *UTC*, but that evokes abolitionist iconography dating back to the late eighteenth century.

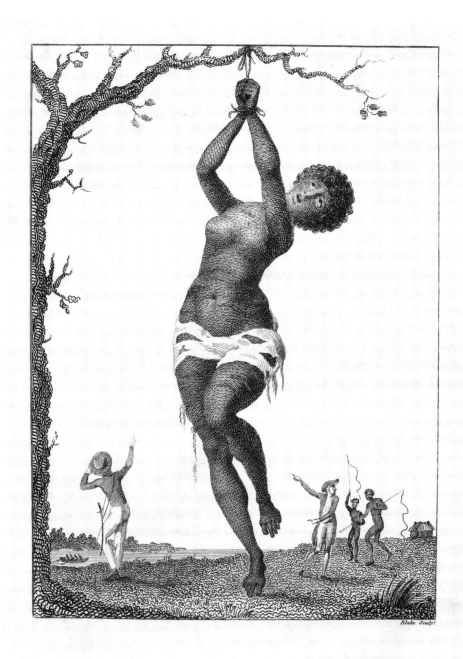

Figure 4.2 William Blake, *Flagellation of a Female Samboe Slave*. Engraving. After a sketch by John Gabriel Stedman. Published St. Paul's, Church Yard, London, 2 December 1793. © National Maritime Museum, Greenwich, London. ZBA 2580.

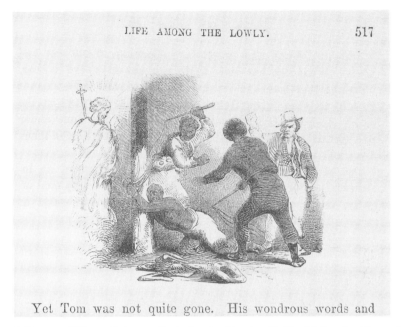

Figure 4.3 Hammat Billings, Part-page illustration for Chapter 40, Harriet Beecher Stowe, *Uncle Tom's Cabin; or, Life among the Lowly* (Boston: John P. Jewett and Company, 1852). Illustrated edition. Original Designs by Billings; Engraved by Baker and Smith. Illustration shows Jesus, Tom, Sambo, Quimbo, Legree. Courtesy Clifton Waller Barrett Collection, University of Virginia.

Images such as William Blake's *Flagellation of a Female Samboe Slave* reveal the growing pornographic edge of such depictions, as from the mid-eighteenth-century flagellation became associated with sexual arousal (Figure 4.2). In mid-nineteenth-century Europe, sadistic pornography had grown as a genre within which whipping ('the English vice') played a central role.[30] In abolitionist narratives, the ugly specificity of eyewitness accounts was transformed into romanticized visual depictions, signalling the voyeuristic element of the scene by contrasting the naked woman's graceful and well-proportioned body with the fully-clothed male observers. In these images, woman exists as an object to be enjoyed, as compassion is centred upon her desirability.[31]

Whipping slaves was a prominent feature of *UTC*, and Sigmund Freud reported a number of patients with sadomasochistic tendencies whom he believed had been influenced by reading it.[32] Billings's 1853 engraving of the key episode in which Uncle Tom is whipped by two black overseers shows Tom as a kneeling supplicant (mimicking popular abolitionist iconography), with a vision of Christ appearing before him (Figure 4.3). Slave-owner Simon Legree watches on while his overseers carry out their task, with one in the ubiquitous pose of a raised arm displaying the silhouetted whip, a graphic and immediately recognizable gesture of cruelty. Several scholars note the significant difference between American and British 'Uncle Tom' imagery, the latter tending towards the explicit and salacious – for example, showing the flogging of bare-breasted female slaves. Such images were unthinkable for American abolitionists who worked hard to attract women

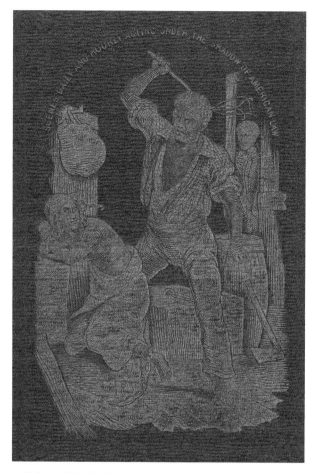

Figure 4.4 'Scenes Daily and Hourly Acting under the Shadow of American Law', cover illustration, Harriet Beecher Stowe, *Uncle Tom's Cabin, or, Negro life in the slave states of America* (London: C. H. Clarke, 1852). British edition. Courtesy University of California Los Angeles Library, Special Collections. PS2954.U54 1852e.

to the movement.[33] The cover of a British edition of *UTC* shown in Figure 4.4 exemplifies this more sexually suggestive rendition, showing a woman being whipped, her lower half draped and her breasts barely concealed.

Vogan's pictorial versions of flogging feature a woman – Dina – as the victim, both on the book cover and in an engraving contained within the book. In these images, Carlo, 'a member of an alien tribe' who hates the station blacks, administers the flogging using 'a long-handled "cat" of six tails', raised high in mid-air in a classic pose (Figures 4.5 and 4.6). As in Blake's image, Dina is suspended by her hands. Her femininity and modesty are emphasized by her flowing hair and concealing drapery. Both the cover illustration and the engraving share these elements, but the cover is focused more closely on Carlo and Dina, and Dina is posed kneeling in the tradition of familiar abolitionist iconography. In the engraving, Lucy stands by, also naked. The squatter Giles stands by in a relaxed stance, dressed in a suit and holding a whip in one hand, a cigar in the other: the juxtaposition of

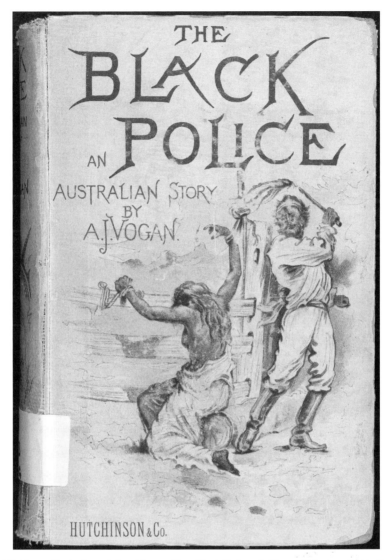

Figure 4.5 Cover illustration, Arthur Vogan, *The Black Police: A Story of Modern Australia* (London: Hutchinson and Co., 1890). Courtesy National Library of Australia, Canberra.

the fully-dressed male spectator with the naked women signifies the pornographic nature of the scene. The combination of text and image makes clear the sexually cathartic effects of this torture upon the squatter:

> Presently the yells and screams of the two girls are heard down by the stockyard, where the boss is standing admiring their graceful, naked bodies as they writhe beneath the lash … Mr Giles returns quite an altered man. Either the enjoyable sight he has just witnessed, or a couple of 'pegs' of whisky he swallowed medicinally afterwards, has sweetened his soul for the time being.[34]

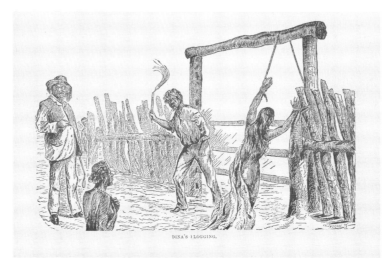

Figure 4.6 'Dina's Flogging', Arthur Vogan, *The Black Police: A Story of Modern Australia* (London: Hutchinson and Co., 1890), 157. Courtesy National Library of Australia, Canberra.

The visual similarity between the abolitionist iconography of Uncle Tom imagery and Vogan's book illustrations is striking, but throughout his text, Vogan amplifies the titillating connotations of the scene of whipping and links it to the Queensland squatter's other acts of sadism and violence to signal moral depravity.

Picturing 'Dispersal'

In addition to his use of antislavery discourse, Vogan drew upon earlier newspaper accounts of frontier violence, as represented in *The Way We Civilise*. This accusatory dossier shows how many in Australia turned a blind eye towards frontier violence, euphemistically termed 'dispersal' and *literally* lacking in visual evidence. Scenes of violence were instead recreated through words, as one eyewitness in the dossier recounts:

> Here is the picture: A lonely region, far remote from any bush highway – country unoccupied, and rarely or never traversed, save by a stockman in search of missing cattle; one well-defined trail leading down the creek, known to be the track of a sub-inspector and his troopers; signs as of horses galloping; crowds of hawks and crows circling in the air, and nearer still the sickening stench; then the dark object on the ground among the long grass, and the last lingering crow dashes up from his dainty meal on the gashed and sightless eyeballs.[35]

Such scenes could not be photographed. The lack of photographic evidence for Australian frontier violence and murder precisely maps white settler society's moral blind spot. I have never seen a photograph of actual frontier conflict, nor even its aftermath, testifying to the murder and violence wreaked upon human bodies. This is not only because of

the technical challenges posed by nineteenth-century photography, but may also be attributed to the semi-secret status of violence against Aboriginal people in Australia: despite the quasi-public nature of such conflict in contemporary debate, as evidenced by *The Way We Civilise*, it was never officially condoned, and massacre, kidnap and rape continued to be stigmatized by many as immoral and inhumane, even at the height of conflict. As Judith Butler reflects of war photography, the visual conventions or 'frames' that permit the recognizability of certain figures of the human are themselves linked with broader cultural norms that determine what will or will not be a 'grievable life'.[36] In this way, the Australian visual record is clearly structured by contemporary moral conventions regarding violence against Aboriginal people – in short, what white settlers wished to see.

If they did exist, what might such images look like? The Australian photographic record forms an extreme contrast with the spectacularized violence recorded in American lynchings of African American people. Photographs of lynchings constituted trophies of the torture and murder inflicted upon black people, and usually include crowds of grinning, triumphant white onlookers.[37] American lynching photographs asserted the legitimacy of black ill-treatment and naturalized white supremacy. Photography was an integral aspect of such torture and murder, and the resulting images circulated publicly until the 1920s to police racial boundaries and reinforce terror. It is difficult to recuperate these deeply complicit images, as curators of recent exhibitions have sought to transform spectacles of violence into visual documents of the past.[38] Despite their shared racialist premise – the subordination of a black minority – unlike lynching, there was no public consensus or widely shared acceptance regarding Australian frontier violence.

Conflict with Native Americans was also publicly condoned – indeed, celebrated. As Richard Slotkin's classic account argues,

> In American mythogenesis the founding fathers were not those eighteenth-century gentlemen who composed a nation at Philadelphia. Rather, they were those who (to paraphrase Faulkner's Absalom, Absalom!) tore violently a nation from the implacable and opulent wilderness – the rogues, adventurers and land-boomers; the Indian fighters, traders, missionaries, explorers and hunters who killed and were killed until they had mastered the wilderness; the settlers who came after, suffering hardship and Indian warfare for the sake of a sacred mission or a simple desire for land; and the Indians themselves, both as they were and as they appeared to the settlers, for whom they were the special demonic personification of the American wilderness. Their concerns, their hopes, their terrors, their violence, and their justification of themselves, as expressed in literature, are the foundation stones of the mythology that informs our history.[39]

Unlike Australian images of the frontier, artists' renditions of conflict with Native Americans express this sense of foundational virtue in showing the latter equipped as well as the invading soldiers, complete with horses and guns, and usually placed face to face on equal terms. However, Martha Sandweiss notes the absence of photographs of actual combat with Native Americans, and the way that photographers had to 'resort to visual subterfuge or words' to impute Indigenous hostility.[40]

The archive of American Civil War photography provides a more useful comparison with Australian images of frontier violence: while generally Civil War photographs show preparations and aftermaths, they also record scenes such as the body-strewn battle ground in Antietam, Maryland, taken by Matthew Brady's assistant, Alexander Gardner, in September 1862 (Figure 4.7).[41] As the *New York Times* wrote about Brady's New York exhibit just a month after the bloody Battle of Antietam: 'Mr. Brady has done something to bring home to us the terrible reality and earnestness of war. If he has not brought bodies and laid them in our dooryards and along the streets, he has done something very like it.'[42] Photographs brought home to civilians the gravity of the conflict, making the war present and real. As Alan Trachtenberg has argued, the 'physical presence' and 'palpable cultural reality' of the Civil War is indebted to the power of the image, providing 'the equivalent of having been there. Photographs are the popular historicism of our era; they confer nothing less than reality itself.'[43] Indeed, as Trachtenberg relates, such photographs exceed attempts to narrate or memorialize war: for some contemporary viewers such as Oliver Wendell Holmes, whose son was a combatant, these images were too realistic to be endured – sickening and shocking, they must be 'stricken from sight'. Nonetheless, in their passage from visibility to legibility, Trachtenberg identifies the Civil War archive's own 'grand invisibilities' – death and slavery.[44] Although photographs made the war real to viewers at home, their complex mediation obscured key aspects of the conflict, in turn defining local, American, blind spots.

Today in Australia many argue for the recognition of the history of frontier violence as war, and for its public memorialization within the Australian War Memorial in Canberra. This

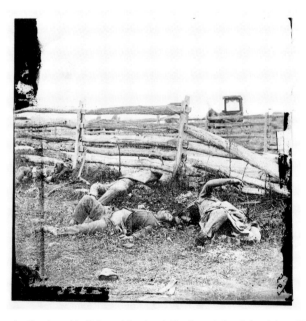

Figure 4.7 Alexander Gardner, 'Antietam, Maryland. Bodies of dead, Louisiana Regiment', September 1862. 1 negative (2 plates). Courtesy of Library of Congress Prints and Photographs Division. LC-B811- 567 [P&P] LOT 4168.

body has so far refused to include such clashes within its ambit, with director Brendan Nelson stating in 2013 that its function is 'to tell the story of Australia's engagement in, and experience of, war and other operations on behalf of Australia. It is not the Memorial's function to tell the story of disputes and armed conflicts where they have occurred within Australia.'[45] Peter Stanley represents many historians' view that this is simply 'legalism', because

> military forces raised in Australia did prosecute war against the Aborigines: the (Military) Mounted Police – which perpetrated the Slaughterhouse Creek massacre of 1838, for example – was raised in Sydney in 1825, so the Memorial is plain wrong to argue that there weren't any soldiers raised in Australia which conducted the frontier war... . An armed conflict occurred across the pastoral frontier for about a century: don't tell me that that's not an actual military conflict. It resulted in more than 30,000 deaths and involved the British army. To try to find legal reasons why it isn't recognised is just logic-chopping and pedantry.[46]

This debate emanates from the Australian 'history wars', pitting those who assert a vision of peaceful settlement against those who argue for recognition of Indigenous dispossession and assimilation.[47] An especially heated aspect of this debate has concerned the quantifiable, forensic extent of violence against Aboriginal people. Perhaps if we had photographic evidence, with the 'palpable cultural reality' it confers, our present-day debate would take a different form.

Similarly, in the absence of visual 'proof', nineteenth-century humanitarians such as Vogan sought to picture scenes of conflict to shock and move their readers. In *The Black Police*, Vogan's remarkable image of a massacre is framed by a textual account of the ordered and happy life of the people of the Upper Mulligan River, which names and thus personalizes a range of people within the community. This peaceful world is disrupted by the 'cruel, Satan-like' Native Mounted Police who 'disperse' – a euphemism for murder – the peaceful group while they are sleeping. A scene of bloodshed and death takes place, with the 'black "boys"' despatching the wounded, resulting in a toll of around thirty men, women and children. A 'little gin [Aboriginal woman]' is gang-raped and left for dead.[48] A righteous witness to the aftermath of massacre comes across the crime scene, and is 'overpowered with mingled feelings of horror, pity and indignation'. 'What cowardly devils!' he declares, as he 'stands before the body of the pretty young mother of Deder-re-re's children. One dark, shapely arm still clasps the baby form; the other, crushed and mangled with attempting to ward off the blows.'[49]

Vogan's engraving of the scene adopts instead the stance of eyewitness to the moment of conflict – and specifically the confrontation between white men and their black female victims (Figure 4.8). Three dead men lie on the ground. The naked mother, futilely holding up one arm to halt the armed and booted policemen, the other holding her baby to her, dominates the foreground; in the background a sinister vignette shows another policeman with a rifle pushing a young woman, shielding her breasts with her arms, into the undergrowth. Vogan's viewpoint here is fictitious, an impossible eyewitness to an event he has reimagined. Vogan's caption, 'Queensland Squatters "Dispersing"

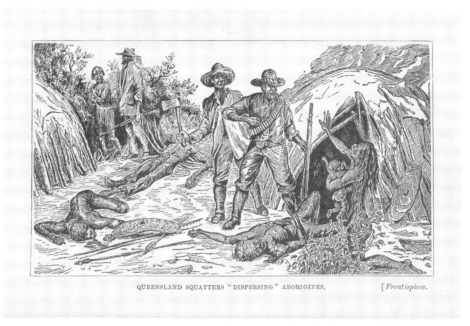

QUEENSLAND SQUATTERS "DISPERSING" ABORIGINES. [*Frontispiece.*

Figure 4.8 'Queensland Squatters "Dispersing" Aborigines'. Frontispiece in Arthur Vogan, *The Black Police: A Story of Modern Australia* (London: Hutchinson and Co., 1890). Courtesy National Library of Australia, Canberra.

Aborigines', draws attention to the rift between what is seen (what 'really happened') and the euphemism used to publicly describe it, adding a sense of undeniable 'revelation'.

Vogan was later to claim that the model for his account was the notorious Myall Creek Massacre of 1838, in which at least thirty unarmed Aboriginal men, women and children were killed by eleven colonists.[50] Seven men were hanged for the crime, against tremendous public opposition, and the event intensified racial tensions within colonial society for decades to follow. Visual precedents for scenes of frontier conflict existed in artists' renditions, many appearing in illustrated newspapers, and these oscillate between showing Aboriginal people as terrifying savages, or, in humanitarian texts, as victims.[51] Such views emphasized the Aboriginal victims' humanity, showing them as sharing universal ties of family – particularly the bond between mother and child – which was destroyed by white violence.

In December 1880 the *Illustrated Christian Weekly* published an engraved illustration that was visually very close to Vogan's in focusing on a confrontation between a clothed white man, gun raised high, and an Aboriginal mother protecting her babies (Figure 4.9). This American periodical commissioned well-known engraver and painter Charles Hunt to illustrate the argument that 'the treatment of the aborigines by the British has equalled, if not surpassed, the most ferocious and horrid crimes committed by the aborigines, of which our illustration is a true picture'.[52] The article cited the work of well-known Australian missionaries, such as Daniel Matthews and John Gribble, who participated in and deployed a global evangelical print culture.[53]

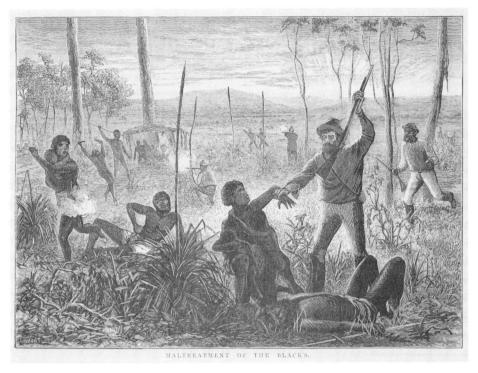

MALTREATMENT OF THE BLACKS.

Figure 4.9 'Maltreatment of the Blacks', *Illustrated Christian Weekly*, 24 December 1880.

'My Dreadful Pictures'

Humanitarians such as Vogan deployed images of atrocity to arouse the viewer's indignation and direct compassion towards the Aboriginal victims of colonialism. Like *UTC*, Vogan's novel *The Black Police* was indeed successful in reaching a wide audience, selling 7,000 copies within two years.[54] However, the public response to *The Black Police* illustrates the difficulty of 'proving' frontier violence to an unreceptive audience, and mobilizing action. Critique of the book focused upon its realism, suggesting that it simply deployed familiar stereotypes and hearsay. Vogan attempted to frame his accusations and arouse popular support through a range of strategies, including abolitionist visual and textual imagery, in the novel form. Several newspaper articles are reproduced in full within his text, including a feature about an atrocity at Thargomindah that had actually occurred.[55] Vogan claimed to have 'endeavoured to sketch from memory a faithful if humble representation of an actual occurrence, in preference to indulging what latent talents we may possess in the walks of imaginative scene-painting'.[56] But Vogan's imagery in particular is highly derivative rather than based upon his own observation – even his engraving 'Officer and "Boy" of Black Police' reproduces William Strutt's 1850 drawings of Victorian police.[57] Despite his inclusion of considerable ethnographic detail, including words from local languages, his use of newspaper accounts, and other empirical observations made during his

travels, Vogan's reliance upon visual and textual stereotypes to convey frontier violence undermined the persuasiveness of his novel.

Australian reviewers typically challenged his account, which one termed 'an inartistic narrative' and another wearily suggesting that the reader will 'soon guess that the general tenor of the book is to heighten the bad impression which is given of the Queensland native police, especially outside of Queensland. The old familiar stories are worked in.'[58] This reviewer implied that for contemporary Queenslanders these stories were apocryphal, calling attention to the inaccuracy of Vogan's flogging scene, and noting with disbelief that 'the black gin … has beautifully long black hair, from which I come to the conclusion that the artist, at any rate, who designed that cover had never seen a she aborigine of Australia'.[59]

Vogan succeeded in attracting the attention of the British-based Anti-Slavery Society, which reviewed his book in *The Anti-Slavery Reporter*. Significantly, the *Reporter* chose to reproduce his seemingly objective 'Slave Map of Modern Australia' (Figure 4.10), but expressed doubt about the accuracy of his claims. The *Reporter* also published Vogan's response of September 1891, thanking it for its 'liberal review', but urging it to acknowledge the truthfulness and reliability of his account in the face of scepticism. In his own defence, he wrote:

> You evidently consider I have overdrawn my picture of the painful scenes I have endeavoured to depict… . But I assure you sir that – putting my capabilities as a writer

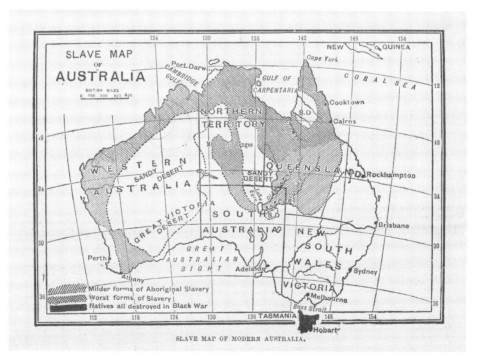

Figure 4.10 'Slave Map of Modern Australia', Arthur Vogan, *The Black Police: A Story of Modern Australia* (London: Hutchinson and Co., 1890), 387. Courtesy National Library of Australia, Canberra.

to one side – I have erred rather on the side of fearing to disgust my reader with a full account of what has come to my knowledge than on that of exaggeration. I boldly declare, and you can make what use of this letter you like, that I have not overdrawn my dreadful pictures at all; and that these scenes of devilish cruelty which have, for at least fifty years, disgraced their portion of Her Majesty's dominion are rampant today.[60]

Acknowledging the dubious status of his images as *proof*, Vogan volunteered his services to travel through the 'dark districts of which I have written, and make a series of photographs of those things which people seem so incapable of believing without some such trustworthy means'.[61] Vogan's conception of the potential of photography to prove injustice and ill-treatment was not to be taken up by Australian campaigners for another two decades.[62] It also pre-dates the use of photography by humanitarians of the Congo Reform Association (CRA) by almost a decade – as I explore further in Chapter 6. One newspaper report noted rumours that a 'price was set' on Vogan's life – and despite the book's strong sales, as a result of these threats he retired from journalism.[63]

Vogan would later reflect upon the contrast between the popular sentiment aroused among Australian audiences by stage performances of *Uncle Tom's Cabin* and their indifference towards Aboriginal people:

When the martyred [missionary] Gribble showed the Sydney public in 1887 what massacres of aborigines were taking place, and how child-slaves were sold for immoral purposes to Chinamen, the majority you belaud was weeping in the theatres over 'Uncle Tom's Cabin' (I saw them!). But this public you believe in as inherently good would not take a step to suppress the horrors. So I investigated them myself; and published the facts in my 'The Black Police'.[64]

Vogan clearly recognized the limits of the sentimental narrative, which, as Lynn Festa writes, 'helps to define who will be acknowledged as human'.[65] Attempting to harness sympathetic feeling for a local cause, Vogan graphically described the massacre and violence specific to the Australian frontier, bringing slavery and frontier violence into conversation, in part, through popular culture references to *Uncle Tom's Cabin*. *The Black Police* was widely read, yet dismissed by some observers on the basis of the author's 'embellishments', as Vogan drew heavily upon familiar stereotypes, in a modernist mélange that attempted its 'truth-effects' via a range of images, anecdotes, eyewitness accounts, newspaper reports, letters and poetry. His impact may have been undermined by the clichéd popular forms he included, but it is also important to note that his book was published following decades of heated local and international debate about colonial violence against Aboriginal people. Reviewers were weary of 'the old familiar stories'.[66] In addition, popular views about biological racial difference had hardened since the mid-nineteenth century, so that by the time Vogan published his novel, Darwin's theory of natural selection had become scientific orthodoxy, applied to humankind in what is often called social evolutionism. Against this unsympathetic context, imperial humanitarian networks – which had proved so effective less than a decade earlier in the case of the

Queenslander campaign – were unable to gain purchase. Within this imperial frame, Vogan's novel and its reception illustrate the limits of humanitarian attempts to harness once-powerful public antislavery sentiments.

Australian analogies

Control over Aboriginal people's lives across Australia was consolidated during the last decades of the nineteenth century by increasingly restrictive legislation and administrative practices. In Western Australia, for example, missionary John Brown Gribble's accusations of slavery by pastoralists in the northwest were taken up by supporters, with one condemning

> the settlers in the district, some of whom appear from Mr. Gribble's story to be of the real LEGREE stamp and to have equalled, if not exceeded him, in abominable cruelty … we defy any reader of 'Uncle Tom's Cabin', or of 'Dred or the Dismal Swamp', to find anything in those horribly realistic pages connected with cruelty to slaves that could excel or even equal the awful atrocities alleged by Mr. Gribble to have been committed, and are still being committed, with impunity in Western Australia.[67]

Growing public concern regarding Western Australia's northwest finally prompted a scandal – as Chapter 6 explores further. However, it is important to recall how American performances of *UTC* lost their radical edge over the course of the nineteenth century, often distorted to accommodate racialist stereotypes and mask inequality.[68] Australian applications of *UTC* imagery could likewise either disguise or leverage protest concerning injustice towards Aboriginal people. In 1895 visiting British photographer George Washington Wilson took a photograph that he titled 'An Australian Uncle Tom's Cabin', showing three residents of a neatly built hut arranged around their front door (Figure 4.11).[69] Their respectable appearance and the seeming comfort of their home evoked Billings's frontispiece to *UTC*'s first edition, which had prompted the satire of the *Times*. However, this idealizing view masked the growing control over the region's Aboriginal families. Around the turn of the nineteenth century, north coast people gradually lost land through revocation and leasing, and endured growing interference by the NSW Aborigines Protection Board. The board increasingly implemented assimilation policies of child removal, known today as the Stolen Generations, intended to Europeanize the younger generation by severing their contact with family and culture.[70] Aboriginal people fought back, and in 1924 the Australian Aboriginal Progressive Association, a precursor to the broader Aboriginal political movement, was established under the leadership of Frederick Maynard.[71]

Wilson's photograph can be understood in a more nuanced way in view of the Aboriginal experience of family life over these years. The *Aborigines Protection Act 1909* (NSW) gave the board the power to 'assume full control and custody of the child of any Aborigine' if a court found there was neglect, but by 1915 the board could take Aboriginal children

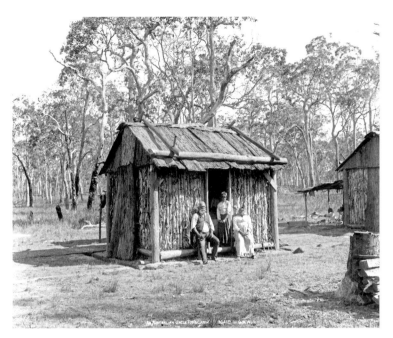

Figure 4.11 George Washington Wilson, Aboriginal Home, Grafton ['An Australian Uncle Tom's Cabin'], 1895. University of Aberdeen. Cultural permission Robyne Bancroft via the State Library of Victoria, Melbourne.

from their homes without a court hearing. Up until 1938 over 1,400 children – from an Indigenous population of fewer than 10,000 – were taken from their parents in New South Wales.[72] In January 1925 Grafton residents, northern New South Wales, read of a tragic case where four children were removed by force from their family. They were 'torn from their parents', in 'a matter that reads like a chapter from "Uncle Tom's Cabin" rather than an episode in democratic Australia in this year of grace 1925'. The affair was discussed at a meeting of the Copmanhurst Shire Council.[73] Unbeknownst to their parents, despite the exemplary nature of the children's care and home, four children were to be removed by a police officer, and white witnesses observed a 'classic example' of 'Uncle Tom's Cabin' in 'heartrending scenes', offering the following description:

> This officer's instruction was to meet the children at the ferry; and thither they went, accompanied by their parents, who did not know that their little ones were to be taken away from them. The scene at the parting was heartrending, but the children were taken despite the protests and tears, and conveyed to Kempsey. The children were properly fed and clothed by their parents. There was a boy of 14, a girl of 13, and another child of six, and another of four.[74]

The practice of removing Indigenous children and placing them in foster homes or training schools to 'assimilate' them continued in New South Wales until 1969.[75] What was perhaps unusual about this case was the fact that the removal took place before a white

audience, and became a matter for white indignation and protest, as councillors drafted a petition and offered to take the two older children into their own homes. Bandjalung/Gumbainggirr Elder Robyne Bancroft draws on community memories to note that this story had a happier ending than most, because the white witnesses were able to challenge the Aborigines' Protection Board and return the children to their father.[76]

Here, the idealized familial harmony of Wilson's view of the Grafton community was radically contradicted by witnesses to the reality of brutal official policy. The ebb and flow of 'Uncle Tom' imagery tells us much about the place of Aboriginal people in the national imaginary over the nineteenth and twentieth centuries. At certain moments the invocation of antislavery was intelligible to local audiences, while at others it was not. In Australia, photography seemingly maps a colonial blind spot, glaringly *absent* from the most intense moments of confrontation between black and white. Humanitarians made use of artists' renditions that drew upon abolitionist visual symbolism including whips, chains and flogging: immediately recognizable signs of slavery that were applied in complex ways to Australian Aboriginal people enduring violent conflict and dispossession. The impact of such visual arguments was varied, in some cases providing a powerful prompt to humanitarian action but at other moments defining the limits of compassion. Alongside such analogies, humanitarians drew upon artistic renditions of frontier violence, challenging celebratory accounts of pioneer heroism. The critical edge of such imagery was all too often blunted by growing control over Aboriginal lives. In an era marked by the absence of atrocity photography, the lurid and shocking signs of slavery and violence were rendered imaginatively by artists, but lacked the force of proof.

5

POPULARIZING ANTHROPOLOGY: ELSIE MASSON AND BALDWIN SPENCER

In 1915 Elsie Rosaline Masson (later Malinowska) published *An Untamed Territory*, an account of a year spent as an *au pair* with the inaugural Northern Territory Administrator John Gilruth and his family in Darwin.[1] During her tropical sojourn Masson had been a passenger aboard the steamer *Stuart*, which was approached by a small lugger – manned by one white and two black men – near the entrance of Port Essington, 150 miles from Darwin. As she later recounted,

> The white man raised a sunburnt face, fierce with grief and excitement, and shouted hoarsely, 'My mate – Jim Campbell – speared by blacks at Junction Bay'. It was curious what a thrill of rage the words brought to the hearers – a sudden instinctive spasm of hatred of white for black.[2]

Masson's profusely illustrated narrative of life in the wild north mobilized historical and scientific knowledge to construct a utopian future for the nation premised upon essential racial difference. Her popular account constitutes the interface between anthropological knowledge, law, and administrative policy, and demonstrates how relations of knowledge and power systematically linked governments and governed.[3] Her textual devices and visual strategies worked to circulate public attitudes and ideas with the effects of segregating races and excluding the non-white. She amplified the 'expert' views of her circle: using humorous and infantilizing stereotypes, she turned the administrators' 'problem' of racial transgression into a palatable, romantic exoticism.[4]

She belonged to an elite global network of anthropologists and colonial administrators, and subsequently married the Polish anthropologist Bronislaw Malinowski. Through her newspaper articles and book, Masson popularized the expert scientific, governmental and policy views of her circle, revealing the ways in which literary and scientific modes of knowing colonial subjects became implicated in practices of governance.[5]

Yet despite her allegiance to hierarchies of race, gender and class, Masson's account of the subsequent trial for murder of the accused Aboriginal man, and her photographs, reveal an emerging sense of respect for the individuals involved. Through visual means

she conveyed relativist notions of a shared humanity which were subsequently reflected in changes to criminal law and policy. The story of Elsie Masson and her improbable career tells us much about the important place of images in the dissemination of anthropological ideas and literature to a popular audience. It demonstrates the ambivalence of racial categories at a time when new ideas of rights and difference began to emerge, expressed in legal debates regarding the treatment of Indigenous people in the North, for example. Masson's use of visual imagery demonstrates her shift between the distancing views of contemporary racial theory to the sympathy borne of first-hand engagement with Indigenous people, and the translation of these ideas into public policy, criminal law, and popular narrative.

The New Darwin

Elsie Masson was born in Melbourne in 1890. She was clever and well-educated, and at the age of sixteen was taken to Europe for an extended tour with her mother and sister, studying music in Leipzig and art in Florence, and developing a good knowledge of French, German and Italian.[6] Her Scottish father, David Orme Masson (1858–1937), was the chair of chemistry at Melbourne University, and a close colleague and friend of the anthropologist and foundation chair of biology Walter Baldwin Spencer (1860–1929), both having arrived in Australia in 1886–7 as part of the university's expansion into the sciences. The Masson and Spencer families were friends; David and Baldwin worked closely together as entrepreneurs of Australian science, and when the University of Melbourne built housing for its staff, they became neighbours.[7]

When the Commonwealth Government assumed control of the Northern Territory in January 1911, it appointed Spencer to lead the 1911 Preliminary Scientific Expedition with three other scientists, including University of Melbourne veterinarian John Gilruth (1871–1937), a forthright Scot. Impressed with their findings, the government appointed Spencer to Darwin for a year (1912) as Special Commissioner and Chief Protector of Aborigines.[8] Gilruth accepted the post of Administrator of the Territory in February 1912. Together with other southern appointments, such as young Chief Health Officer Mervyn Holmes (born Melbourne 1884) and Supreme Court Judge David Bevan (1873–1954), Gilruth and Spencer must have shared a sense of excitement and possibility as they planned how to 'develop' the Territory. Their modern, scientific aims were signalled by one of the Commonwealth's first actions, on 3 March 1911, in changing the capital's name from Palmerston to Darwin in honour of the famous British naturalist. Spencer in particular would have found this an inspiring symbol, as a committed social evolutionist who applied Darwin's principles of natural selection to humankind.

Elsie Masson joined Gilruth's household as an *au pair* in April 1913, departing towards the end of 1914. She was recruited on the promise of 'pretty walks' and a comfortable verandah, but she managed to fit in considerable travel and observation of Territory life during this time, as well as accumulating many photographs now held by Oxford University's Pitt Rivers Museum (Figures 5.1–5.2). This family memorabilia records the comfortable existence she led in Darwin, living in the government residence and very much part of its affairs.

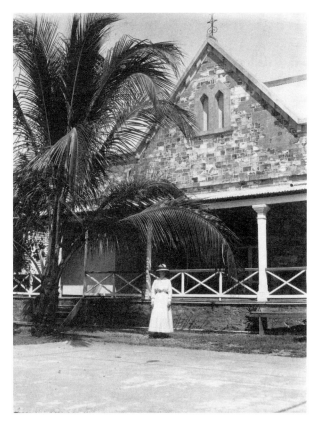

Figure 5.1 Elsie Masson outside Government House, Darwin. Wayne Collection, Copyright Pitt Rivers Museum, University of Oxford. 1998.306.138.

Masson published a series of articles about her experiences from mid-1913, and these were published as a book, *An Untamed Territory*, by Spencer's London publisher, Macmillan, in 1915. Her domestic, feminine perspective intersected in complex ways with the themes of exoticism, discipline and development that were to become emblematic of the north. Her life entailed daily interaction with a large multiracial servant workforce, and numerous expeditions to sights of interest, sometimes as the 'first white woman'.

Masson occupied an interesting position in between naïve and expert observer: she had literary talent, and her privileged middle-class upbringing gave her access to some of the most influential figures of the day, whose scientific skills authorized their policy-making for Aboriginal affairs and the future of the north. Her book popularized the professional views of Spencer, Holmes and their colleagues, providing an account of life in the Territory that presaged a now-venerable genre of imagining the north. From its earliest mythologization during the 1880s, narratives of northern Australia were concerned to canvass the region's potential to become productive and prosperous, yet in a white way. The many photographs she included worked powerfully to endorse her narrative.

Although she is always referred to in terms of the high-profile men she knew, Masson gave a distinctively romantic, humorous, stereotypical inflection to her circle's views,

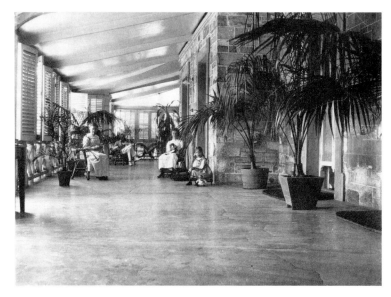

Figure 5.2 Gilruth household on Residence Verandah, Darwin. Wayne Collection, Copyright Pitt Rivers Museum, University of Oxford. 1998.306.137.

facilitating their reception by a popular audience. She softened the disciplinarian racial essentialism of Spencer and his colleagues through an enjoyment of Darwin's hybrid exoticism, as is evident in her introduction:

> Of all parts of Australia, the least, although the longest, known is that huge expanse now called the Northern Territory. The Australian who visits it is surprised and strangely entranced with this portion of his continent. He is fascinated by the romance of the life and by the varied elements that compose it – the crude beginnings of white man's civilization, the savage state of the Stone Age Aboriginal, and, foreign to both, the peculiar flavour of the East, reminding him that he is now within tropic regions.[9]

Untamed was dedicated to Dr John Gilruth, Administrator of the Northern Territory, and his wife and also to medical officer Mervyn Holmes, to whom she 'owed most of the photographs'. She thanked Spencer for 'photographs he so kindly gave me and for his generous help and encouragement', and for making it possible for her to study life in Darwin and outlying parts of the Territory, such as country round Darwin to Pine Creek Railway Line, the Daly River, Alligator River, and the northern coast as far as the Roper River in the Gulf of Carpentaria. Her intellectual debt to Spencer is particularly clear with respect to views of the capacity and future of the Territory and its Aboriginal people.

Spencer the scientist

As many scholars have argued, Baldwin Spencer played an important role in shaping ideas about Australian Aboriginal people and their culture, including through his

innovative and effective use of visual media.[10] His representations of Aboriginal people provided the basis for both local policy and for international theories about humankind. Understanding how his work was drawn into these discourses helps us to shift analytical emphasis from the metropolis to the ways in which such formulations constitute the political rationalities of colonial governmentalities – in Foucault's terms, those historically constituted complexes of knowledge/power that determine how relations are established between political rule and other techniques, objects and instruments in the field of colonial power.[11] During the late nineteenth and early twentieth centuries, the relationship between anthropology and the law became closely linked, constituting colonial subjects and populations as objects of knowledge and sites of intervention. Such governance constituted a continuum extending from political government, including the judicial system, through to forms of self-regulation, judging some populations to be below the threshold required for freedom's rule to be applied.[12] Spencer is often considered to embody the link between disciplinary knowledge and state power through his influential position as scientific authority on Aboriginal people, which led to his appointment to the key official posts of director of the Museum of Victoria in 1899 and Protector of Aborigines in the Northern Territory in 1912.[13]

He had trained as a biologist and worked with the evolutionary typologies of the Pitt Rivers Museum in Oxford, where he was a pupil of Edward Tylor, the leading British anthropologist of the nineteenth century and adherent of evolutionary anthropology. For Tylor the principles of social development assumed that 'the institutions of man are as distinctively stratified as the earth on which he lives'.[14] Following in this paradigm, Spencer was to profoundly influence contemporary theories on social evolution through his professional ethnographies, popular syntheses and government reports. Fundamental to his work was the translation of the scientific theory of natural selection into human terms, encouraging popular notions of biological difference between so-called 'races' of men and specifically arguing that Aboriginal people represented 'humanity's childhood', preserving a primitive stage in the development of humankind.[15] In this view, the 'authentic' people of remote Australia who continued to lead a traditional way of life were of scientific interest, but those who had changed and adopted aspects of Western lifestyle were not: so in 1892, he had visited Ebenezer Mission in northwestern Victoria, but found its well-dressed, Christian residents of little interest.

Spencer joined forces with Central Australian telegraph operator Francis Gillen (1855–1912) in 1894; together, the pair pioneered an anthropological approach founded on extensive ethnographic fieldwork, facilitated by Gillen's familiarity with Arrernte language, and the use of new photographic and film technologies. Their first book, *The Native Tribes of Central Australia* (1899), 'took the scientific world by storm'.[16] As George Stocking shows, Gillen and Spencer were pivotal in the disciplinary transition to fieldwork and participant observation, while the rich collections of cultural data they amassed were of intense interest to metropolitan 'armchair anthropologists' searching for the origins of marriage, religion, law and other social institutions.[17] As Malinowski declared in his glowing review of their popular two-volume *Across Australia* (1912), 'The monumental works of Dr Frazer, as well as the piercing analysis and brilliant conceptions of the late A. Lang, owe their leading features to the "howling and naked savages" of Central Australia.'[18]

Spencer the protector

As Special Commissioner and Chief Protector of the Aborigines, Spencer travelled throughout the Territory during 1912, submitting a report in mid-1913. This began with a standard Spencerian definition of the Aboriginal people of the Territory, who had 'no idea whatever of the cultivation of crops nor of the domestication of animals'. He concludes of 'the native': 'In this respect he is far lower than the Papuan, the New Zealander or the usual African native, all of whom have reached the agricultural stage and live in villages or compounds surrounded by their crops, with a more or less permanent food supply and therefore also with time and thought to spare for other branches of work.'[19]

Reprising older notions of human development as progress through different stages of development, Spencer was also systematic in applying an evolutionist approach to Aboriginal people. As well as preserving an early stage of human development, Spencer emphasized the 'child-like' character of Aboriginal people whom he considered 'a very curious mixture; mentally, about the level of a child who has little control over his feelings and is liable to give way to violent fits of temper… . He has no sense of responsibility and, except in rare cases, no initiative'.[20] The report made wide-reaching recommendations, including control over the Aboriginal population's movement, employment, 'half-castes', reserves, education and legal jurisdiction. It was obsessed with segregation – of Aboriginal people from 'Asiatics', of 'half-castes' from 'wild' Aboriginal people, and undesirable white from Aboriginal. For those leading a traditional way of life, he advocated reserves.

Patrick Wolfe has argued for the pernicious effects of Spencer's 1913 report and its recommendations for the 'half-caste', implicating him in developing the policy and legislation of assimilation known today as the Stolen Generations, but this very much overstates its public impact.[21] Although Spencer's eminent status as an authority on Aboriginal culture indeed prompted his appointment as Aboriginal Protector at a key nation-building moment, his 1913 report was tabled but ignored.[22] More importantly, Spencer's 1913 report echoed the views and recommendations of a number of predecessors: since the 1890s protectors had been arguing against interracial relations and especially contact between Aboriginal people and 'Asiatics' in the north.[23] However, his report marked the inception of an era of growing legislative and administrative restriction over Aboriginal lives, especially those defined as 'half-castes'.

Given his determined focus on 'wild' Aboriginal people, this was perhaps Spencer's first serious encounter with 'half-castes', and Russell McGregor suggests that his views on the extent to which the fringe-dwellers had retained their traditional culture were contradictory, even within the Preliminary Report.[24] These contradictions become explicit in the context of further discussion of the Territory's future as expressed through their popular dissemination by Masson, whose account 'translated' Spencer's evolutionist ideas into popular parlance and naturalized their logic.

Masson the 'First White Woman'

Elsie Masson arrived in Darwin in 1913, after Spencer had left, but she visited many of the places he had been before her, and his review of *Untamed* reveals their furious

agreement. Spencer's review was a vehicle for his own concerns, such as the need for white women to populate the north, the development of transport links to Darwin, the natural separateness of racial 'worlds', and the injustice of the British legal system when dealing with cultural difference. He likened *Untamed* to Mrs Aeneas Gunn's 1902 bestseller, *We of the Never-Never*, which he had also praised, recounting her experiences at Elsey Station, near Mataranka, south-east of Darwin. Gunn's novel, he wrote,

> was simply the experience of a woman who had the courage to go out into the northern wilds and build up a home there, but it gave us our first idea of life in the 'Never Never' country from a woman's point of view. Now we have Miss Masson's book, the work of another woman who has also felt the strange fascination of what she has most happily called 'An Untamed Territory'. Mrs. Gunn has brought home to us the manner of life on an outback station. Miss Masson has written with a different and in some respects a wider and more general outlook, because she has had the chance of seeing more and going farther afield.[25]

Spencer's 1913 report had urged the need for white women to go to the Territory in order to counter interracial relationships, recommending that all officials be married men and even suggesting women protectors.[26] Masson was adventurous in visiting some of the sights of the Territory as the only passenger aboard the steamer *Stuart*. She visited the remote Oenpelli (now Gunbalanya) in Arnhem Land, receiving a warm welcome as 'the one white woman, the first seen by the women of Oenpelli, Mrs Cahill and her niece, for three years … [which] caused great commotion'.[27] In addition, Masson wrote a report for Spencer on the Roper River Mission, established in 1908 by the Church Missionary Society at Mirlinbarrwarr, now known as Ngukurr.[28]

Spencer quoted approvingly from Masson's first chapter, 'A Woman's Life in Darwin', which asserted, 'On the woman no less than on the man depends the success of a great venture such as the civilisation and development of the Northern Territory,' and commented, 'She touches here upon a question of vital importance. We have heard a good deal about the possibility of white men living in the Territory, but very little about white women, and yet from the point of view of settling this empty country the question of whether women and children can live there is the main problem to be solved.'[29]

Masson reported on the trials of keeping house in the tropics and provided intimate portraits of her dealings with white, Chinese and Aboriginal servants. Her private collection, now held in the Pitt Rivers Museum at the University of Oxford, also includes many photographic portraits seemingly made by Elsie herself, which are distinctive in naming the subjects and sometimes recording details about their lives; however, they are also racially segregated, locating their subjects within their place of work, such as the picturesque Chinese cook and laundryman, Dhobie, white residence staff, and 'No More' and his buffalo (Figure 5.3). This assemblage defines a domestic racial hierarchy and naturalizes the place of each worker within it.

She focuses especially on the 'missis' of the house's humorous trials with the 'black boy' who needs constant management and unexpectedly 'goes bush' (Figure 5.4), and a small Larrakia family of whom she concludes: 'Simple, merry folk, docile but never cringing, frequently exasperating but endlessly amusing, they know a sure way to gain affection,

Figure 5.3 Dhobie. Wayne Collection, Copyright Pitt Rivers Museum, University of Oxford,. 1998.306.11.

the way of a responsive, artless child.'[30] Her portrait of Aboriginal housemaid Nellie is framed by a humorous account of her 'strange' dress sense and her 'hideousness', but 'soon she forgets her first repulsion, and finds the good-humoured face almost comely, and an easy grace beneath the ugly one-piece cotton dress' (Figure 5.5).

On one level, Masson's position evokes the imperial myth of the 'good fella missus' – the maternal white mistress whose benevolence and authority legitimates her racial control.[31] As Katherine Ellinghaus has argued of Gunn's writing, its silences and harmonious familial stereotypes masked the brutal realities of the frontier, much as the author herself adhered to contemporary conventions of propriety – even while she flouted them by going to the outback at all.[32] Yet the ambiguity of white women's position in imperialism has been summed up by Anne McClintock, who argues that 'the rationed privileges of race all too often put white women in positions of decided – if borrowed – power, not only over colonised women but over colonised men. As such, women were not hapless onlookers of empire but were ambiguously complicit both as colonisers and colonised, privileged and restricted, acted upon and acting.'[33]

As a consequence, Victoria Haskins has persuasively suggested that 'we might consider how "resistance" of white women to colonialism might arise subversively out of their discursive and performative engagements with Aboriginal people, and especially out of collaborative exchanges with Aboriginal women, through which the ambivalences of their "white woman" identity become evident'.[34] This is how I understand the insistent recurrence of Masson's transition from repulsion to respect, which takes place again and again as she describes her developing relationships – with her Chinese hawker, whose strange vegetables the household learns to enjoy, the Aboriginal maidservants, and finally even black men accused of murder. Her ambivalence is echoed in some of Spencer's own

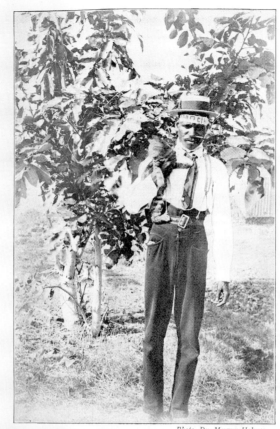

Photo, Dr. Mervyn Holmes.

A DARWIN HOUSE BOY.

Figure 5.4 Mervyn Holmes, 'A Darwin House Boy', Elsie Rosaline Masson, *An Untamed Territory* (London: Macmillan, 1915), opposite, 48.

contradictory claims about Aboriginal people, as his insistence on Aboriginal primitivism and eventual extinction is contradicted or relativized by acknowledgement of Aboriginal humanity. For Spencer,

> Perhaps the best chapter in the book is the one called 'Undercurrents', in which life in Darwin, 'made up of many little worlds, each continuing in its own way, impinging on, but never mingling with, the others', is described. 'There is the life of white officialdom, the Eastern life of Chinatown, the life of the pearling fleets, and, under all, the life of the native camps … a visitor may walk into a party of blacks crooning soft corroboree songs to themselves; then he may suddenly come upon a small joss-house guarded by chipped stone dragons, with its gaudy gilt fretwork, waxen images, and pewter bowls, glimmering through the incense thickened air; and, looking out to sea, his eye may light on a fleet of pearling luggers, sailing lazily home like a flock of tired birds against a sunset sky.'[35]

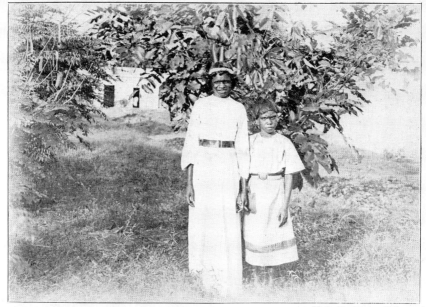

Photo, Dr. Mervyn Holmes.

NELLIE AND ONE OF HER FRIENDS.

Figure 5.5 'Nellie and one of her friends', Masson, *An Untamed Territory*, opposite, 49.

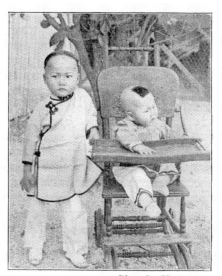

Photo, Dr. Maplestone.

CHILDREN OF CHINATOWN.

Figure 5.6 'Children of Chinatown', Masson, *An Untamed Territory*, opposite, 30.

Here, Masson's relish of exoticism softened the harsh racial segregation implemented by Gilruth, Holmes and their coterie through new legislation and regulations. Gilruth quickly became unpopular with the heterogeneous Darwin population due to his heavy-handed race and class governance, founded on Spencer's views on race.[36] Although officials saw hybridity and cultural difference in negative terms, as evidence for miscegenation or deviation from the white norm, this did not preclude the enjoyment of a romantic tropical aesthetic (Figure 5.6).

This pleasure was suffused by an elegiac tone contrasting the future, and its productive scientific rationality, with all the loss it would necessarily entail: a pioneer past, the picturesque confusion of polyglot Darwin, and above all, Aboriginality, or the 'passing of the Aborigines'. Poised on threshold of a transformed – tamed – Territory, Masson envisages herself riding a Modernist wave that sees and simultaneously destroys the past. As Meaghan Morris has noted of journalist Ernestine Hill's 1930s travel writing, its descriptive form also implies death: Hill laments the demise of pioneer Territory culture, representing 'death as a condition of colonial empirical narration', and construing the Northern Territory as 'a gorgeous charnel-house'.[37] Masson, too, assumes this nostalgic stance, contrasting moments of modernity, such as the first car trip in the Northern Territory, with a visit to Port Essington, whose lonely ruins signify a failed experiment, far from the 'civilisation, population and prosperity' of the rest of Australia (Figures 5.7–5.8).[38]

Masson's chief lament, however, is for a passing Indigenous way of life. She attends a 'corroboree', and as she walks away, its sound is drowned out by a neighbouring piano and the 'strident strains of a gramophone', 'prophetic, so it seemed to us, of the fate of this primitive people, relic of a bygone era'.[39] This view was axiomatic: as Spencer had

Photo, Professor Baldwin Spencer.

THE MOTOR-CAR IN THE BUSH.

Figure 5.7 Baldwin Spencer, 'The Motor-Car in the Bush', Masson, *An Untamed Territory*, opposite, 85.

noted, 'One thing is certain and that is that in all parts where they [Indigenous people] are in contact with outsiders, especially with Asiatics, they are dying out with great rapidity.'[40] Such passages are illustrated by Spencer's photographs, such as 'The Corrunbuck', now known as the didjeridoo (Figure 5.9) and 'Blacks at Corroboree' – images that record a traditional way of life and that obscure any signs of contact with Europeans. Books

REMAINS OF COMMANDANT'S QUARTERS AT PORT ESSINGTON.

Figure 5.8 Baldwin Spencer, 'Port Essington', Masson, *An Untamed Territory*, opposite, 129.

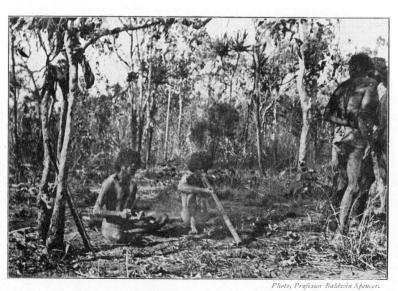

Photo, Professor Baldwin Spencer.

THE CORRUNBUCK.

The hollow pipe that accompanies the chant of a corroboree.

Figure 5.9 Baldwin Spencer, 'The Corrunbuck', Masson, *An Untamed Territory*, opposite, 61.

about people on the brink of extinction were highly marketable at this time, including Spencer and Gillen's own works, and were given ethnographic authority by the detailed observation of 'tradition' captured by participant observer, and especially his camera.[41] Photography concentrated this sense of imminent Aboriginal disappearance; since its invention, the medium has been likened to embalming or autopsy and worked here to signify the passing of Aboriginality.[42]

Spencer the humanist?

Despite his explicitly hierarchical view of race, Spencer also argued for the existence of an autonomous and coherent Indigenous moral and legal order. For example, under the heading 'morality and general character of the Aboriginals', he wrote:

> It is not infrequently stated by white settlers that the natives have no morality. This is, of course, entirely untrue – that is, of aboriginals in their normal state, before they have been degraded by contact with a civilization that they do not understand and from which they need protection. Their moral code is a very different one from ours and certainly permits of and sanctions, practices which, in some cases, are revolting to us, but there are others, such as their strict law in regard to what woman a particular man may marry, and vice versa, which it is a serious mistake to interfere with until we can give them something better and something that they can understand.[43]

Spencer also wrote an odd paean to Aboriginal 'heroes', arguing that 'many aboriginals are possessed of qualities and perform actions that would call for warm admiration and appreciation if exhibited or done by whites'. These included the actions of a man called 'Neighbour' in saving the life of a policeman who was taking him to prison.[44] Yet in a jarringly hostile commentary, he continued:

> It is only also fair to add that one could relate many equally heroic deeds done by white men and women in the Northern Territory; in fact, more heroic because such things mean more to a white man that they do to an aboriginal. But they serve to show that the latter is capable of what we regard as truly unselfish action – of disregarding his own interests, and even risking his own life to help someone else.[45]

He immediately went on to describe particularly 'savage' practices, as if to insist on their essential primitivism. His illustrations were taken from his ethnographies, portraits of unclothed, decorated people artlessly posed, individually or in groups. Although Spencer is sometimes considered a more liberal observer than his racialist contemporaries, such representations of Aboriginal people consolidated their subordinate and subhuman status, although in oddly ambivalent ways.

Despite Spencer's premise of Aboriginal primitivism, an uneasy oscillation marks acknowledgement of evidence that challenged this formulation – such as in several

of his ethnographic books, including his popular *Across Australia*, which began by stating:

> It is extremely difficult to convey in words a true idea of many of the native ceremonies. Any such description is apt to give the impression of a much higher degree of civilization or, at least, of greater elaborateness than is really the case. It must always be remembered that though the native ceremonies reveal, to a certain extent, what has been described as an 'elaborate ritual', they are eminently crude and savage. They are performed by naked, howling savages.[46]

Some scholars have argued that the very wealth of detail captured in Spencer and Gillen's ethnographies created an internal textual dissonance that challenged the logic of evolutionism: anthropologist Elizabeth Povinelli, for example, suggests that despite the graphic and, especially to a Victorian reader, shocking details of Arrernte sexual practices, these anthropological accounts nonetheless exceeded interpretations of 'savagery' and affirmed Indigenous humanity.[47] Although it is difficult to assess such claims regarding contemporary reception, these textual instabilities point to ways that Spencer and Masson and their readers both subordinated yet simultaneously acknowledged the coherence and substance of Aboriginality.

The murder of Jim Campbell, 1913

Masson's views themselves evolved in response to the trial of nine Aboriginal men for the murder of a white trepanger, Jim Campbell. This event concludes her book and clearly loomed large in her Northern Territory experience. As I described at the beginning of this chapter, she had been a passenger aboard the steamer *Stuart* as it headed towards the entrance of Port Essington, when a small lugger approached, and a white man shouted the news of the murder of trepanger Jim Campbell.[48] Her visceral response, 'a thrill of rage … a sudden instinctive spasm of hatred of white for black', remains unusual and powerful in its candid confession of race hate. Like the moment in *Heart of Darkness* when an African 'boy' announces 'Mistah Kurtz, he dead', for Masson this moment marks an ambivalent moment of reckoning with the other.[49] Her 'rage', however, is immediately tempered by a discussion of Campbell aboard the steamer in a complex passage worth reproducing in full:

> 'He was one of them cattle-stealers on the Victoria River,' said one. 'He went to Junction Bay to get out of the way of the police. He used to collect trepang there. Oh, the blacks are not too good at Junction Bay!'
> 'Who was Jim Campbell? One of the best!' exclaimed another with enthusiasm – 'One of Australia's best. He got into trouble somewhere inside, and came to the Territory some years ago. It's a wonder the blacks didn't get him before. They're not too good at Junction Bay.'

That there was another side to it, the side of these Junction Bay natives, who did not suffer from any excess of virtue, was shown by the remark made by a little South Sea Islander who came aboard at Port Essington. Himself a trepanger, living alone with his blacks hundreds of miles from any dwellings of white men, yet he did not seem at all disturbed by the news. 'My friend Jim Campbell, he very rough on blacks,' was all he said.[50]

Here, the very softness and dispassion of the 'little South Sea Islander' gives him authority and tells the reader whom to believe. Masson's sympathy for the Territory's Aboriginal people is awakened through this violent clash and its judicial aftermath, as she attended the trial and followed proceedings. This event also maps the close relationship between anthropological and legislative frameworks over this period, the crucial role of law in governance, and the ways that changes in the structure of governance affect the relative social significance of law within situations of legal pluralism.[51]

In July 1913, Gilruth telegrammed the Secretary of External affairs in Melbourne to report the spearing and tomahawking of Clare Ernest ('Jim') Campbell at Junction Bay, 30 km west of Maningrida in Arnhem Land. A 'Malay' man and Aboriginal people working with Campbell took his body to King River, near Darwin, where the co-owner of their lugger, Charles Williams, examined and buried his body.[52] The event was quickly reported in newspapers across Australia, and Campbell was initially described as 'a reckless, generous, kind-natured man' who had been wanted for cattle-duffing near Victoria River Downs.[53] A month later, officials brought nine Aboriginal men back to Darwin, arrested on suspicion of involvement in the murder.[54] In mid-September the trial of Nundah, Namarangarie, Lemerebee, Wharditt, Terrindillie, Meeboolnan, Warangeah, Angoodyea and Daroolba took place. Fifteen witnesses were called, including eleven Aboriginal people, constables Cameron and Johns, Mr Williams, and a South Sea Islander called Alex. Four spoke no English and their evidence was interpreted.[55]

In her account of the trial, Masson noted the Aboriginal people's difficulties under the British legal system, including the language barrier and a tendency to incriminate themselves: for example, two suspects had come to the police camp because they had heard that they were wanted; in court when witnesses such as Ada were asked to identify the accused, the latter helpfully identified themselves. These problems were couched in humorous terms, with the naïvety of the Aboriginal people tipping over into satire. Readers found the use of 'Aboriginal Lingo' in the courtroom especially entertaining, as when English reviewers were said to have 'picked out with amused curiosity' the way in which the judge administered the oath to one of the witnesses. Masson recounted that the judge said, pointing to the prisoners:

'Now, Ada you savvy those blackfella there?' 'Yasa, me savvy.' 'You see those white gentlemen there?' (motioning towards the jury). 'Yasa, me see'em.' 'All right, Ada. Now: you tell those gentlemen all you savvy about those blackfella. And you talk straight fella.' 'Yaas.' 'And loud fella.' 'Yass.'[56]

Masson's satirical, layman's description of the cultural misunderstandings that characterized proceedings translated legal problems into humorous and everyday terms,

with the effect of trivializing what, for the Indigenous participants, was a deadly serious ordeal. Yet despite this narrative technique, she employed several countervailing strategies that expressed sympathy for the Indigenous prisoners and detailed their unfair treatment by the justice system. Her arguments echo Spencer's report, published just a few months earlier (in July 1913) and its recommendations for reform.[57] What is particularly notable about Masson's account of the trial is her use of photographs. She noted that the fifteen witnesses included 'the wives of the prisoners with their babies' and reproduced medical officer Mervyn Holmes's group photographic portrait, showing them clothed, standing in the Darwin Kahlin Compound where they were living, a new facility driven by Spencer that was at that time a showpiece of transformation and civilization (Figure 5.10). The children are naked and chubby, sitting astride their mothers' shoulders.

Masson described the prisoners in detail, reviewing the cultural misunderstandings that characterized the trial, and again reproduced Holmes's portraits of them, with the men

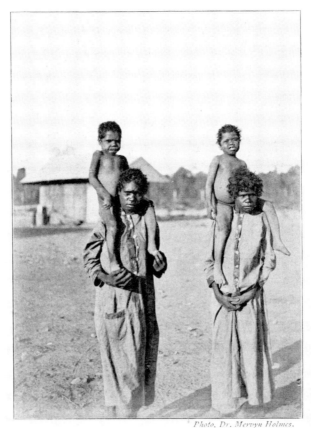

Photo, Dr. Mervyn Holmes.

THE WIVES OF THE PRISONERS AND THEIR BABIES.

Figure 5.10 'The wives of the prisoners and their babies', Masson, *An Untamed Territory*, opposite, 163.

holding up blackboard signs chalked with their names. Although these resemble mug-shots, they have the effect of making these figures real, bringing their human presence into the more abstract and distancing account of the trial (Figure 5.11).

The witness Ada, a Hodgson Downs woman who had worked for Campbell for four years, described how Campbell and his ten companions had been trepanging one night when he was attacked. She told the story of how Campbell had 'punished' an old man named Nadjimo by putting him into a trepang boiler, causing a painful death.[58] Retaliation for Nadjimo's death was the principle cause of Campbell's murder.

Masson's photograph of trepang boilers provided graphic testimony to this agonizing assault, showing the large metal cauldrons lined up along a beach (Figure 5.12). Her photographs performed two parallel functions: first, they asserted the humanity of the Aboriginal people – showing not just the accused but their families, revealing the familiar

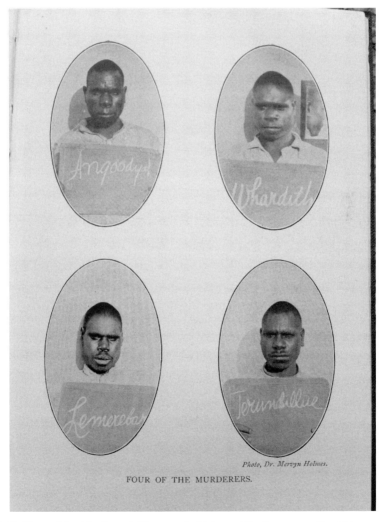

Photo, Dr. Mervyn Holmes.

FOUR OF THE MURDERERS.

Figure 5.11 'Four of the Murderers', Masson, *An Untamed Territory*, opposite, 164.

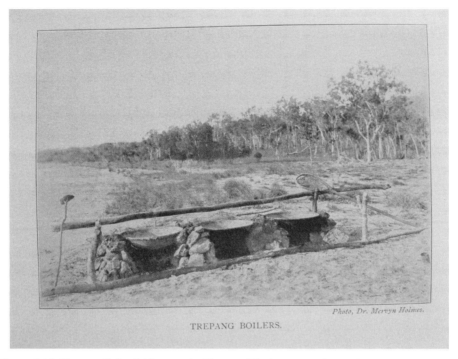

Figure 5.12 'Trepang Boilers', Masson, *An Untamed Territory*, opposite, 168.

social relationships of a universal humanity. They wore clothing, and the women and children stood in the local Kahlin Compound. Second, the photograph of the trepang boilers documented atrocity, pointing towards the vulnerability of Aboriginal people to white cruelty. They show a crime scene, the aftermath of torture and death. These twin strategies of the evocation of a universal humanism and of forensic proof were a powerful combination; they presage the tactics of the Congo Reform Association, as the next chapter explores. Masson's account constituted a relativist conception of Aboriginality, and ultimately argued for the need to acknowledge the autonomy and coherence of Indigenous tradition, and what today is termed customary law (or customary systems of law [CSL]).

The judge found that Namarangarie, Warangeah, Meelboolnan and Nundah were not guilty, but the remaining five men were sentenced to death.[59] However, many agreed with Spencer's 1913 report, tabled a few months earlier, which denounced the 'unfair position occupied by Aboriginal prisoners as compared with white men'.[60] Parliamentary debate ensued, and Patrick Glynn, the Minister of External Affairs, was asked whether he would delay the execution until further examination of the matter.[61] In November 1913, their sentences were commuted to imprisonment for life with hard labour.[62]

Masson asked,

Who can blame them for what they did? Who can say they committed a crime in ridding themselves of this cruel intruder into their bush world, who acted toward them with deliberate brutality? … It is to be feared that only too often the savage black who

commits an act of violence is only avenging equal outrages done to his own race by the savage white.[63]

Such arguments prompted a relativist sympathy for the Indigenous people, picturing them as exploited and ill-treated by the intruder. She concluded with the suggestion that the event may have signalled the intrusion of white civilization into the Aboriginal world, in which case 'the death of the white man will be well – too well – avenged'.[64] Sympathetic as she was, like Spencer, her view was premised on the inevitable extinction of the 'primitive' black race before the onslaught of the white. Masson's account of the case skilfully guides the (white) reader from shared, visceral feelings of racial solidarity to a relativist position that acknowledges the cruelty or 'white savagery' of the murder victim, and the humanity of the accused, however undeveloped and childlike. Her argument broadcast the views of the close-knit circle of officials linked to Gilruth during these early years of Commonwealth administration, including Spencer, Holmes and Supreme Court Judge Bevan. As Spencer's review of *Untamed* concluded,

> To those who are interested in the Blackfellow the two last chapters can be warmly recommended. The account of the trial of the natives who speared Jim Campbell is particularly good, and though no other verdict than guilty could have been given under the white man's law, except that the words 'with extenuating circumstances' might well have been added, yet, under that of the blackfellow the natives were perfectly justified in what they did … Jim Campbell richly deserved his fate and it is notorious that those who cruelly ill-treat the natives as he did almost invariably end their lives in the same miserable way. Sooner or later these natives will go back to their country proud of the distinction of having been in Fanny Bay. Until such time as there is a special court to deal with these wild and semi-civilised natives, just as we have children's courts amongst ourselves, and a special place of detention for them, there is little chance of dealing justly and effectually with the native problem.[65]

Law, race and anthropology

Since the 1992 legal recognition of native title in Australia, popularly known as Mabo, there has been considerable research on the uses of colonial common law to assert British jurisdiction as a technology of sovereignty. Mark Finnane has explored how the law has dealt with the 'reality of persisting Aboriginal difference in customs, norms and perspectives', tracing the instability of a relativist acknowledgement of cultural difference in the policing and court systems.[66] In the Northern Territory, the reinvigorated expansion of white settlement after 1911 led to increased interracial violence, and the influx of officials from the cities of the south led to a new apparatus of law, administrative practices and ideas beginning to be established, including formal justice mechanisms.[67] As a jurisdiction overseen by the national government and forming a majority Indigenous population still leading a largely traditional way of life, the Territory posed a new set of practical challenges for the administration of criminal justice.[68]

In 1913, Judge Bevan of the Supreme Court pointed out some of these complexities in extending legal jurisdiction over the new frontier, and particularly the injustice caused by prejudiced white juries. He predicted that Aboriginal people would lose faith in white law, leading to the escalation of violence, with further white casualties and the eventual 'extinction of the blacks' – a chain of events that he believed threatened the Territory's future.[69] These difficulties were exemplified by a sequence of well-publicized trials of Aboriginal men, and in particular two almost simultaneous Darwin murder trials. In *King v Lindroth* (1913), a white man was acquitted of killing an Aboriginal stockman, in what was considered a 'scandalous miscarriage of justice', while as Masson detailed, five Aboriginal defendants were convicted of killing Jim Campbell in *King v Nundah and Others* (1913). Both trials depended on Aboriginal witnesses and expressed the common white Territorian's view of Aboriginal people, that, in Judge Bevan's words, 'a "nigger" is something a good bit lower than a dog, to be exploited and used for his own purposes'.[70] Bevan, Gilruth, and Spencer's successor, Protector Stretton, recommended abolishing juries in criminal trials in the Territory.[71] Bevan proposed the institution of a trial by a judge and two assessors, influenced by his colleague Lieutenant-Governor of Papua, Mr Justice Herbert.[72]

The Minister Patrick Glynn disagreed, and considered that these trials would have ended in the same way had they been tried before southern juries, 'though fully conscious, as they should be, of the equal sacredness of life in all human beings and of the clear and equal rights of the aborigines to protection'.[73] However, these problems, all identified by Masson, continued, as late as the 1960s.[74] Unsurprisingly, Spencer's July 1913 report concurred with Gilruth's and Bevan's views, but where Bevan wanted merely to amend the legal system to remove white racist juries, Spencer went further to argue for recognition of what today is referred to as customary law, although only among the 'wild Aboriginals'. Spencer argued for allowing 'their own customs' to prevail among 'wild blacks' and even those 'coming under the influence of civilisation', pointing out the unfair position of black prisoners, 'as compared with white men' and detailing all the features Masson had criticized in *King v Nundah*.[75] These systems of law, policy and anthropology were profoundly imbricated, and as I have tried to show, via Masson's popular yet informed account this complex apparatus of governance was communicated to a general audience.

Masson's narrative of life in the newly separated Territory was also a means of exploring a modern, white future for the north, with the corollary of the extinction of the Aboriginal population. Following Federation in 1901, the new nation of Australia was an ardent adherent of the global 'religion of whiteness' that worked in concert with other countries in a transnational economy of 'people and ideas, racial knowledge and technologies' to exclude non-white peoples.[76] However, Masson's narrative also exposes the instabilities within the apparatus of racial science and colonial governance cemented into place during these years. Through her growing engagement with the Indigenous people she encountered, she aimed to arouse sympathy for and acknowledgement of what Minister Glynn had asserted were their 'clear and equal rights … to protection'.

6

'A RAY OF SPECIAL RESEMBLANCE': H. G. WELLS AND COLONIAL EMBARRASSMENT

[Photographs] send out a ray of special resemblance and remind one more strongly of this friend or that, than they do of their own kind. One notes with surprise that one's good friend and neighbour X and an anonymous naked Gold Coast negro belong to one type, as distinguished from one's dear friend Y and a beaming individual from Somaliland, who as certainly belong to another.

H. G. WELLS, *A Modern Utopia*, 1905

This chapter explores how ideas about a vision of a shared humanity, the basis for humanitarianism and the development of human rights, emerged through the networks and flows of British imperialism. The 1904 Royal Commission inquiry into the administration and treatment of Aboriginal people in Western Australia, headed by anthropologist and administrator Walter Edmund Roth, documented terrible conditions for Indigenous people.[1] Published late in the year, Roth's Report presented the shockingly graphic testimony of Aboriginal witnesses who effectively communicated the terror and violence Aboriginal people were subjected to in their own country, and their vulnerability to burning, shooting and rape by 'civilized' representatives of British 'justice'. The report's revelatory public narrative, with its graphic evocation of human suffering, caused huge controversy in both Australia and Britain. Many Australians were horrified, and a vociferous newspaper and humanitarian campaign was strengthened by appeals to a new sense of national honour, following federation in 1901. Sympathizers with Aboriginal people in WA's northwest had limited success in their attempts to draw upon photographic evidence to document Aboriginal suffering. Their failure forms a striking contrast with the powerful deployment of photographs of colonial atrocity by the precisely contemporaneous campaign of the Congo Reform Association (CRA) in Africa. Nonetheless, the Roth Report was extensively debated in Britain, in the context of public concern about labour conditions across the empire. With metropolitan humanitarians framing the report's shocking stories of the suffering Indigenous body as a form of 'slavery', these events in Western Australia were seen to threaten the moral legitimacy of the British

Empire. The treatment of Aboriginal people in Western Australia's northwest thus became part of metropolitan political debates about race, evolution and humanity.

A key figure in these British debates was the popular writer, H. G. Wells. While Wells has often been recognized as a player in the agitation leading up to the 1948 UDHR, discussion of his views on human rights tends to be confined to the years immediately around the Second World War. Yet Wells's contribution to the formulation of a code of human rights was in fact the culmination of his fifty-year-long exploration of the large ideas of his age. An important moment in the development of his ideas was his literary 'thought-experiment', *A Modern Utopia*, published in 1905, which Wells assessed late in his life as 'one of the most vital and successful' of his books.[2] What Wells called a 'ray of special resemblance' expresses a universalizing view of humankind in keeping with the notion of human rights he was to work on in later years.

The 'New Slaveries'

During the early months of 1905, debate in the British parliament and press revealed the extent to which Britain's identity and imperial reputation were at stake in the Western Australian scandal. Public debate considered the colony within the same frame of reference as Belgium's Congo Free State, Britain's Transvaal Colony in South Africa, and the islands of São Tomé and Príncipe. Safeguarding free labour was of central importance in Britain's African colonies, as a marker of progressive colonial rule that distanced Britain from an earlier era of slavery.[3] As Kevin Grant has argued, in the two decades before the First World War, Great Britain witnessed the largest revival of antislavery protest since the legendary age of emancipation in the early nineteenth century. These latter-day abolitionists focused on the so-called 'new slaveries' of European imperialism in Africa, condemning coercive systems of labour taxation and indentured servitude. Grant argues that this form of humanitarianism influenced the transition from empire to international government and the advent of universal human rights in subsequent decades. Both evangelical philanthropists and advocates of human rights shaped British responses to 'the new slaveries' of European imperialism in Africa, illustrating the important role of British humanitarianism in establishing the foundations of twentieth-century international government under the League of Nations.[4]

British parliamentary debate about the Chinese labour question in the Transvaal Colony over the first half of 1905 was interwoven with debate about the Roth Report and highlighted the shame of 'slavery' under colonial rule. In 1904, over 64,000 Chinese indentured labourers were imported to the rich gold mines of the Witwatersrand under what the Trade Union Congress termed 'conditions of slavery', as the British Government sought to rebuild South Africa's economy after the Boer War.[5] This was a deeply unpopular step in a period when general opinion in much of the Western world was hostile to Chinese immigration, and unemployment among British workers was high. In debating the Transvaal Labour Importation Ordinance in February 1904, Herbert Samuel, Member for Cleveland (Yorkshire) asked,

> If the Ordinance passed into law how should we be able to hold up our heads in the face of foreign criticism? The Frenchman and the German would say: 'You English

set yourselves up as teachers of humanity to the world at large. You condemn the harsh Government of Russia, you pass resolutions against the cruelties of Turkey, you circularise the Powers about the administration of the Congo Free State, but look at your own newest colonies; see how you keep your unskilled labourers there – like beasts in a stable – prisoners in gaol, like what Mill once called a "human cattle farm"'. He did not think that would redound to the greatness or glory of the British Empire, that it would add to its prestige, or raise the honour of its name.[6]

Debate moved back and forth between the Roth Report and the Chinese in Transvaal, drawing direct comparisons regarding labour and the treatment of native races in both colonies.

The debate about Western Australia reveals the fluidity of notions of 'slavery' and 'freedom' for contemporary humanitarians and official administrators, who applied abolitionist discourse to many diverse situations and projects.[7] On 30 March 1905, John Campbell, the Irish Member for South Armagh, introduced Roth's findings to the House of Commons in a long and fiery speech. He began by stating that the report 'indicated, in the first place, that the native population in Western Australia were living in a condition of slavery', using 'the word [slavery] advisedly'.[8] Aboriginal men received no wages, and 'when they were incapacitated by old age or infirmity they were turned adrift remorselessly without the slightest provision being made for them'.[9] He described arrest for cattle-killing, the way that male and female witnesses were chained continually from the moment of arrest until the end of the trial and often, if convicted, throughout their sentence. Young women witnesses were systematically 'outraged' (raped), children were not educated, and the police made a profit from witness ration allowances. He read into Hansard the evidence of two Aboriginal witnesses: a boy of fourteen named Boodungarry, and Garngulling, a prisoner in Wyndham gaol, who told how a police officer, Inglis, had threatened him at gun-point and raped Aboriginal women.[10]

The question of the independence of Western Australia, which was granted control over Aboriginal affairs only in 1898, was highly sensitive.[11] As Alfred Lyttelton, Secretary of State for the Colonies and a proponent of decentralization pointed out, 'Nobody could defend such a condition of affairs or read of it without a feeling of great abhorrence. But hon. Members would remember that they were dealing with a self-governing colony which as regarded its internal affairs was substantially independent.' It had been Lyttelton's controversial decision to import Chinese labour to the Transvaal: on this occasion, he argued that the Australian Government were 'conscious of the evils which existed [and] desirous of dealing with the matter with thoroughness and expedition'.[12] Canadian-born Conservative Gilbert Parker (Gravesend), who had spent time in Australia including a stint working for the *Sydney Morning Herald*, suggested briskly that 'they should not grow too sentimental over even such a state of things as had been described'.[13] Western Australia's shame was a direct reflection on Britain's own honour, and contemporaries seemingly did not perceive a disjunction between upholding colonial independence and yet applying 'sympathetic pressure' on colonial opinion. As the Lord Archbishop of Canterbury put it,

Though the matter is one which immediately concerns Western Australia, it does concern the whole of the British Empire. We have always believed, and prided

ourselves in the belief, that we of the British race have some peculiar gift – it has been proved a thousand times in India and elsewhere – for dealing with the extraordinarily difficult problem of government of races other than our own; and I venture to think that a Report of this kind, while it comes to us as a rude shock, is satisfactory in this, that it is unique in its character.[14]

The British Foreign Minister, Lord Lansdowne, by contrast with the unsentimental Parker, had read Roth's report 'with feelings of deep indignation, and also with feelings of humiliation', because, to his mind, 'one of the most mortifying features of these incidents is that they will, in the future, deprive our remonstrances of a good deal of the force that they have hitherto commanded'. Imperial humiliation regarding Western Australian 'slavery' undermined British moral legitimacy and hindered the work of the Congo reform campaign against slavery and atrocity in Africa. In March 1905, at the time of the House of Commons debate, the British Foreign Office explained its reluctance to act against the Congo colonial administration by referring to its embarrassment about Western Australia. Lansdowne wrote of the Congo scandal, 'Ghastly, but I am afraid the Belgiums will get hold of the stories as to the way the natives have apparently been treated by men of our race in Australia.'[15] The British-based humanitarians of the CRA also acknowledged that Australian controversy was a threat to their own interests in Africa, with one warning, 'Do not let us forget, Chinese labour, West Australian irregularities, and Nigerian expeditions are the deadly foes of our Congo movement.'[16]

Photographing atrocity in the Congo

The accusation that Leopold's regime of terror in the Congo was a 'crime against humanity' represented a radical new conception of an international political community that transcended sovereign law. This humanitarian campaign was tremendously successful in mobilizing support in Britain and North America, effectively deploying photography as a central strategy. In 1904, journalist Edmund Morel formed the CRA in response to reports and photographs of the brutal treatment of the Indigenous population of the Congo Free State under the rule of Belgian King Leopold II. Scholars have recently claimed that this episode marked the emergence of photography as witness to colonial atrocity – chaining, flogging and mutilation – and was a turning-point in the development of human rights.[17] Mark Twain's 1906 *King Leopold's Soliloquy* presented Leopold's imaginary rumination on the campaign, in which he cursed the 'incorruptible kodak', 'the only witness I have encountered in my long career that I couldn't bribe'.[18]

Sharon Sliwinski suggests that photography was used in two distinct ways within this campaign – as forensic proof and to evoke a mythical humanism. In the context of an official report, British investigator Roger Casement published forensic photographs of mutilated Congolese children who had been maimed in reprisal for the failure to meet quotas of rubber collection. Sliwinski notes that the CRA's campaign, as expressed by Morel's 1906 *Red Rubber*, advanced a radical conception of the Congolese as rights-bearing people: using the legal language of the General Act of Berlin, Morel argued that

Figure 6.1 'Portrait of Mola Ekilite (seated) and Yoka', c.1904. Courtesy of Anti-Slavery International.

they had been deprived of their rights to land, property and labour.[19] Images such as those of maimed children Mola and Yoka starkly revealed the effects of brutality on these small human beings, at the same time as demonstrating the colonial regime's inhumanity (Figure 6.1).

By contrast, Sliwinski suggests, photographs taken by missionary Alice Seely Harris were used by missionaries, especially in magic-lantern slide lectures, to promote a 'mythic ideal of universal human dignity'.[20] Harris's photo of Nsala records the grieving father looking at the hand and foot of his murdered five-year-old daughter, killed and eaten by 'sentries' of the Anglo-Belgian India Rubber Company (Figure 6.2). Christina Twomey examines the processes of authentication at work in this campaign, pointing out that the photographs emerged from a much older tradition of missionary photography that relied upon narrative framing and missionary endorsement to establish the black subjects' credibility. As she notes, the story about Nsala focused attention on the father's grief, and endowed him with a common humanity.[21]

Indeed, Nsala's image brings together both the forensic power of the atrocity image and an inclusive universalism. As many have noted – for example, of *Uncle Tom's Cabin*'s fictional yet compelling cast of characters – transforming the anonymous, suffering black body into an individual through sentimental narrative was an effective means of personalizing ill-treatment and creating proximity between viewer and viewed. As Thomas Laqueur argued, a humanitarian tradition of detailing 'the pains and deaths of ordinary

Figure 6.2 Alice Harris, 'Nsala looking at the severed hand and foot of his daughter', Boali, 1904.
Courtesy of Anti-Slavery International.

people' produced a literary 'reality effect' that was a powerful means of evoking sympathy
and recognition of the other's humanity.[22] Nsala's tragic story rhetorically constituted him
as the object of metropolitan pity, transforming oppressive colonial rule in the Congo into
an 'occasion for benevolence'.[23] In *Red Rubber*, the photograph appears in the concluding
pages, framed by Morel's rising indignation. Morel explicitly rejected sentimentalism – for
example, when he exclaimed, 'No grandmotherly legislation, no sentimental claims are
being urged in their interest. Only justice.' Nonetheless, he condemned Leopold's regime
in passionate terms, urging his readers to assume responsibility for what they saw and
concluding that the 'reek of its abominations mounts to Heaven in fumes of shame'.[24] The
photograph of the grieving father, lost in mournful contemplation, effectively combined
a universalizing sentimentalism with the shockingly gruesome sight of his daughter's
severed body parts, demonstrating how difficult it is to separate the shocking atrocity
image with its message of bodily suffering from a broader vision of humanity.

Witnessing Aboriginal 'Slavery'?

By contrast with the Congo, however, photographs of heavily neck-chained Australian
Aboriginal prisoners were circulated by settler interests as evidence for maintaining the
rule of law, overpowering those humanitarians who sought to liken these conditions to
slavery. Perhaps this can be attributed in large part to imperial, and colonial, humiliation,
which concealed brutality in Western Australia even as campaigners attempted to

expose it, producing scandal at the release of Roth's report. Activists such as the Irish-born Walter Malcolmson claimed that although 'it is commonly believed that freedom exists wherever the British flag flies', after living for several years in the northwest of Western Australia, he had 'no hesitation in stating that brutal slavery is in full swing in this part of the Empire'. In the northwest, where Aboriginal labour was essential to settler industry, Malcolmson described how 'native prisoners' were 'worked in chains, most of them connected in pairs by a chain, the ends of which are padlocked round their necks, the said chains being about 12 feet long, and quite strong enough to hold a pair of bullocks'.[25]

These allegations were upheld by Roth's inquiries, which made detailed investigations of the nature and use of neck-chains, and drew upon photographic evidence for this practice, noting that sometimes in addition to neck-chains, Aboriginal people might be further secured with wrist cuffs, 'as your Commissioner has seen in photographs of constables escorting the chain-gangs'.[26] Against charges of slavery, the pastoralist lobby argued that neck-chains were the most humane method of restraint, fully justified by the need to defend white settlement. The conservative *West Australian* denounced Roth's findings, quoting officials and 'old hands' who challenged the nature of his evidence, and his report, 'so framed as to be the starting-point of a scandal and a scare, rather than the beginning of a sober reformation'.[27] Argument centred upon the status of Roth's evidence, and many drew upon their outback experience to challenge the picture drawn by Roth's report. A former pearler, for example, argued that neck-chains were 'scarcely worse than a modern linen collar, and the total weight of the gear is nothing compared with the loads the native women sling from the neck when in the bush'.[28] Sir John Forrest, premier from 1890 to 1901 and then member of the new federal House of Representatives until 1918, typified the official response in attacking the report's 'somewhat sensational character', questioning whether the neck-chain was as 'inconvenient to the aboriginal as the wrist-chain', and stating that the chains 'are not heavy and are protected by coverings so as to avoid that portion which presses close to the skin being unduly uncomfortable during the hot weather'.[29]

However, many among the church leaders and general population of Perth were shocked and outraged by the inquiry's findings. The Rev. H. Wilkinson of Perth's Charles Street Methodist Church was not alone in delivering a sermon on Roth's report, nor in taking as his text Ecclesiastes 4.1 – 'Behold the tears of such as were oppressed and had no comforter, and on the side of their oppressors there was power.'[30] In exhorting his audience to scrutinize the inquiry's findings and acknowledge the plight of the Indigenous people that it had brought to light, Wilkinson deployed a powerful visual metaphor for the act of bearing witness – an act that implies responsibility towards what one has seen.[31] Nonetheless, such responses betrayed considerable ambivalence, as the citizens of Perth struggled with what they were seeing: Wilkinson agonized over the findings, asking repeatedly, 'Is it true?', and reviewing the evidence for and against its conclusions. As Chris Healy argues, settler colonialism has been characterized by a complex process of recognition and disavowal of Aboriginal presence, as Indigenous people are too often imagined to be absent despite evidence to the contrary. Put differently, the problem is not that settler Australians did not know about Indigenous experience, but that they did not

care to understand it.[32] Local reflections also expressed the fallibility and partiality of the witness, and the widespread anxiety about how to respond to Roth's findings, as settlers were confronted with the colonial paradox that disciplining 'uncivilized' people through the use of force could seem the only way to correct their behaviour, yet violence appeared as the antithesis of civilized government.[33]

Photographs of the Aboriginal prisoners at the centre of this debate were displayed in ways that hindered their appearance as proof of inhumanity, as they were given a limited range of meanings by white settlers within the context of prevailing ideas of progress, Indigenous savagery and white humanity, as well as specific local arguments that neck-chaining was the most humane method of restraint. The pastoralist-owned *Western Mail* was typical in providing a lengthy analysis of the evidence for chaining, and argued that this practice was humane, and indeed necessary to restraining this lithe and athletic people. The writer had 'known of eight out of a gang of blacks run away when chained to wheelbarrows and to each other' and despite immediate pursuit by a horseman, 'they had found some way of liberating themselves'. Its photograph supplement – normally filled with images of rural industry, community and entertainment – featured 'The Treatment of Aborigines – Prison Life in the Nor'-west' (Figure 6.3).[34]

This visual assemblage juxtaposed groups of chained and orderly prisoners marshalled into rows, with newly built police stations and gaols. One prisoner, overlooked by a warder, was captioned 'Lembie – A Notorious Criminal. This aboriginal escaped from Wyndham gaol four times, on the last occasion, releasing 42 prisoners' (Figure 6.4). Other photographs included 'Aboriginal Bathing Gang' and 'A Band of Cattle-Killers en route to Wyndham', each showing gangs of Aboriginal prisoners chained together in heavy neck-chains (Figure 6.5).

Modern viewers, especially within Australia, now respond to these images with shock and disgust. They have become shameful evidence for colonial oppression and inhumanity. 'Aboriginal Bathing Gang' (Figure 6.5) in particular, with its phalanx of grim-faced, defeated warriors, their enslavement signified by the heavy metal neck-chains, has become an icon of colonial injustice as it circulates on social media and in activist campaigns.

However, what is more difficult for us to grasp is that in 1905 many members of the Australian public perceived these photographs as proof of the savagery and primitivism of Aboriginal people, as well as their humane containment by the justice system. Conversely, one journalist vouched for 'The Evidence of Photographs' as proof of the good health of Aboriginal 'matrons' at a remote pastoral station, of whom 'there was no necessity to add that the party was extremely happy. Contentment was written all over the features of these well-fed and well-clothed dames'. This was 'The Other Side of the Picture'.[35] Local narratives of savagery and lawlessness refuted allegations of Indigenous ill-treatment, and blinded contemporary observers to injustice. Throughout the emotive public debate over the treatment of Aboriginal people, photographs of prisoners functioned less as proof of inhumanity than as a means of naturalizing the subjugation of Aboriginal people.

More effective was the use of photographs of neck-chained Aboriginal prisoners in an international scientific and conservationist context, where seemingly less emotional

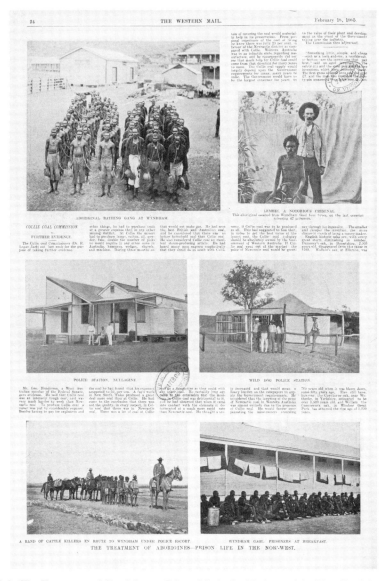

Figure 6.3 'The Treatment of Aborigines – Prison Life in the Nor'-west', in 'The Aborigines Question,' *The Western Mail* (18 Feburary 1905), 12, and *Illustrated Supplement,* 24.

arguments carried more weight. Roth's findings were corroborated the following year by photographs made by the German anthropologist Hermann Klaatsch, following fieldwork at Wyndham in northwestern Western Australia. Klaatsch was a prominent physical anthropologist at the University of Heidelberg who was hosted by fellow anthropologist Roth in Brisbane upon his arrival in Australia in 1904, before travelling around northern Australia for three years.[36] In July 1906 Klaatsch went to Wyndham, and his description of the chaining and maltreatment of the Indigenous prisoners there, presented to the 1907 Adelaide Meeting of the Australasian Association for the Advancement of Science,

attracted international attention. In his lecture, Klaatsch stated that he was 'sorry to have to sustain the correctness of Dr Roth's allegations', finding it impossible to contact the 'wild blacks' around Wyndham because every white person was 'regarded with the dread that the natives attached to police officers, who, in their mind, were likened to dangerous

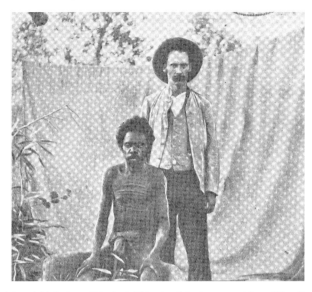

Figure 6.4 'Lembie – A Notorious Criminal. This aboriginal escaped from Wyndham gaol four times, on the last occasion, releasing 42 prisoners', in 'The Aborigines Question,' *The Western Mail* (18 Feburary 1905), 12, and *Illustrated Supplement,* 24.

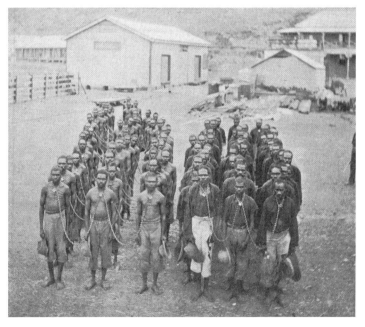

Figure 6.5 'Aboriginal Bathing Gang', in 'The Aborigines Question,' *The Western Mail* (18 Feburary 1905), 12, and *Illustrated Supplement,* 24.

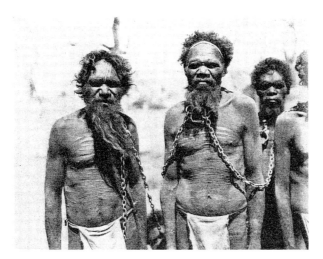

Figure 6.6 Hermann Klaatsch, 'Sclussbericht uber meine Reise nach Australien in den Jahren 1904–1907', ['Final Report on My Trip to Australia in the Years 1904–1907'], *Zeitschrift fur Ethnologie* [*Journal of Ethnology*], vol. 39 (1907): 634–90.

animals'.[37] However, he distanced himself from the emotive local debate by emphasizing his objective view as a scientist. He stated:

> Deeply regretting the extinction of the Tasmanians, I think everyone will agree with me if I suggest that a more enlightened treatment of the Australian aborigines is justifiable on scientific grounds alone, apart altogether from humanitarian questions. My object as a scientist is not to blame any person or institution, but to enlist the services of the white Australians in suggesting more improved methods of treatment of their black brothers.[38]

His photograph of chained prisoners subsequently circulated in Europe as evidence for Aboriginal ill-treatment in the context of an emerging international natural conservation movement (Figure 6.6).[39]

Klaatsch's allegations were taken up by the humanitarian Anti-Slavery Society in its periodical, *The Anti-Slavery Reporter,* and even the *Times*.[40] Underlining Klaatsch's status as eyewitness, the *Reporter* noted that 'in support of his allegation, the lecturer stated that he had witnessed the arrival of native prisoners at Wyndham who had travelled from 300 to 400 miles chained by the neck'.[41]

The view from Britain

When British Members of Parliament responded with emotion to the Roth report, or when the experienced colonial traveller Gilbert Parker urged against 'sentiment', they signalled its effective communication of the suffering of distant Aboriginal people to this audience, and its potential to prompt compassion. No doubt a considerable proportion

of this affective response concerned a sense of the damage done to the audience's own 'honour' – such as when the Archbishop and Lansdowne expressed their feelings of indignation, humiliation and mortification. In a reminder of the ways that emotions may be politicized, Sara Ahmed has argued that the public expression of empathy and shame may absolve the confessor's conscience with the effect of allowing them to 'move on', drawing a line between past and present, victim and self.[42] In this way, humanitarian campaigns have often acted as a potent mechanism for the distribution of power, sustaining rather than challenging inequality. Yet we can also discern empathy for the Aboriginal victims in the responses to the Roth Report, for example in MP John Campbell's references to his 'abhorrence' of the 'appalling' report, to these 'poor people', and to his desire to 'call special attention to the question of the children. The lot of these little creatures was a very sad one indeed.'[43] Here again, the humanitarian narrative relied upon the suffering body as the common bond between victim and viewer, potentially moving the spectator from feeling to action.

The Anti-Slavery Society also saw the affective value of Roth's 'terrible report', which it described as 'very startling', and 'revealing facts of a shocking and most deplorable character'. Already in January 1905, it had received the inquiry's findings by telegram and reported them in *The Anti-Slavery Reporter*.[44] Australian campaigners knew the value of British opinion and sought to publicize their cause through the Society. As Roth himself came under sustained personal attack, he privately sent a package of documents and reports to an ally, the Rev. Rentoul in Melbourne, writing, 'I am so thankful to learn that you intend speaking up in the old country on behalf of these poor down-trodden people. Are they not as worthy of consideration as the Chinese of the Transvaal? … *This is a matter upon which I would beg of you to give every publicity in the English pulpit and press.*'[45] The *Reporter* continued to discuss Roth's findings, both during the parliamentary debate in March 1905 and throughout the year.[46] Along with the London *Times*, it followed conditions in West Australia over subsequent years, maintaining its notoriety among British readers. In 1907, following Klaatsch's display of the Wyndham prisoners, the *Reporter* printed an article titled 'Inferior Races' that quoted Wells's dry query from *A Modern Utopia*: 'Is there, however, an all-round inferior race in the world? Even the Australian black-fellow is, perhaps, not quite so entirely eligible for extinction as a good, wholesome, horse-racing, sheep-farming Australian white may think.'[47]

Wells, race and rights

Wells's views concerning Australian race relations formed part of an outlook sceptical of race and in favour of inclusivity, world government and *The Rights of Man* – the title of a book he published in 1940. Herbert George Wells (1866–1946) was the 'father of science fiction' and author of more than one hundred books, including novels such as *War of the Worlds*, *The Time Machine* and *The Invisible Man*. He also wrote social commentary and nonfiction works on history and politics. Through Wells's utopian exploration of the large ideas of his age – such as new global forms of political community, evolution and identity,

and wide-reaching technological change – his popular writing helped to define new ideas about a shared humanity. Wells commanded tremendous influence as a public intellectual whose fictional and non-fictional writing – and work in radio and later film – reached a wide popular audience.[48] Central to Wells's life work was a conception of a new global community, in which participation was determined by merit and purpose, regardless of race or class. From his earliest futurist works, written during the 1890s, Wells argued that rapid technological change around the globe, especially in communications, would inevitably produce a single human community. A key implication of this vision was that humanity had a new capacity to transcend inherited inequalities of class and privilege, and eventually, even race.

Wells's views about race and their important role within his large-scale utopian visions have received little attention from scholars, but they form a key element of *A Modern Utopia*. These ideas originated from his early encounter with evolutionism, but were given impetus and direction by contemporary sociological thought, debates about colonial peoples of the early years of the twentieth century, and travels in America in 1906. He had studied biology at the Normal School of Science (now part of Imperial College London) between 1884 and 1887, under Thomas Henry Huxley, a proponent of Darwin's theory of natural selection. In his autobiography, Wells later reflected that his 'contact with evolutionary speculation at [his] most receptive age' caused his 'preoccupation with the future'. Several of his novels, starting with *The Time Machine*, published in 1894 when he was twenty-eight, were 'based on the idea of the human species developing about divergent lines'.[49]

In these novels of the 1890s, he explored the theme of evolution applied to the human world, most clearly in *The War of the Worlds* (1897), which examined what would happen if a superior alien race of Martians treated humankind in the way British colonists had dealt with Australian Aboriginal people. He cautioned,

> We must remember what ruthless and utter destruction our own species has wrought, not only upon animals, such as vanished bison and the dodo, but upon its own inferior races. The Tasmanians, in spite of their human likeness, were entirely swept out of existence in a war of extermination waged by European immigrants, in the space of fifty years. Are we such apostles of mercy as to complain if the Martians warred in the same spirit?[50]

This comparison is often cited as an example of Wells's cultural relativism; however, it must be noted that Wells betrayed his underlying commitment to his own race and nation in the novel's ending: rather than pursuing his Tasmanian analogy to its grim conclusion, which would have seen the Martians introducing deadly diseases to humankind, he *reversed* this historical process to kill off the invaders.

Wells himself considered the 'keystone to the main arch of [his] work' to be his book *Anticipations of the Reaction of Mechanical and Scientific Progress Upon Human Life and Thought*.[51] First published in 1900 as a series of papers in *The Fortnightly Review*, this book was viewed by Wells as an innovation in attempting to forecast the human future as a whole.[52] For Wells, what was new and exciting about this work was its recognition of the

'fundamental change in the scale of human relationships and human enterprises brought about by increased facilities of communication' – that is, globalization – and therefore the inevitability of a world state in a form he termed the New Republic.[53]

Published four years later, *A Modern Utopia* was a 'fresh attack' on the problem of how to bring the New Republic into existence, motivated not by existing conditions, but by the questions 'What is it that has to be done? What sort of world do we want?'[54] Wells wrote the book in serial form in literary magazine *The Fortnightly Review* between October 1904 and April 1905, spanning precisely those months in which debates over the Roth Report were proceeding in the British parliament and press. The novel followed two travellers from Earth who are catapulted into a parallel world, a reformed, alternative society in which human life around the globe is a single unit. The novel's tenth chapter, 'Race in Utopia', noted that above basic physical needs, humankind vacillates between two conflicting impulses – the 'desire for distinction, and his terror of isolation', leading to national or religious groupings.[55] Yet over the previous century, the rapid development of 'material forces' and especially communication had dissolved the isolation in which nationality 'perfected its prejudices' and had instead developed a 'world-wide' culture.[56] A 'swarm of inferior intelligences' had applied Darwinism to humankind in a 'wildly speculative ethnology' that had defined a 'Keltic race', a 'Teutonic race', 'even an Anglo-Saxonism'. Wells exclaimed, 'And just now, the world is in a sort of delirium about race and the racial struggle. The Briton forgetting his Defoe, the Jew forgetting the very word proselyte, the German forgetting his anthropometric variations, the Italian forgetting everything, are obsessed by the singular purity of their blood, and the danger of contamination the mere continuance of other races involves.'[57] Wells deplored the 'extraordinary intensifications of racial definition [that] are going on; the vileness, the inhumanity, the incompatibility of alien races is being steadily exaggerated' and predicted that 'these new arbitrary and unsubstantial race prejudices … will certainly be responsible for a large proportion of the wars, hardships and cruelties the immediate future holds in store for our earth.'[58] He censured the widespread antipathy to the Chinese, and referred to the political injustices of this way of thought, such as the 'depopulation' of the Congo Free State by the Belgians.

Wells was reading new sociological work that was beginning to challenge popular biological theories of race. Standing at the intersection of anthropological and popular spheres, he brought his professional training to bear on public debates and disseminated 'expert' arguments into the public domain. Wells cited the work of contemporaries who had started to argue that 'all races are complex mixtures of numerous and fluctuating types', such as Joseph Deniker's *The Races of Man*, commenting that 'from that book we may learn the beginnings of race charity'.[59] Wells himself was 'disposed to discount all adverse judgements and all statements of insurmountable differences between race and race'. Instead, he pointed to photographic portraits as the basis for perceiving a universal humanity, arguing that the 'educated explorer' evades the 'delusions' of race, seeing men as individuals, classifying only by 'some skin-deep accident of tint, some trick of the tongue or habit of gesture, or such-like superficiality'.[60] Turning to visual evidence to support this claim, he argued: 'And after all there exists today available one kind at least of unbiased anthropological evidence. There are photographs. Let the reader turn over the pages of some such copiously illustrated work as *The Living Races of Mankind*, and

look into the eyes of one alien face after another. Are they not very like the people one knows?'[61]

Wells provides a significant example of how empathy may be prompted through picturing a shared humanity. Many have focused upon the visual strategy of documenting the violation of human rights, and the role of shared witnessing in mobilizing concern: through aesthetic encounters, suggests Sharon Sliwinski, the idea of justice became a principle that 'should not only be done but also must be seen to be done'.[62] Yet distinct from this atrocity genre runs an alternative way of seeing: what Wells called a 'ray of special resemblance' expresses a universalizing view of humankind that underlay his work throughout his career, and formed the basis of the ideas about human rights he was to work on in later years. This is evident in Wells' response to *The Living Races of Mankind: A Popular Illustrated Account of the Customs, Habits, Pursuits, Feasts, and Ceremonies of the Races of Mankind throughout the World* (1902). A kind of imperial guide-book, this was aimed at a popular audience, illustrated with the 'absolutely trustworthy … products of the camera'.[63] The book was supposedly intended to satisfy the 'great growth of interest … in the more distant races of mankind', but was innovative in responding to the commercial insight that 'the most promising fields of enterprise … the most profitable markets for our own wares, may some day be found in places which are now the darkest corners of the earth'.[64]

In reviewing *The Living Races of Mankind* for the *American Anthropologist* journal, Otis Mason of the Smithsonian's National Museum of Natural History deemed the nearly 700 photogravures as 'far more trustworthy in ethnology than any drawing can be', and noted the authors' view that because these 'many peoples in all continents [were] coming patrons of British trade, they [the authors] treat them fairly, not grotesquely, and present always fine types of each'. Mason concluded that 'you have only to take their word and enjoy one of the handsomest picture galleries of humanity, whose authors are in love with their kind'.[65] This is precisely how Wells responded to the collection, writing 'for the most part, one finds it hard to believe that, with a common language and common social traditions, one would not get on very well with these people'. The text incorporated numerous contemporary racial assumptions, but Wells noted that although 'here or there is a brutish or evil face', you can find equal types in 'the Strand on any afternoon'.[66]

By contrast with the high-profile atrocity imagery that had publicized the CRA campaign, the *Living Races* images did *not* work to picture the violation of human rights. At this time photography was believed to provide forensic proof of injustice, and there was widespread faith in the 'incorruptible kodak', as Twain had termed the medium's documentation of Congo atrocity. However, here we see another route to asserting a shared humanity, through picturing likeness between far-distant peoples. While mosaics of 'types' had been compiled from the 1870s onwards, and were often used to define difference within social evolutionist frameworks, even some of the most committed Darwinists acknowledged the complexity and ambiguity of applying concepts of biological race to humankind.[67] In 1876, for example, British anthropologist Edward Tylor reviewed the magnificent 1873–6 *Anthropologisch-Ethnologisches Album*, a compilation of portraits from around the world. For Tylor, photography served to check 'rash generalisation as to race' through revealing 'the real intricate blending of mankind from variety to variety'.[68]

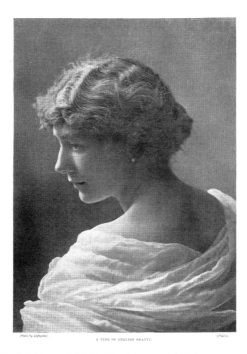

Photo by Lafayette] A TYPE OF ENGLISH BEAUTY. [Public.

Figure 6.7 'A Type of English Beauty', H. N. Hutchinson, J. W. Gregory and R. Lydekker, *The Living Races of Mankind: A Popular Illustrated Account of the Customs, Habits, Pursuits, Feasts, and Ceremonies of the Races of Mankind throughout the World* (New York: D. Appleton and Co., 1902) Vol II, 493.

While *Living Races*' text and images were also structured by contemporary conventions of anthropological racialism and Eurocentric aesthetic criteria, the effect of this photographic portrait mosaic upon viewers exceeded its classifying intentions. 'A Type of English Beauty', for example, was the product of well-known high-society photographer James Lafayette, and directs attention to the subject's softly-lit profile, wavy coiffure and muslin draperies (Figure 6.7).[69] By contrast, 'A Zulu Girl' evokes a long tradition of frontal anthropometric 'type' portraiture, intended to present an individual in a way that permitted standard measurement and yielded cross-cultural comparison (Figure 6.8). Yet, for Wells, difference was less significant than likeness: 'There are differences, no doubt, but fundamental incompatibilities – *no!* And very many of them send out a ray of special resemblance and remind one more strongly of this friend or that, than they do of their own kind.' In an explicit transnational and racial comparison, he commented, 'One notes with surprise that one's good friend and neighbour X and an anonymous naked Gold Coast negro belong to one type, as distinguished from one's dear friend Y and a beaming individual from Somaliland, who as certainly belong to another.'[70] He questioned whether there was any such thing as an 'inferior race', asking ironically,

Is there, however, an all-round inferior race in the world? Even the Australian black-fellow is, perhaps, not quite so entirely eligible for extinction as a good, wholesome,

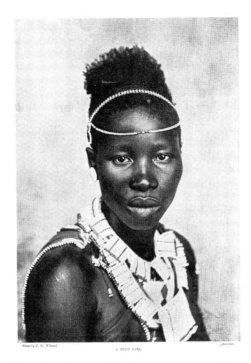

Figure 6.8 'A Zulu Girl', H. N. Hutchinson, J. W. Gregory and R. Lydekker, *The Living Races of Mankind: A Popular Illustrated Account of the Customs, Habits, Pursuits, Feasts, and Ceremonies of the Races of Mankind throughout the World* (New York: D. Appleton and Co., 1902) Vol II, 305.

horse-racing, sheep-farming Australian white may think. These queer little races, the black-fellows, the Pigmies, the Bushmen, may have their little gifts, a greater keenness, a greater fineness of this sense or that, a quaintness of the imagination or what not, that may serve as their little unique addition to the totality of our Utopian civilisation. We are supposing that every individual alive on earth is alive in Utopia, and so all the surviving 'black-fellows' are there. Every one of them in Utopia has had what none have had on earth, a fair education and fair treatment, justice, and opportunity.[71]

Addressing the reader directly, he asked, 'If you are not prepared to regard a world-wide synthesis of all cultures and polities and races into one World State as the desirable end upon which all civilising efforts converge, what do you regard as the desirable end?' With chilling prescience, he referred to those 'queer German professors who write insanity about the Welt-Politik' and assume that the 'best race is the "Teutonic"', a view that opened out a 'brilliant prospect for the scientific inventor' for 'national harrowing and reaping machines, and race-destroying fumigations'.[72]

Wells was to reiterate these views on race, first expressed in *Utopia*, throughout his subsequent career. In 1906 his travel essay *The Future in America: A Search After Realities*, which he published following his first trip to the United States, included a chapter titled 'The Tragedy of Colour', which sympathetically explored the problems of

African Americans, drawn in part from his meeting with Booker T. Washington.[73] Years later, he was involved in the debates leading up to the 1948 *Declaration of the Rights of Man*. Many histories of human rights begin the Declaration's story with the San Francisco Conference of 1945, where, in reaction to the atrocities committed during the Second World War, the promotion of human rights was included among the purposes of the United Nations. Yet in the early stages of the war, prior to the Holocaust, Wells had already initiated an international public campaign leading to the recognition of human rights as a matter of international concern.[74] In October 1939, he wrote a letter to the *Times* in which he referred to 'the extensive demand for a statement of War Aims on the part of young and old, who want to know more precisely what we are fighting for', and called for a Great Debate.[75] Soon afterwards, he was invited to draft the original charter for discussion under the chairmanship of Lord Sankey; he did so, asserting in the Introduction his vision of a new form of political community within the context of rapid technological and social change. The final draft of the Declaration was published as a series under the title 'The Rights of Man' in the *Daily Herald*, February 1940, along with comments by distinguished persons.[76] Later in the war, in September–October 1944, the Dumbarton Oaks Conference did not meet the expectations raised by the human rights movement, despite proposals for a new world organization by the United States, the United Kingdom, the Soviet Union and China. The San Francisco Charter, signed on 26 June 1945, after the war, provided much stronger language on human rights.[77]

Conclusion

The Roth scandal became a significant imperial embarrassment, even though it lacked the profile and effectiveness of the concurrent CRA campaign. The Congo campaign marked a new use of atrocity imagery, often considered to have emerged only after the Second World War. From this time onwards, visual culture, and specifically photographic evidence of atrocity, was to be increasingly significant in bringing distant suffering into proximity with global audiences in order to arouse humanitarian concern. However, the lack of photographic 'proof' and subsequent invisibility of the treatment of Aboriginal people in Western Australia contributed to public indifference at this time. Photography could also be drawn upon to suggest a new view of humanity itself. In a visual tradition of humanism that has often been overlooked, popular writer H. G. Wells not only participated in the public response to scandal, but also, in seeking to challenge injustice on the basis of 'race', used visual evidence to question contemporary views, pointing to a 'picture gallery of humanity' to condemn injustice and assert a cosmopolitan vision of humankind.[78]

It is tempting to wonder whether humanitarian sentiment expended upon the Congolese victims of colonial torture – pictured as enslaved, mutilated and even devoured by cannibal oppressors – displaced concern for the even more distant, and certainly less visible, Australian Aboriginal people. If we see imperial concern for Indigenous peoples as an emotional economy, perhaps the Congo absorbed all the available compassion that could be spared. Or perhaps, the ugly revelation of the torture and violation of children's bodies

was simply more shocking. The web of political interest, imperial shame and pride that configured relations between the colonial powers and their colonies – Britain and Western Australia, Belgium and the Congo – allowed one site of injustice to become the target of humanitarian reform, while obscuring another. In this way, British imperial embarrassment about 'Western Australian irregularities' thwarted attempts to acknowledge and address injustice in the remote nor'west. Such comparisons reveal the contingency and fragility of visual arguments in the shadow of colonialism, qualifying the historical achievements of the CRA and its campaign, and pointing to the limits of photography as a means of constituting the global humanity grounding human rights.

7

HAPPY FAMILIES: UNESCO'S *HUMAN RIGHTS EXHIBITION* IN AUSTRALIA, 1951

Although I had presented war in all its grimness in three exhibitions, I had failed to accomplish my mission. I had not incited people into taking open and united action against war itself … What was wrong? I came to the conclusion that I had been working from a negative approach, that what was needed was a positive statement on what a wonderful thing life was, how marvelous people were, and, above all, how alike people were in all parts of the world.

EDWARD STEICHEN, *A Life in Photography*, 1963

Following Federation in 1901, control over Aboriginal lives continued to grow, as racial frameworks continued to define Australian Aboriginal people as primitive and childlike. Between the wars, new ideas about race combined with new photographic technologies to facilitate the revelation of Aboriginal ill-treatment to a national and global audience. The 1930s marked a transformation in the status of Indigenous Australians, as a profound shift took place in ways of seeing and thinking about Aboriginal people, and images began to be deployed in documenting injustice and arguing for better treatment.[1] Popular forms of visual media such as picture magazines were taken up by Indigenous leaders for their own ends, as with the first 1838 Day of Mourning and Protest – against invasion by the British in 1788, still celebrated as 'Australia Day'. A new Aboriginal policy was developed, but with the outbreak of Second World War, these developments were held in abeyance. At the conclusion of the war, the impact of Holocaust imagery upon Australian audiences created an intensified role for photographic evidence in reporting distant atrocity. This shift in visual culture intersected with new understandings of the pernicious effects of racial thought, and it became increasingly common for observers to draw an analogy between Jewish and Aboriginal experiences of displacement and oppression, as well as the treatment of other 'subject races'. However alongside and entangled with this visual discourse of violation circulated a genre of humanism.

A universal language of human rights?

Atrocity imagery has become the principal modern media strategy for arousing empathy and arguing for rights; indeed, recent histories of human rights argue that rights are *only* visible in their violation. Lynn Hunt, for example, writes that 'human rights and spectatorship have a necessary yet vexed relationship. Rights come into existence when a group of people sees that their rights are being violated; it is the perception of violation that makes the rights palpable.'[2] In this approach, photography shows us what those *without* rights, or those struggling for rights, may look like.[3] For many, the shocking photographs taken at the liberation of the Nazi camps have come to symbolize this message, and indeed to inaugurate a new era of photojournalism.[4] Yet at the end of the Second World War, the new apparatus embodied in the UDHR was articulated through a range of visual narratives that sought to create a sense of a universal humanity and a shared global culture through picturing 'unity in diversity'. This utopian historical moment saw the emergence of a new visual strategy of 'struggle', shading into violence and atrocity, alongside a vision of harmony centred on the family, conveyed via photography and media. As Article 1 of UNESCO's constitution stated, it would collaborate in the 'work of advancing the mutual knowledge and understanding of peoples, through all means of mass communication and to that end recommend such international agreements as may be necessary to promote the free flow of ideas by word and image'.[5]

From 1945 to 1950 a cosmopolitan view of the future of internationalism dominated intellectual and political visions of an anticipated new world order circulating around the creation of UNESCO. However, Glenda Sluga and others have traced continuities between the interwar liberal idealism of the League of Nations' mandate system and its notions of imperial 'trusteeship', and postwar international efforts. The league's aim to create world citizenship through education, symbolized by its slogan 'One World in the things of the mind and spirit', also underpinned the UN and UNESCO's faith in the 'universal power of knowledge'.[6] At this great utopian moment, for figures such as Julian Huxley, UNESCO's first director general and an adherent of Darwinism, the aim was 'unity-in-variety of the world's art and culture', to be achieved through a policy of miscegenation and education of the 'darker races' and the less privileged.[7] Although explicitly opposed to the racism of Nazism, UNESCO's political thinking in this immediate postwar period saw 'development' of the world's colonies as a new source of imperial legitimacy.[8] Similarly, conceptions of 'the nature of man' relied upon foundational imperial narratives: in drafting the declaration, for example, delegates debated the relation between the individual and the community (Article 29) and made extensive reference to Daniel Defoe's *Robinson Crusoe* – that 'prototypically modern realistic novel' about a European who builds himself a colony in a remote land.[9] Delegates agreed to temper the individualism of the UDHR by declaring that the free and full development of his personality could be developed only in community. In this discussion, the Indigenous character, Friday, was not mentioned. As Joseph Slaughter has pointed out, in ignoring Friday, delegates rearticulated Defoe's colonial characterization of the social relations of Crusoe's island – in which there was no scope for Friday himself to become a protagonist or even a legal person.[10]

Photography became a major means of furthering UNESCO's goals to overcome barriers of nation, language and illiteracy. It was already the basis of new forms of mass communication that had emerged during the 1940s, in the form of photo-books, exhibitions, magazines and other ephemera. As Tom Allbeson has argued, postwar conceptions of photography as a universal language and of cultural diplomacy as a means to achieve mutual understanding were co-constitutive, producing a standardized visual language that underpinned a shift from nationalist to internationalist conceptions of identity.[11]

The Family of Man, 1955

The most famous of the visual projects mounted at this time was the 1955 photographic exhibition, *The Family of Man (FoM)*, curated by Edward Steichen at New York's Museum of Modern Art. This international blockbuster contained 503 photos from sixty-eight countries, and toured the world, showing the seemingly eternal dimensions of human life – birth, play, work, marriage, death. Steichen explained that *FoM* aimed to illustrate the 'essential oneness of mankind throughout the world', mirroring mankind back to itself.[12] It was tremendously popular, and by 1960 had been seen by around seven million people in twenty-eight countries, Steichen noted, arguing that photography 'gave visual communication its most simple, direct, universal language'.[13] However, the *FoM* exhibition is now remembered in terms of Roland Barthes's antihumanist critique of its simultaneously exoticizing and incorporative effects – emphasizing difference only to assert a transcendent sense of shared humanity, an essence that effaces cultural and historical differences, and naturalizes the status quo. Barthes's famous attack on the exhibition set out the primary antihumanist objection to such attempts to visualize universalism on the grounds of effacing difference and history:

> This myth of the human 'condition' rests on a very old mystification, which always consists in placing Nature at the bottom of History. Any classic humanism postulates that in scratching the history of men a little, the relativity of their institutions or the superficial diversity of their skins (but why not ask the parents of Emmet Till, the young negro assassinated by the Whites what they think of The Great Family of Man?), one very quickly reaches the solid rock of a universal human nature. Progressive humanism, on the contrary, must always remember to reverse the terms of this very old imposture, constantly to scour nature, its 'laws' and its 'limits' in order to discover History there, and at last to establish Nature itself as historical.[14]

Such critique applies equally well to the UDHR and its culture committee's work. Others have examined the *FoM*'s complicity with American Cold-War liberalism and its 'benign view of an American world order stabilized by the rule of international law'.[15] Louis Kaplan argues that its conception of global community echoed American liberal foreign policy, with all its exclusions, excisions and suppressions.[16] Despite the positive intent of Steichen's

assertion that 'the family unit is the root of the family of man, and we are all alike', as Kaplan points out, 'The utopian inclusiveness of the ambiguous myth of human community demands a series of exclusions that mask inequalities and cultural hierarchies.'[17] More concrete attacks were also mounted at the time of the exhibition: in 1959, for example, Nigerian Theophilus Neokonkwo razored and tore down several images because he objected to the representation of Africans as primitive and unclothed. The same year, the exhibition's hosts in Russia objected to an image of a Chinese beggar on the grounds that it undermined a new communist ally.[18] Its Japanese sponsors insisted on including a large mural depicting the victims of the atomic bombings of Nagasaki and Hiroshima.[19] These protests expressed national sensitivities concerning implied civilization and racial status as well as national trauma, challenging the visual rhetoric of inclusivity and equality.

Australia and the UDHR

Although the most famous of these postwar visual projects, the *FoM* was by no means unique. A year after the United Nations proclaimed the UDHR in 1948, it mounted an exhibition displaying photographs, as well as photographs of images, documents and objects in mural collages designed 'to convey a compelling visual history of human rights' and disseminate the abstract contents of the UDHR.[20] After the Paris exhibition ended, 12,000 copies of a portable photograph album intended to form the basis for local exhibitions was sent out to the fifty member states, including twenty copies that were sent to Australia.

Australians were closely involved in the process of drafting, proclaiming and disseminating the UDHR underway at the United Nations. Australia was one of the fifty-one founding member states of the UN and one of eight nations involved in drafting the Universal Declaration, largely due to the influential leadership of Dr Herbert Vere Evatt, the head of Australia's delegation to the UN. In 1948, Evatt became President of the UN General Assembly and oversaw the adoption of the Universal Declaration.[21] Another hard-working member of the Human Rights Working Committee was the peppery but knowledgeable Australian lawyer Colonel Hodgson.[22] However, the form of Australia's engagement with the declaration and its application at home was shaped by the particular political and administrative individuals involved, as well as restrictive domestic attitudes towards the rights of immigrants, women and Indigenous people.

The UN's travelling exhibition opened first in Brisbane in July 1951, announced as 'Visual history at its best!' and one of the 'most formative and educative displays of pictures yet assembled on the subject of human rights'. The images were roughly divided into fourteen themes, each covering a historical struggle for a set of rights. The first twenty-four images offer a preamble from prehistory to the postwar period, as widely different cultures were enfolded into a single human narrative of progress, expressed visually by photographs of famous monuments, artefacts and architecture. The introductory text stated that 'the illustrations mark the stages along the road leading from the cave-man … to the free citizen of a modern democracy'. Human rights,

it began, 'are the outcome of a struggle that has been going on since the dawn of human history'.[23] Key documents of rights were featured, with the notable exclusion of the Russian Declaration of the Rights of the Toiling and Exploited People (1918), but, as Tom Allbeson points out, 'The Soviet Union [was], in a sense, the exhibition's unconscious; while not explicitly referenced, the threat of nuclear war animated much of postwar visual culture.'[24]

What is striking about this initial popular version of the UDHR is the emphasis on duty as the foundation of rights, as well as the prominent role of what was termed 'struggle' in providing a historical account of the journey towards human rights. An epigraph quoting Mahatma Gandhi stated, 'I learnt from my illiterate but wise mother that all rights to be deserved and preserved come from duty well done. Thus the very right to live accrues to us only when we do the duty of citizenship of the world.'[25]

Significantly, the visual expression of 'struggle' was often represented by depictions of the violation of rights, and often atrocity. This marks the first deliberate and systematic use of such imagery to convey the notion of human rights. However, it forms a significant counterpart to the more harmonious, humanist conception of a shared human history, culture and identity. While much of the exhibition presages the harmonious, familial imagery of the *FoM* in its depiction of a shared way of life, a counter-narrative of atrocity is introduced through images such as war dead, including piles of Nazi victims' corpses (Figure 7.1), 'book-burning' (Figure 7.4) and torture. Through collage, different cultures – and even historical epochs – are visually juxtaposed to emphasize specific issues or rights. Universal themes such as 'Emancipation of Women' (Figure 7.2), 'Right to Education' (illustrated by a collage of three photographs and a painting showing people reading or in

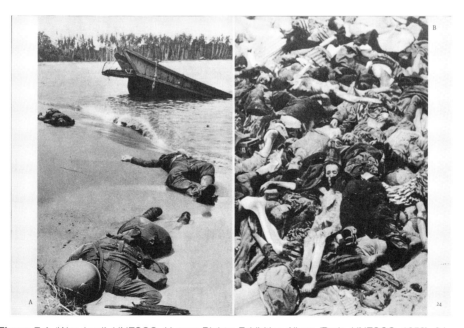

Figure 7.1 'War dead'. UNESCO, *Human Rights: Exhibition Album* (Paris: UNESCO, 1950), 24.

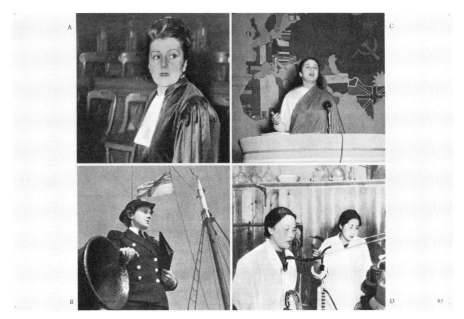

Figure 7.2 'The Emancipation of Women'. UNESCO, *Human Rights: Exhibition Album* (Paris: UNESCO, 1950), 67.

libraries), and 'Social Security. Family and Property' (Figure 7.3) emphasize social stability and harmony.

Happy families

In November 1951 the UNESCO travelling exhibition opened in Adelaide at the Public Library lecture room. It was launched by T. S. Raggatt, the chairman of the UNESCO Australian National committee for education; Walter Duncan, the professor of political science and history at Adelaide University, who opened the exhibition; and Mr Brocksopp, UNESCO State committee member. The exhibition's purpose was 'to show man successively as a physical organism, a moral personality, a worker, an intelligent being and a member of the community'.[26] Displayed at the lecture room, on North Terrace, were more than 100 pictures mounted by the 'Misses' Pat Lewis and Frances Cashel. The pictures, 'reproduced in photogravure from ancient manuscripts, sculptures, paintings, mosaics, engravings, and contemporary photography', depict the 'dramatic struggle of man, from earliest times, to assert his birthright to free citizenship' and included the topics of the abolition of slavery, freedom of movement, protection against arbitrary arrest, freedom of the press, emancipation of women, right to education, freedom of religion and the dignity of labour.[27]

Walter Duncan (1903–1987) was a professor of politics at the University of Adelaide, and a champion of adult education. He was a left-wing liberal, was impressed by the

Soviet regime, and was a hostile critic of capitalism, imperialism and religion.[28] In his opening speech, Duncan argued that 'people still had to be awakened to the significance and implications of the UDHR to which their Governments had agreed'. He pointed out that 'not all of the rights in the declaration are recognised in every country', and suggested that South Australians

> might examine the declaration and see how many are recognised here. Some comparatively recent rights included the right to work, to rest and leisure, to form trade unions, to equal pay for equal work, to education and to participation in culture … The right to form trade unions was only recently acknowledged in the US … In SA, the right to equal pay for equal work seems to have aroused some controversy recently.[29]

He declared that the declaration was a 'supremely worthwhile' goal, and represented 'the ends for which the State and governments existed',[30] and concluded that 'it can never be sufficiently emphasised that the end of all State action is the development of individual personality. That is, respect for the dignity and rights of the individual'.[31] Duncan's view of the declaration as a means to challenge the status quo was, however, contradicted by media responses. Two images from the exhibition were reproduced in Adelaide newspapers over following days: a portrait of a Maori mother and child, and another of Nazi book-burning, neatly encapsulating the twin themes of familial humanism and atrocity that were to become emblematic of the modern visual discourse of human rights.

Despite Duncan's radical views, his challenging speech and, particularly, his reference to 'equal pay for equal work' – and notwithstanding even South Australia's strong feminist tradition – the exhibition did not spark confrontation. From the exhibition's 110 photographs, the Adelaide *News* reproduced a Maori madonna, weaving rushes, with the caption 'Security of Family Life'. It argued, 'Maori mother and child represent the security of family life and the need for a calm, cheerful home in which each member respects the rights of others,' and commented,

> A section of the exhibition is devoted to social security, family and property. In present days, there is nothing revolutionary in the stipulation that men and women, without any limitation due to race, nationality, or religion, have the right to marry and found a family. But the rights of women, within the family itself, are only a recent achievement.[32]

This rather puling statement suggested only that women had a right to marry and participate in a family, a circumscribed role even at the time. As Sekula pointed out of the later *FoM,* such imagery 'universalizes the bourgeois nuclear family, suggesting a globalized, utopian family album, a family romance imposed upon every corner of the earth. The family serves as a metaphor also for a system of international discipline and harmony.'[33] Australia had opposed 'equal pay' clauses in the drafting of the UDHR, given entrenched disparities in domestic wages between men and women, and continued to oppose such moves into the 1950s on the grounds of 'community sentiment' against women working outside the home.[34]

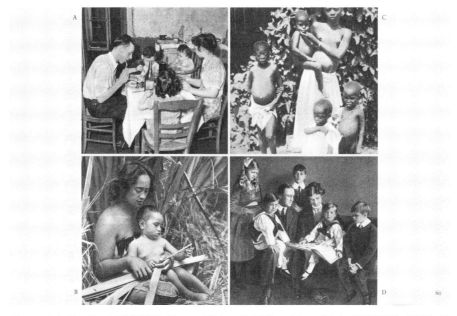

Figure 7.3 'Families'. UNESCO, *Human Rights: Exhibition Album* (Paris: UNESCO, 1950), 60.

Another significant gap was the total absence of Australian Aboriginal people in the exhibition. Instead, the Maori mother and child, provided a regional gesture towards unity in diversity. This national lacuna reflected continuing community prejudice despite official commitment to a system of human rights.

'Struggle'

Of particular interest is the exhibition's innovative narrative of 'struggle', adumbrating a now-dominant visual language of human rights as pictured through their violation. As I've noted, through images showing the Nazi regime, such as the mass adulation of Hitler, book-burning, and the Buchenwald concentration camp, the UN exhibition can be seen to draw upon a new genre of atrocity imagery: photographic evidence for distant suffering that has now come to assume a predominant place in global visual culture.[35] The shocking photographs emanating from the liberation of the camps in the wake of the Second World War gave photographs of atrocity a new documentary power.[36] Photography became the preeminent means of bearing witness to distant horror.[37] In the immediate aftermath of the war, as Fay Anderson argues, Australian press coverage of the Holocaust obscured local understanding of the Jewish genocide by editorial practices that reported events in isolation, rather than as a deliberate Nazi programme.[38] Nonetheless, over following years a growing sense of outrage framed these images, inaugurating the principal modern media strategy of arousing empathy and arguing for rights.

The second image from the exhibition chosen by the Adelaide *News* was a seventeenth-century engraving headlined 'Books Burnt Publicly' to illustrate the

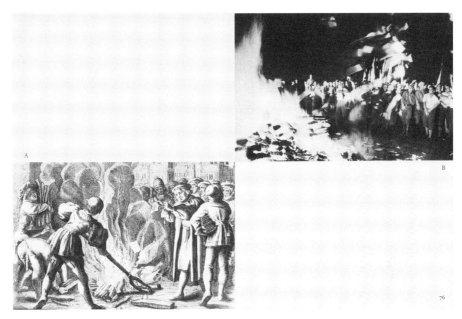

Figure 7.4 'Book-burning'. UNESCO, *Human Rights: Exhibition Album* (Paris: UNESCO, 1950), 76.

freedom of thought and opinion. It argued that 'rulers have checked the progress of civilisation by silencing reformers, persecuting scientists and philosophers, and burning libraries, as pictured above ... The freedom of thought and opinion is illustrated in a large section of the exhibition.'[39] By picturing the history of human rights as a 'struggle' against repression, the exhibition became intelligible as a linear narrative, as, one by one, specific types of freedom were fought for and won. This modernist faith in improvement was for many disrupted by growing recognition of what is now termed the Holocaust in the aftermath of the war, prompting scepticism towards grand narratives of progress, universality and equality.

Aboriginal rights

As I have noted, the UN exhibition made no reference to Australia's Indigenous people. This notable absence contrasted with the growing popular acknowledgement of new ideas of rights and the evils of racism, and especially demands from Aboriginal activists for better conditions and equality.[40] Campaigners such as the Victorian Council for Aboriginal Rights were making arguments for including Aboriginal people at just this time: in June 1951, for example, medical doctor and outspoken activist Charles Duguid appealed to the federal government to include Australian natives in the UDHR and in Australia's own constitution. He declared, 'There will be no justice for the aborigines until they get full education, the same as whites, work instead of the dole, and decent wages.'[41] The UDHR also provided ammunition for the campaign for constitutional reform that emerged

during the late 1950s, launched by activists such as Jessie Street. Street argued against the explicit exclusion of Aboriginal people from Commonwealth control and for the nation's commitment to the UDHR. Calls grew for a referendum to remove discriminatory clauses from the constitution, culminating in the 1967 referendum, which allowed the Commonwealth to create laws for Aboriginal people.

However, as Annemarie Devereaux has shown, as the local implications of ratification became clearer, the Australian Government's engagement with these issues during the late 1940s and 1950s shifted to very qualified acceptance of the International Covenant on Civil and Political Rights (ICCPR) and the International Covenant on Economic, Social and Cultural Rights (ICESCR). Australia abstained on clauses covering the prohibition of slavery, freedom of movement and a right to equality, and voted against clauses prohibiting racial hatred, a right to self-determination and specific plans for compulsory, universal and free primary education.[42] Australian government departments were aware that several Aboriginal policies were vulnerable to allegations of inconsistency with the conventions' human rights requirements, including the prohibition of arbitrary interference and the removal of half-caste children, but the Department of Interior argued that convention rights were not intended to apply to 'natives who have not yet reached a state of civilization where they can fend for themselves and protect their own interests'.[43]

Instead of applying human rights principles to Australian circumstances, a domestic policy of assimilation was implemented in 1951 that mirrored the UNESCO rhetoric of unity and inclusivity. This 'new deal for the Aborigines' aimed to raise the status of Aboriginal people so that they could qualify for full citizenship, by merging them into the mainstream population – although it was an agenda contested then and now, primarily on the grounds of its coercive implementation.[44] Official visions of an Indigenous future relied upon an imagined modernity and equality, contrasted with a primitive past, in a conversion narrative as old as colonization. The Australian government produced glossy official publications filled with high-quality photographs in visual conversion narratives that contrasted substandard living conditions with new building programmes. Newspapers and magazines such as the *Australian Women's Weekly* promoted assimilation by reproducing the logic of transformation – 'from *this* to THIS!' – demonstrated by individual 'success stories'. What was new was the sight of Aboriginal people taking their place as equals in a modern society, becoming ideal suburban middle-class families.[45] However, despite the rhetoric of equality, some pointed out the hypocrisy of providing inferior dwellings and resources through housing schemes; they were often implemented as a means of instructing Aboriginal people, rather than given to them as a right.

The intensified role for photographic evidence in reporting distant atrocity after the war intersected with new understandings of the pernicious effects of racial thought, and it became increasingly common for observers to draw an analogy between Jewish and Aboriginal experiences of displacement and oppression. Visual campaigns to improve Indigenous living conditions during the 1950s drew on photographic evidence that was frequently explicitly compared with concentration camp imagery. In 1955, for example, Murray River camp settlements were described as 'shocking' because they were 'second-class concentration camps'.[46]

Soviet attack

Amid increasing international interest in Australia's treatment of its Indigenous people, communists seized upon photographic evidence to challenge Australia's standing on human rights.[47] Soviet criticism in the United Nations and other international forums became a powerful form of external scrutiny, as photographs of Aboriginal prisoners and 'fringe-dwellers' transcended barriers of language and culture to become effective ammunition against Australia's international reputation on Indigenous issues.

In 1949, the communist *Tribune* attacked the official treatment of Aboriginal workers using front-page photographs of Aboriginal prisoners in neck-chains which were taken up around the world. The images were accompanied by the following description: 'Not imaginary Russian "slave camp" inmates, such as have Dr Evatt's sympathy, but Australian Aborigines are here pictured in chains in a real Australian slave camp.'[48] The 'inmates' featured were held at Fitzroy Crossing, Western Australia, for eighteen months while police sought evidence for their offence, but were eventually released without charge. The issue was taken up overseas by the British Anti-Slavery Society and the Soviet government, which republished the photographs.[49] In April 1949 the Polish delegate to the United Nations, Jan Drohojowski, launched a sustained attack on Australia's human rights record, asking: 'Who is coming to the rescue of alleged violations of human rights in Hungary? From the antipodes comes Australia, a country whose original immigrants have almost entirely exterminated the aborigines. As a matter of fact, Australia seems to consider the remaining aborigines as zoological specimens.'[50]

In October, speaking in the UN Political Committee debate on the violation of human rights in Bulgaria, Rumania and Hungary, the Soviet Foreign Minister, Andrey Vyshinsky, attacked the Australian Government's 'total disregard' for the human rights of Aboriginal people. Governed by Cold-War dynamics, the External Affairs Minister (Dr Evatt) replied 'bluntly' in the House of Representatives, accusing the Russians of deflecting attention from their own record on religious persecution.[51] Soviet support for the Aboriginal campaign against a Long Range Weapons facility, Woomera, was effectively dismissed on the grounds that it was concerned not so much about the Indigenous occupants as for the limitation of Western technological development.[52]

The Soviets found photographs published in official assimilation pamphlets a particularly useful means of attacking Australia's record on Indigenous affairs. While these photo-booklets were intended to serve as propaganda for the success of assimilation, they presented visual evidence for squalid living conditions that contradicted their own claims. Australian legations were required to distribute them to show their government dealing humanely with its Indigenous 'problem'. Typical of this paternal, benevolent attitude was *Our Aborigines*, first issued in 1957, which noted under 'Citizenship' that the position of Aboriginal citizens 'is somewhat like that of a minor who is basically a citizen but who, because he is under the age of 21 years, may not be able to do everything that other inhabitants of Australia may be able to do, and who may be protected and assisted in ways in which the adult is not protected and assisted'.[53]

Overseas observers were appalled by photos contrasting the poor circumstances of the camps many Indigenous people lived in, representing the past, with modern, hygienic

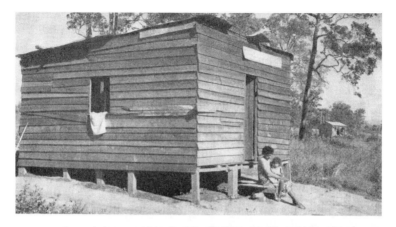

To people living on the fringe of the white community the gulf between may seem very great. This separation can be reduced when families move from shacks like this to homes in residential areas, but acceptance by the community is as necessary as improved housing.

Figure 7.5 'Woman and weatherboard house', *Fringe Dwellers* (Canberra: Government Printer, 1959), 12. Booklet prepared under the authority of the Minister for Territories, with the cooperation of the Ministers responsible for aboriginal welfare in the Australian states, for use by the Aborigines' Day Observance Committee and its Associates in connexion with the celebration of National Aborigines' Day in Australia, 10 July, 1959.

circumstances standing for their future. Soviet President Nikita Khrushchev referred to visual evidence contained within the pamphlet *Fringe Dwellers* to attack Australia at the United Nations (Figure 7.5).[54] In October 1960, at a United Nations Correspondents lunch in New York, Krushchev said, 'Take Australia – Prime Minister Menzies has spoken here. Why did he not tell of the way in which the native population of Australia was treated? Why did he not tell of that shameful fact, that most of the native population of Australia has been virtually wiped out?'[55] By 1961 the Department of External Affairs had begun to note that 'adverse references now appear regularly in the Soviet and Communist Chinese press and radio', such as when Krushchev was reported in the Moscow press as having 'pointed to the eternal shame that rested on the ruling class of Australia for the extermination of the Aborigines'.[56] In 1961 an Aboriginal camp depicted in the pamphlet *One People* prompted criticism of Australia in the Moscow newspaper *New Times*, which was published in eight languages.[57]

These visual conversion narratives were premised on an evolutionist vision of assimilation, as Aboriginal people would abandon their close-knit communities and an ethos of collective identity and resources to pursue the goals of possessive individualism. In an idealizing vision very close to that of Christian missionaries before them, in order to attain rights, Indigenous Australians must undergo transformation to become educated, productive citizens.

Conclusion

The inclusive UNESCO ideal of 'unity in diversity' contrasted starkly with the domestic emphasis on coercive conversion, mapping the limitations of Australia's deployment of

human rights in the immediate postwar period. The UNESCO/*Family of Man* projects showed the sameness of diverse peoples, linked to a story of a shared progressive struggle to secure a range of global rights. By contrast, the state-produced assimilationist photo-booklets pictured an evolutionary movement from primitive to civilized, and the transformation of Aboriginal people into citizens who would eventually be *worthy* of rights. Despite their utopian intent, in practice, the building of universal rights entailed a process of 'inclusive exclusion', requiring the abandonment or invisibility of certain groups, such as Aboriginal people.[58] This history challenges our understanding of the development of human rights as one of inevitable progress: despite their idealizing intent, such blind spots remind us that the UDHR was drafted in a world still largely under colonial rule, and for a less visually sophisticated global audience than today's. Postcolonial state formation and national self-determination still lay in the future.

The symmetry between the programme of universality espoused by the UNESCO and Australian assimilationist ideals of unity in diversity is striking, revealing how the practice of human rights has been profoundly shaped by state agendas and cultural predispositions. On one level, the domestic application of the ideals and language of human rights indicates the tension between the principles of universalism and local difference that continues to be central to current analysis of global networks, linked to concepts of universal human rights and local values. This dilemma is a problem not merely of articulation between different orders of practice, but of how to conceive human subjectivity and difference.[59] It is true that the dichotomization of universal and local values overlooks the effects of globalization and transnational juridical processes, where many Indigenous peoples, for example, adopt human rights principles, identify with a pan-global category and become enmeshed in transnational linkages.[60] Notwithstanding commitments to cultural diversity and local rights, the application of universal values by state or corporate interests often proves to overlook or subsume local agendas in the interests of the powerful. Postcolonial historian Dipesh Chakrabarty notes that our notions of social justice, human rights and other aspects of political modernity are unthinkable without the European Enlightenment and its ideal universal and secular conception of the human. However, as he notes, nineteenth-century colonizers preached this humanism at the colonized even while they denied it in practice, reducing the figure of the human to the white, male European.[61] Nonetheless, his exploration of the appropriation of Enlightenment Europe in the subcontinent shows how these ideals have since provided the basis for critique of social injustice. The gap between ideal and practice is not a reason to condemn the ideal, but perhaps simply allows us to measure how far we have left to travel.

Afterimages

The period I have examined in this book pre-dates the fully fledged Aboriginal rights movement that became mainstream during the 1960s. From the invention of photography in 1839 to the formal declaration of a new code of human rights in 1948, the long century explored here has seen the medium play an important role in the growth of humanitarianism and empire. Humanitarian deployment of the medium of photography

over its first century reveals the ambivalence and moral uncertainties of colonialism, as some of history's most divisive and pernicious notions of race were elaborated. The social uses of photography chart the shifting boundaries of the 'human' in debates about Australian Aboriginal people, who were sometimes considered to inhabit the category's fringe. As I have shown, humanitarians employed a strategy of sameness and equality in seeking to show Indigenous Australians as 'just like us', for example, in dignified portraits characterized by mimicry of upper-class Englishmen. However, as a Darwinist taxonomy of race was theorized and consolidated from mid-century, photographs were used to show how *different*, and necessarily subordinate, Aboriginal people were. Despite moments of recognition, and an ambivalent sympathy that emerges most clearly from personal encounters, the oppression and dispossession of Aboriginal people were masked by sentimental narratives of a 'dying race' underwritten by an evolutionist racial hierarchy. Settlers were also blind to the violence and brutality inflicted on Aboriginal people on the frontier, despite attempts to arouse pity and concern that drew upon analogies with an older discourse of slavery, construing Aboriginal people as passive objects of pity. Recognition was increasingly limited as ideas about biological difference reached a climax towards the turn of the nineteenth century. Elsie Masson's droll narrative framed images of infantilized and subordinated Aboriginal people, and was deeply implicated in the imbrication of law, anthropology and colonial governance, even as it was disrupted by an emerging relativist acknowledgement of an Aboriginal right to equal treatment. Her visual narrative of difference and hierarchy gave way to a more inclusive vision of a shared humanity, reinforced by what could be called an allusion to atrocity, in picturing the scene of a crime against Nadjimo, cruelly tortured to death.

The story of how photography has worked to evoke a 'fellow-feeling' for distant others traces the rise of a new visual culture, characterized by an emphasis on the shock and compassion prompted by atrocity imagery. It shows how photography harnessed older tactics to arouse the viewer's emotions – as historians such as Laqueur have shown, the technique of detailing the suffering body in order to create empathy dates back to at least the eighteenth century. Yet a historical perspective also shows that this is only part of the story – only a partial view of 'the frame that blinds us', in Judith Butler's words.[62] Focusing only on violation and atrocity overlooks the equally important role of an idealizing tradition of humanism, expressing a conception of political community that transcends the nation state.

In an alternative strategy, H. G. Wells advanced an inclusive vision of a global community, in which human commonality would overcome inequality and injustice. The dissemination of photography was interlinked with his expanded conceptualization of humanity – as Wells claimed in 1939, 'Towards the end of the 19th century we began to realize that all the islands had been found and that the world was becoming one community.'[63] Subverting visual taxonomies of race, Wells looked for a universal humanity in asserting his vision of rights. UNESCO and the UDHR went further to disseminate this vision of an international political community, picturing a human history of both 'struggle' – that is, the violation of rights – as well as an ideal harmony constituted by the naturalized 'family of man'.

In practice, as I have tried to show, such idealizing visions have been limited in their application to local circumstances, as power relations and structural inequalities govern

their effects. Assimilation policies and the Cold-War *Family of Man*-style visions of global community have both been shaped by political context. Through these diverse strategies, photographs have participated in the construction of emotional narratives, calling upon the viewer to register likeness or difference, to defend, laugh at, patronize, or to feel pity, shock or outrage on behalf of the people they show. They have constituted certain historical actors as objects of pity and benevolence, while showing others as unworthy. The lesson for us now is to understand our implication within these complex viewing practices and how they have governed our ideas of both inequality and justice. Through such engagement we may begin to see beyond the 'frame that blinds us', to a clearer view of our place within the world, and our responsibilities to others.

NOTES

Chapter 1

1 Susie Linfield, *The Cruel Radiance: Photography and Political Violence* (Chicago: University of Chicago Press, 2010), 37.

2 Adam Smith, *The Theory of Moral Sentiments*, ed. D. D. Raphael and A. L. Macfie (Indianapolis: Liberty Fund, [1759] 1984), 10.

3 See for example Carlo Ginzburg, 'Killing a Chinese Mandarin: The Moral Implications of Distance', *Critical Inquiry* 21, no. 1 (1994): 46–60; Karen Halttunen, 'Humanitarianism and the Pornography of Pain in Anglo-American Culture', *American Historical Review* 100, no. 2 (1995): 303–34.

4 Lynn Hunt, *Inventing Human Rights: A History (*New York: W. W. Norton and Company, 2007), 176.

5 Ibid., 176.

6 Emily Baughan and Bronwen Everill, 'Empire and Humanitarianism: A Preface', *Journal of Imperial and Commonwealth History* 40, no. 5 (2012): 727–8.

7 Duncan Ivison, *Rights* (Stocksfield: Acumen, 2008), 1–2.

8 Richard Ashby Wilson and Richard D. Brown, 'Introduction', in *Humanitarianism and Suffering: The Mobilization of Empathy*, ed. Richard Ashby Wilson and Richard D. Brown (Cambridge: Cambridge University Press, 2009), 1–28.

9 Wilson and Brown, 'Introduction', 2.

10 Gary J. Bass, *Freedom's Battle: The Origins of Humanitarian Intervention* (New York: Knopf, 2008). For a prominent dissenting view, see Samuel Moyn's, *The Last Utopia* (Cambridge: Belknap Press of Harvard University Press, 2010), 19–20, 243n. Moyn rejects the connection between humanitarianism and human rights, which, he argues, took recognizable form only in the 1970s. In my view, Moyn's definition of human rights is unhelpfully narrow, and I prefer to see humanitarianism and human rights as 'adjacent, overlapping' concepts. See Wilson and Brown, 'Introduction', 2.

11 Thomas Dixon refers to 'felt judgements'. See Thomas Dixon, *From Passions to Emotions: The Creation of a Secular Psychological Category* (Cambridge: Cambridge University Press, 2003); William M. Reddy, *The Navigation of Feeling: A Framework for the History of Emotions* (Cambridge: Cambridge University Press, 2001); Barbara Rosenwein, 'Worrying about Emotions in History', *The American Historical Review* 107 (2002): 921–45.

12 Affect is not merely a universal dimension of *attachment*, it is always already an *attachment to*, given specificity by a range of social encounters. Sara Ahmed, 'Happy Objects', in *The Affect Theory Reader*, ed. Melissa Gregg and Gregory J. Seigworth (Durham and London: Duke University Press, 2010), 29–51.

13 Sarah Ahmed, *The Cultural Politics of Emotion* (Edinburgh: Edinburgh University Press, 2004), 8–9, 83.

14 Daniel Wickberg, 'What Is the History of Sensibilities?' *The American Historical Review* 112, no. 3 (2007): 661–84; See also James Chandler, 'The Politics of Sentiment: Notes toward a New Account', *Studies in Romanticism* 49, no. 4 (2010): 553–75.

15 Smith, *The Theory of Moral Sentiments*, 9.

16 Ibid., 10.

17 Ibid.

18 Karsten Stueber, 'Empathy', *The Stanford Encyclopedia of Philosophy*, last revised 14 February 2013, http://plato.stanford.edu/archives/win2014/entries/empathy/.

19 Carolyn Burdett, 'Is Empathy the End of Sentimentality?' *Journal of Victorian Culture* 16, no. 2 (2011): 259–74.

20 Some now consider empathy to refer to a closer identification with another's emotional state than sympathy, but I choose to retain the inclusive sense of Smith's 'fellow-feeling'.

21 See for example C. Daniel Batson, 'These Things Called Empathy: Eight Related but Distinct Phenomena', in *The Social Neuroscience of Empathy*, ed. Jean Decety and William Ickes (Cambridge, MA: MIT Press, 2009); C. Daniel Batson, *Altruism in Humans* (Oxford and New York: Oxford University Press, 2011).

22 Giacomo Rizzolatti and Corrado Sinigaglia, *Mirrors in the Brain: How Our Minds Share Actions and Emotions*, trans. Frances Anderson (Oxford and New York: Oxford University Press, 2008).

23 Smith, *The Theory of Moral Sentiments*, 112.

24 John Mullan, *Sentiment and Sociability: The Language of Feeling in the Eighteenth Century* (Oxford: Clarendon Press, 1988).

25 David Brion Davis, *The Problem of Slavery in the Age of Revolution, 1770–1823* (Oxford and New York: Oxford University Press, 1999).

26 Thomas Laqueur, 'Bodies, Details, and the Humanitarian Narrative', in *The New Cultural History*, ed. Lynn Hunt (Berkeley and Los Angeles: University of California Press, 1989).

27 Ibid., 178.

28 Elizabeth B. Clark, '"The Sacred Rights of the Weak": Pain, Sympathy, and the Culture of Individual Rights in Antebellum America', *Journal of American History* 82, no. 2 (1995): 463–93.

29 Richard Rorty, 'Human Rights, Rationality, and Sentimentality', in *On Human Rights: The Oxford Amnesty Lectures*, ed. Stephen Shute and Susan Hurley (New York: Basic Books, 1993); Martha Nussbaum, *Poetic Justice: The Literary Imagination and Public Life* (Boston: Beacon, 1996); K. Anthony Appiah, *Cosmopolitanism: Ethics in a World of Strangers* (New York: W. W. Norton, 2006).

30 Halttunen, 'Humanitarianism and the Pornography of Pain'.

31 Lauren Berlant, 'Introduction: Compassion (and Withholding)', in *Compassion: The Culture and Politics of an Emotion*, ed. Lauren Berlant (New York and London: Routledge, 2004).

32 Ibid., 10.

33 Lynn Festa, *Sentimental Figures of Empire in Eighteenth-Century Britain and France* (Baltimore: Johns Hopkins University Press, 2006).

34 Lynn Festa, 'Humanity without Feathers', *Humanity* 1, no. 1 (2010): 9. See also Amit Rai, *Rule of Sympathy: Sentiment, Race and Power, 1750–1850* (New York: Palgrave, 2002).

35 Ibid., 104.

36 Ibid., 103.

37 There is a considerable amount of literature considering the moral and political implications of viewing distant suffering, including Luc Boltanski *Distant Suffering: Morality, Media and Politics* (Cambridge: Cambridge University Press, 1999); Mark Reinhardt, Holly Edwards and Erina Duganne, eds, *Beautiful Suffering: Photography and the Traffic in Pain* (Chicago: University of

Chicago Press and Williams College Museum of Art, 2007); Geoffrey Batchen , Mick Gidley, Nancy K. Miller and Jay Prosser eds, *Picturing Atrocity: Photography in Crisis* (London: Reaktion, 2012); Sharon Sliwinski, *Human Rights in Camera* (Chicago: University of Chicago Press, 2011).

38 Marcus Wood, *Blind Memory: Visual Representations of Slavery in England and America 1780–1865* (New York: Manchester University Press and Routledge, 2000).

39 Saidiya Hartman, *Scenes of Subjection: Terror, Slavery and Self-Making in Nineteenth-Century America* (Oxford and New York: Oxford University Press, 1997).

40 See especially Abigail Solomon-Godeau, *Photography at the Dock: Essays on Photographic History, Institutions, and Practices* (Minneapolis: University of Minnesota Press, 1991), 176; John Tagg, *The Burden of Representation: Essays of Photographies and Histories* (Minneapolis: University Of Minnesota Press, 1993); Allan Sekula, *Photography against the Grain: Essays and Photo Works 1973–1983* (Halifax: Nova Scotia University Press, 1984).

41 Sliwinski, *Human Rights in Camera*; see also Linfield, *Cruel Radiance.*

42 Maurice O. Wallace and Shawn Michelle Smith (eds) *Pictures and Progress: Early Photography and the Making of African American Identity* (Durham: Duke University Press, 2012); Deborah Willis and Barbara Krauthamer, *Envisioning Emancipation: Black Africans and the End of Slavery* (Philadelphia: Temple University Press, 2013).

43 For key articulations of this shift, see Elizabeth Edwards, 'Objects of Affect: Photography beyond the Image', *Annual Review of Anthropology* 41 (2012): 221–34; Elizabeth Edwards and Christopher Morton, eds, *Photography, Anthropology and History: Expanding the Frame* (Farnham: Ashgate Publishing, 2009); and from a different perspective, see Ariella Azoulay, *The Civil Contract of Photography* (New York: Zone Books, 2008).

44 Judith Butler, *Frames of War: When is Life Grievable?* (London: Verso, 2009), 67; Linfield, *The Cruel Radiance*, 30.

45 Jill Bennett, *Empathic Vision: Affect, Trauma and Contemporary Art* (Stanford: Stanford University Press, 2005), 10; Reinhardt, Edwards and Duganne, *Beautiful Suffering.*

46 Michael Barnett, *Empire of Humanity: A History of Humanitarianism* (Ithaca: Cornell University Press, 2011).

47 For overview histories, see Paul Gordon Lauren, *The Evolution of International Human Rights: Visions Seen* (Philadelphia: University of Pennsylvania Press, 1998); Rob Skinner and Alan Lester, 'Humanitarianism and Empire: New Research Agendas', *The Journal of Imperial and Commonwealth History* 40, no. 5 (2012): 729–47; Paul Gilroy, 'Race and the Right to be Human' (inaugural address on accepting the Treaty of Utrecht Chair, Utrecht University, Utrecht, 3 December 2009), 6; Andrew Porter, 'Trusteeship, Anti-Slavery and Humanitarianism', in *The Oxford History of the British Empire,* ed. Andrew Porter (Oxford and New York: Oxford University Press, 1999); Barnett, *Empire of Humanity*, 8–9.

48 Gilroy, 'Race and the Right to be Human', 6.

49 Bass, *Freedom's Battle*; Barnett, *Empire of Humanity*, 57–8; Thomas Bender, ed., *The Antislavery Debate: Capitalism and Abolitionism as a Problem in Historical Interpretation* (Berkeley: University of California Press, 1992).

50 Deirdre Coleman, *Romantic Colonisation and British Anti-Slavery* (Cambridge: Cambridge University Press, 2005).

51 William Grant Broughton, *The Counsel and Pleasure of God in the Vicissitudes of States and Communities: A Sermon* (Sydney: R. Mansfield, 1829), 10.

52 Coleman, *Romantic Colonisation,* 11; Coral Lansbury, *Arcady in Australia: The Evocation of Australia in Nineteenth-Century English Literature* (Carlton: Melbourne University Press, 1970).

53 From William Thomas's diary, cited in Henry Reynolds, *This Whispering in Our Hearts* (Sydney: Allen and Unwin, 1998), 25; Coleman, *Romantic Colonisation.*

54 Jane Lydon, *The Flash of Recognition: Photography and Indigenous Rights* (Sydney: New South Books, 2012).

55 Elizabeth Elbourne, 'The Sin of the Settler: The 1835–36 Select Committee on Aborigines and Debates over Virtue and Conquest', *Journal of Colonialism and Colonial History* 4, no. 3 (2003) https://muse.jhu.edu/login?auth=0&type=summary&url=/journals/journal_of_colonialism_and_colonial_history/v004/4.3elbourne.html; Zoë Laidlaw, '"Aunt Anna's Report": The Buxton Women and the Aborigines Select Committee, 1835–37', *Journal of Imperial and Commonwealth History* 32, no. 2 (2004): 1–28. Physician Dr Thomas Hodgkin was inspired by the Select Committee in 1837 to establish the British and Foreign Aborigines' Protection Society, with Thomas Fowell Buxton as president.

56 *Report from the Select Committee on Aborigines* (British Settlements), Parliamentary Papers (1837), VII (425), 74–6; Laidlaw, 'Aunt Anna's Report'.

57 Elbourne, 'The Sin of the Settler', para. 48.

58 Alan Lester and Fae Dussart, *Colonization and the Origins of Humanitarian Intervention* (Cambridge: Cambridge University Press, 2014), 1.

59 Ibid., 5.

60 Hilary M. Carey, *God's Empire: Religion and Colonialism in the British World, c.1801–1908* (Cambridge: Cambridge University Press, 2011); Porter, 'Trusteeship, Anti-Slavery and Humanitarianism'.

61 Catherine Hall, *Civilising Subjects: Metropole and Colony in the English Imagination 1830–1867* (Cambridge: Polity, 2002); Tony Ballantyne, W*ebs of Empire: Locating New Zealand's Colonial Past* (Wellington: Bridget Williams Books, 2012).

62 Norman Etherington, 'Introduction', in *Missions and Empire*, ed. Norman Etherington (Oxford and New York: Oxford University Press, 2005); Elizabeth Elbourne, *Blood Ground: Colonialism, Missions, and the Contest for Christianity in the Cape Colony and Britain, 1799–1853* (Montreal: McGill-Queen's University Press, 2002); Bernard Porter, *Critics of Empire: British Radicals and the Imperial Challenge* (London: I. B. Tauris, 2008); Alan Lester, 'Humanitarians and White Settlers in the Nineteenth Century', *Missions and Empire* ed. N. Etherington, The Oxford History of the British Empire Companion Series (Oxford: Oxford University Press, 2005), 64–85.

63 Susan Thorne, *Congregational Missions and the Making of an Imperial Culture in Nineteenth-Century England* (Stanford: Stanford University Press, 1999); see also Hall, *Civilising Subjects*; Elbourne *Blood Ground*.

64 Rowan Strong, *Anglicanism and the British Empire, c.1700–1850* (Oxford and New York: Oxford University Press, 2007), chap. 4.

65 La Trobe to Colonial Secretary, 18 November 1848, cited in Henry Reynolds, *Dispossession: Black Australians and White Invaders* (Sydney: Allen and Unwin, 1989), 192.

66 Isobel Crombie, 'Australia Felix: Douglas T. Kilburn's Daguerreotype of Victorian Aborigines, 1847', *Art Bulletin* 32 (1991): 21–31.

67 Deborah Bird Rose, *Dingo Makes Us Human: Life and Land in an Aboriginal Australian Culture* (Cambridge: Cambridge University Press, 1992); Marcia Langton, 'The Edge of the Sacred, the Edge of Death: Sensual Inscriptions', in *Inscribed Landscapes: Marking and Making Place*, ed. Bruno David and Meredith Wilson (Honolulu: University of Hawaii Press, 2002).

68 William Westgarth, *Australia Felix; or, a Historical and Descriptive Account of the Settlement of Port Phillip* (Edinburgh: Oliver and Boyd, 1848).

69 Patrick Brantlinger, *Dark Vanishings*: *Discourse on the Extinction of Primitive Races, 1800–1930* (Ithaca: Cornell University Press, 2003).

70 *The Sydney Morning Herald*, 15 June 1848, 2.

71 'Australia Felix', *Illustrated London News*, 26 January 1850, 53.

72 James Bennett Clutterbuck, *Port Phillip 1849* (London: John W. Parker, 1850).

73 'Australia Felix', *Illustrated London News*, 26 January 1850, 53.

74 Jayeeta Sharma, 'Missionaries and Print Culture in Nineteenth-Century Assam: The Orunadoi Periodical of the American Baptists Mission', in *Christians and Missionaries in India: Cross-Cultural Communication since 1500*, ed. Robert Frykenberg (Grand Rapids: Wm E. Erdmans Publishing Co., 2003).

75 'Description of Australia', *Orunodai* 6, no. 1 (1851): 1–3. Trans. Jyotiprakash Tamuli in Guwahati, Assam, courtesy of Stephen Morey of La Trobe University, email, November 2012.

76 *Orunodai* was described as having 400 subscribers, and two or three 'small [wood]cuts' were also included in every issue. See *Baptist Missionary Magazine* 38 (1858): 292.

77 Tony Bennett and Patrick Joyce, eds, *Material Powers: Cultural Studies, History and the Material Turn* (London and New York: Routledge, 2010); Tony Bennett, Ben Dibley and Rodney Harrison, 'Introduction: Anthropology, Collecting and Colonial Governmentalities', *History and Anthropology* 25, no. 2 (2014): 137–49.

78 Marilyn Lake and Henry Reynolds, *Drawing the Global Colour Line* (Carlton: Melbourne University Press, 2008).

Chapter 2

1 *Punch*, 4 March 1865, 86.

2 Douglas A. Lorimer, *Colour, Class, and the Victorians: English Attitudes to the Negro in the Mid-Nineteenth Century* (Leicester: Leicester University Press, 1978); John Marriott, *The Other Empire: Metropolis, India and Progress in the Colonial Imagination* (Manchester: Manchester University Press, 2003). Several scholars have drawn upon psychoanalytic approaches in arguing that establishing such equivalences acted as a form of displacement for metropolitan Victorians – for example, as race served to police or transfer class anxieties, or the urban waif served to 'rehearse and modify' the colonial encounter. See Kate Flint, *The Transatlantic Indian, 1776–1930* (Princeton: Princeton University Press, 2009); Anne McClintock, *Imperial Leather: Race, Gender and Sexuality in the Colonial Contest* (New York and London: Routledge, 1995); Lindsay Smith, 'The Shoe-Black to the Crossing Sweeper: Victorian Street Arab and Photography', *Textual Practice* 10, no. 1 (1996): 29–55.

3 Susan Thorne, *Congregational Missions and the Making of an Imperial Culture in Nineteenth-Century England* (Stanford: Stanford University Press, 1999); see also Catherine Hall, *Civilising Subjects: Metropole and Colony in the English Imagination 1830–1867* (Cambridge: Polity, 2002).

4 For discussion of colonial governmentalities see Michel Foucault, *Security, Territory, Population: Lectures at the College de France, 1977–78*, ed. Michel Senellart, trans. Graham Burchell (London: Palgrave Macmillan, 2007).

5 Charles Dickens, *Bleak House* (London: Vintage, [1852–3] 2008), 221. Also in 1853, Dickens wrote his notorious essay 'The Noble Savage', in which he termed Africans 'savages' and as 'something highly desirable to be civilised off the face of the earth'. Charles Dickens, 'The Noble Savage', *Household Words*, 11 June 1853.

6 Thomas Carlyle, 'Occasional Discourse on the Negro Question', *Fraser's Magazine for Town and Country* 40 (1849), 670–9.

7 Ibid.

8 Stephanie Spencer, *O. G. Rejlander: Photography as Art* (Ann Arbor: UMI Research Press, 1985).

9 *The Photographic News*, 8 October 1886.

10 Alfred Wall, 'Photographic Pictures and Illustrations', *Photographic Journal* (15 September 1863): 359.

11 Alfred Wall, 'Rejlander's Photographic Art Studies', *Photo News* (24 September 1886): 619–20.

12 Lydia Murdoch, *Imagined Orphans: Poor Families, Child Welfare, and Contested Citizenship in London* (Chapel Hill: Rutgers University Press, 2006), 21–5.

13 The Church of England had a strong tradition of support for empire and for missions, such as the Church Missionary Society, founded in 1799. In this Anglican engagement with the British Empire, a public theological discourse of empire was articulated.

14 Rowan Strong, *Anglicanism and the British Empire, c.1700–1850* (Oxford: Oxford University Press, 2007), 211–12.

15 Despatch, 20 December 1842. Cited in John Dunmore Lang, *An Historical and Statistical Account of New South Wales: Both as a Penal Settlement and as a British Colony*, vol. 6 (London: Forgotten Books, 1875), 476.

16 Edward Eyre, 'Manners and Customs of the Aborigines of Australia', in his *Journals of Expeditions of Discovery into Central Australia and Overland from Adelaide to King George's Sound in the Years 1840–1*, vol. 2 (London: T. & W. Boone, 1845), 420.

17 The colony followed the usual pattern of relations with the Indigenous inhabitants, ranging from violence to accommodation. Various attempts were made to protect and 'civilise' Aboriginal people and to school Aboriginal children, resulting in the establishment of the Native School Establishment in Adelaide in 1845. Barry Patton, 'Aboriginal Child Separations and Removals in Early Melbourne and Adelaide', in *Evangelists of Empire? Missionaries in Colonial History*, ed. Amanda Barry, Joanna Cruickshank, Andrew Brown-May and Patricia Grimshaw (Melbourne: University of Melbourne eScholarship Research Centre, 2008), http://msp.esrc.unimelb.edu.au/shs/missions.

18 Strong, *Anglicanism and the British Empire*, 218.

19 After viewing a statue of a seamstress inspired by Thomas Hood's pathetic poem 'Song of the Shirt', Short wrote in his diary, 'It is the most pathetic thing I ever saw … it moved me to tears.' See Fred T. Whitington, *Augustus Short, First Bishop of Adelaide: The Story of a Thirty-Four Years' Episcopate* (London: Wells Gardner, Darton and Co., 1888), 262–3.

20 *Report of the Society for the Propagation of the Gospel*, 1849, 189.

21 *The Colonial Intelligencer, or, the Aborigines' Friend* 38 (June 1851): 216.

22 Mathew Blagdon Hale, *The Aborigines of Australia: Being an Account of the Institution for Their Education at Poonindie, in South Australia* (London: Society for Promoting Christian Knowledge, 1889).

23 Ibid., 1.

24 Ibid, 3. Hale wrote,

> It appeared to me that the slaves, when freed from the compulsory control of those who had been their masters, would be subject to no control at all, unless some powerful moral influence could be brought to bear upon them, in place of the physical restraint from which they were being relieved, and I know of no moral influence which could be brought to bear upon them except by means of Christian teaching.

25 Ibid., 62.

26 Fagging was a system developed in Britain's public school system where junior boys would perform a range of simple tasks for senior boys, who were in turn responsible for their welfare. Whitington, *Augustus Short*, 7.

27 This boarding school for colonial youth was not dissimilar from the mission in its aims and approach, which Short described in 1853 as 'educating their minds, shaping their characters, and making their souls Christian'. Katharine Thornton, *The Messages of Its Walls and Fields: A History of St Peter's College, 1847 to 2009* (Adelaide: Wakefield Press, 2010), http://www.stpeters.sa.edu.au/#history.

28 Peggy Brock and Doreen Kartinyeri, *Poonindie: The Rise and Destruction of an Aboriginal Agricultural Community* (Adelaide: Aboriginal Heritage Branch and South Australian Government Printer, 1989), 3–4; Peggy Brock, *Outback Ghettos: A History of Aboriginal Institutionalisation and Survival* (Melbourne: Cambridge University Press, 1993), 24.

29 David Horton, ed., *The Encyclopaedia of Aboriginal Australia: Aboriginal and Torres Strait Islander History, Society and Culture* (Canberra: Aboriginal Studies Press, 1994), 1016. Short proposed that the Society for the Propagation of the Gospel buy a portion of it; he later bought an adjoining run himself to ensure its isolation. Matthew Moorhouse, 'Quarterly Report for Period Ending 30 September 1850', *Register* (1 September 1850): 3–4.

30 Christobel Mattingley and Ken Hampton, eds, *Survival in our Own Land: 'Aboriginal' Experiences in 'South Australia' since 1836* (Adelaide: Wakefield Press, 1988), 179; Augustus Short, *The Poonindie Mission, Described in a Letter from the Lord Bishop of Adelaide to the Society for the Propagation of the Gospel* (London: Society for the Propagation of the Gospel, 1853).

31 Hale, *The Aborigines of Australia*, 22; Cameron Raynes, *A Little Flour and a Few Blankets: An Administrative History of Aboriginal Affairs in South Australia, 1834–2000* (Gepps Cross: State Records of South Australia, 2002), 16.

32 Short, *The Poonindie Mission*, 18; see also *South Australian Register* Saturday 19 March 1853, 3; Wollaston, G. G. 1852. Letter to George Wollaston at Poonindie Mission, Private Record Group (PRG) 1131/2, Mortlock Wing, State Library of South Australia.

33 Short, *The Poonindie Mission*, 18.

34 Susan Thorne, *Congregational Missions and the Making of an Imperial Culture in 19th-Century England* (Stanford: Stanford University Press, 1999); Anna Johnston, *Missionary Writing and Empire, 1800–1860*, Cambridge Studies in Nineteenth-Century Literature and Culture (Cambridge: Cambridge University Press, 2003). For a review of religious publishing in America, see David Paul Nord, *Faith in Reading: Religious Publishing and the Birth of Mass Media in America* (Oxford and New York: Oxford University Press, 2004).

35 Johnston, *Missionary Writing and Empire;* Anna Johnston, 'A Blister on the Imperial Antipodes: Lancelot Edward Threlkeld in Polynesia and Australia', in *Colonial Lives across the British Empire: Imperial Careering in the Long Nineteenth Century*, ed. David Lambert and Alan Lester (Cambridge: Cambridge University Press, 2006), 58–87.

36 Jane Lydon, '"The Colonial Children Cry": Jo the Crossing-Sweep Goes to the Colonies', *Journal of Victorian Culture* 20, no. 3 (2015): 1–18.

37 Short, *The Poonindie Mission;* Augustus Short, *A Visit to Poonindie: and Some Accounts of that Mission to the Aborigines of South Australia* (Adelaide: William Kyffin Thomas, 1872).

38 Short, *The Poonindie Mission*, 16.

39 Ibid., 17–18.

40 Ibid., 18; see also Hale, *The Aborigines of Australia*.

41 John Daly, '"Civilising" the Aborigines: Cricket at Poonindie, 1850–1890', *Sporting Traditions: The Journal of the Australian Society for Sports History* 10, no. 2 (1994): 59–68.

42 Short, *The Poonindie Mission,* 19–20.

43 Acts 17:26 (King James Version).

44 See David Hilliard, *God's Gentlemen: A History of the Melanesian Mission, 1849–1942* (Brisbane: University of Queensland Press, 1978); Charlotte MacDonald, 'Between Religion and Empire: Sarah Selwyn's Aotearoa/New Zealand, Eton and Lichfield, England, c.1840s–1900', *Journal of the Canadian Historical Association* 19, no. 2 (2008): 43–75.

45 Short, *A Visit to Poonindie*, emphasis in original.

46 Adam Smith, *The Theory of Moral Sentiments*, ed. D. D. Raphael and A. L. Macfie (Indianapolis: Liberty Fund, [1759] 1984), 112.

47 Bernard Smith, *European Vision in the South Pacific* (Oxford: Clarendon Press, 1960).

48 Cited in Nicholas Thomas, *Entangled Objects: Exchange, Material Culture, and Colonialism in the Pacific* (Cambridge, MA and London: Harvard University Press, 1991), 172.

49 *South Australian*, 26 June 1849.

50 Matthew Moorhouse, Protector of Aborigines, to Hale, Poonindie, 4 February 1854. University of Bristol Library, Special Collections, Matthew Blagden Hale Papers, DM130/200-204. Protector Matthew Moorhouse, who organized this commission, wrote in February to Hale to let him know that 'he has only had one sitting but if you consider it unlike him when finished Mr Crossland will try again'. Matthew Moorhouse, Protector of Aborigines, to Hale, Poonindie, 6 February 1854. University of Bristol Library, Special Collections, Matthew Blagden Hale Papers, DM130/200-204.

51 In June Hale was charged £6, and in October Moorhouse wrote again to advise Hale that he had 'procured a painting of the boy you sent up a few weeks ago', presumably the portrait now known as Nannultera. Matthew Moorhouse, Protector of Aborigines, to Hale, Poonindie, 22 October 1854. University of Bristol Library, Special Collections, Matthew Blagden Hale Papers, DM130/200-204 [pencilled page 99].

52 Short, *A Visit to Poonindie*, 8.

53 See the University Bristol Library's Mathew Blagden Hale Papers containing eleven Poonindie portraits including four duplicates (series DM130). Also see related contemporary material held in the Pitt Rivers Museum at the University of Oxford; Mill Cottage Museum, Port Lincoln; Ayers House Museum (National Trust of South Australia); and the South Australian Museum.

54 A. De Q. Robin, 'Hale, Mathew Blagden (1811–1895)', *Australian Dictionary of Biography* (Canberra: Australian National University, 2013), http://adb.anu.edu.au/biography/hale-mathew-blagden-3689/text5771.

55 Jane Lydon and Sari Braithwaite, '"Cheque Shirts and Plaid Trowsers": Photographing Poonindie Mission, South Australia', *Journal of the Anthropological Society of South Australia* 37 (2013): 1–30.

56 G. W. Hawkes, 'Poonindie Mission', *South Australian Register*, 28 September 1858, 3.

57 Another six daguerreotypes and ambrotypes survive today in a house museum, Mill Cottage, near Poonindie. Bruce Bott, 'Octavius Hammond of Poonindie: Medical Practitioner and Priest', *Journal of the Historical Society of South Australia* 37 (2009): 22–40. They were probably produced by one of the several travelling photographers in South Australia during the 1850s and 1860s, such as the American Townsend Duryea.

58 See 'Ambrotypes', *Powerhouse Museum*, accessed 16 October 2013, http://www.powerhousemuseum.com/collection/database/theme,1306,Ambrotypes.

59 Margot Riley, Fashion Curator, State Library of New South Wales, personal communication with the author, December 2013.

60 Strong, *Anglicanism and the British Empire*.

61 Report of Mr Edward Hitchin, Secretary to Commissioner of Crown Lands &c. on Poonindie Native Institution April 3rd, 1859, Commissioner of Crown Lands and Internal Correspondence: 59/275.

62 Hale, *The Aborigines of Australia*, 48.

63 John Brown Gribble, *The Warangesda Mission* (London: Wells Gardner, Darton and Co., 1884), 378.

64 See engraving by James Thomson, Portrait of Augustus Short, First Bishop of Adelaide (1849). Courtesy National Library of Australia, Rex Nan Kivell Collection NK1947.

65 Whitington, *Augustus Short*, 263.

66 Westminster Archives, Reports from various colonial dioceses mainly in Australia and New Zealand. Also a report of the Synod of the Church of England held at Goulburn. Accession BUR/F1 1866–1868.

67 Sari Braithwaite, Tom Gara and Jane Lydon, 'From Moorundie to Buckingham Palace: Images of "King" Tenberry and His Son Warrulan, 1845–55', *Journal of Australian Studies* 35, no. 2 (2011): 165–84. Another copy of the Mill Cottage daguerreotype is held in the Pitt Rivers Museum, probably made during the same session.

68 Brock and Kartinyeri, *Poonindie*; Tom Gara, 'Wanganeen, Robert Mckenzie (1896–1975)', *Australian Dictionary of Biography* (Canberra: Australian National University, 2002), http://adb.anu.edu.au/biography/wanganeen-robert-mckenzie-11957/text21431. It is unlikely that the daguerreotypes were made prior to his baptism in 1861.

69 P. A. Howell, 'Poole, Frederic Slaney (1845–1936)', *Australian Dictionary of Biography* (Canberra: Australian National University, 1988), http://adb.anu.edu.au/biography/poole-frederic-slaney-8075/text14093.

70 This belongs to a series of six *cartes de visite* in the collection. The reverse bears the studio mark 'T. Duryea, Photographer to His Excellency, 56 King William Street, Adelaide', which dates it to after 9 November 1867, when the Duke of Edinburgh visited Duryea's studio to have his portrait made. Wanganeen died in 1871, dating the *carte de visite* to between 1867 and 1871. A lantern slide copy of the Bristol *carte de visite* is held in the Pitt Rivers Museum, but with damage visible on the Bristol version carefully touched up by hand.

71 Margaret Allen, 'A "Tigress" in the Paradise of Dissent: *Kooroona* Critiques the Foundational Colonial Story', in *Changing the Victorian Subject*, ed. Maggie Tonkin, Mandy Treagus, Madeleine Seys and Sharon Crozier-De Rosa (Adelaide: University of Adelaide Press, 2014), 59–81.

72 Allen, 'A "Tigress" in the Paradise of Dissent', 61.

73 Mary Meredith, *Koorona* (London: Simpkin, Marshall: 1871), 219.

74 *South Australian Register*, 11 January 1866, 2.

75 In 1866 Short referred to 'a fund placed at my disposal for the benefit of the Natives by Miss Burdett Coutts'. Augustus Short, Letter to Mrs Meredith from the Bishop, 13 January 1866. State Library of South Australia, SRG 94/W60. This collection contains Anglican Church records relating to Point Pearce Aboriginal Mission from Mrs Mary A. Meredith, and comprises letters, reports, vocabulary lists, lists of Aboriginal people living on the mission, 'Rules for the Yorke Peninsula Mission', newspaper cuttings, and a chapter from a periodical on Mission work in South Australia, dating between 1866 and 1892.

76 Mrs James [Christina] Smith, *Caroline and Her Family: With, The Conversion of Black Bobby* (Mt Gambier: Watson & Laurie, 1865).

77 *Border Watch*, 25 November 1865; Advertising, *Border Watch*, 23 December 1865, 3.

78 Mrs James [Christina] Smith, *The Booandik Tribe of South Australian Aborigines: A Sketch of Their Habits, Customs, Legends and Language* (Mount Gambier: South East Book Promotions Inc., 2001)

79 Smith, *The Booandik Tribe*; Smith, *Caroline and Her Family*; Amanda Nettelbeck, '"Seeking to Spread the Truth": Christina Smith and the South Australian Frontier', *Australian Feminist Studies* 16, no. 34 (2001): 83–90.

80 Charles Dickens, *Bleak House* (London: Vintage, 2008), 648–9.

81 Jane Lydon 'The Colonial Children Cry: Jo the Crossing-sweep goes to the colonies', *Journal of Victorian Culture* 20, no. 3 (2015): 1–18.

82 Gribble, *Warangesda*, 378.

83 Hale, *The Aborigines of Australia*, 49.

Chapter 3

1 Enrico Hillyer Giglioli, *Viaggio intorno al globo della r. pirocorvetta italiana Magenta negli anni 1865–66–67–68* [*Voyage around the Globe on the Magenta 1865–68*] (Milano: Maisner, 1875), 750.

2 Ibid., 773–4.

3 These are held in the Pigorini, Rome, accession 4161. The woman is identified in Australian collections such as the State Library of Victoria as belonging to the 'Barwidgee Tribe', and so is affiliated with the Dhudhuroa. I thank Indigenous Elder Gary Murray for his advice on this matter.

4 Kopytoff coined the term 'object biographies'. Igor Kopytoff, 'The Cultural Biography of Things: Commoditization as Process', in *The Social Life of Things*, ed. Arjun Appadurai (Cambridge: Cambridge University Press, 1986), 64–94; Elizabeth Edwards and Christopher Morton, eds, *Photography, Anthropology and History: Expanding the Frame* (Farnham: Ashgate, 2009), 1–24, quotation, 10.

5 Elizabeth Edwards, *Raw Histories: Photographs, Anthropology and Museums* (Oxford and New York: Berg, 2001), 13. See also Morton and Edwards, *Photography, Anthropology and History*. As many have argued in recent years, photographs can be understood as actants, or elements in distributed networks of people and things that make up the social. See also Patrick Joyce and Tony Bennett, 'Introduction', in *Material Powers: Cultural Studies, History and the Material Turn*, ed. Tony Bennett and Patrick Joyce (London and New York: Routledge, 2010).

6 Margaret Jolly and Serge Tcherkézoff, 'Oceanic Encounters: A Prelude', in *Oceanic Encounters: Exchange, Desire, Violence*, ed. Margaret Jolly, Serge Tcherkézoff and Darrell Tryon (Canberra: Australian National University E Press, 2009), 2.

7 Bernard Smith, *European Vision and the South Pacific* (Oxford: Clarendon Press, 1960).

8 Christopher Morton, 'Double Alienation: Evans-Pritchard's Zande and Nuer Photographs in Comparative Perspective', in *Photography in Africa: Ethnographic Perspectives*, ed. Richard Vokes (Woodbridge and Rochester: Boydell and Brewer, 2012).

9 Anita Herle, 'John Layard Long Malakula 1914–15: The Potency of Field Photography', in Christopher Morton and Elizabeth Edwards, *Photography, Anthropology and History : Expanding the Frame* (Farnham, UK: Ashgate, 2009), 241–63.

10 Akhil Gupta and James Ferguson, 'Discipline and Practice: "The Field" as Site, Method and Location in Anthropology', in *Anthropological Locations*: *Boundaries and Grounds of a Field Science*, ed. Akhil Gupta and James Ferguson (Berkeley and Los Angeles: University of California Press, 1997); Jolly and Tcherkézoff, 'Oceanic Encounters'.

11 Giglioli, *Voyage around the Globe*, 773.

12 Ibid., 776. It is likely that Giglioli acquired these from a Melbourne-based photographer such as Washbourne. Aldo Massola reproduced several from the Museo Nazionale di Antropologia e Etnologia in Florence, but I have been unable to re-locate these despite extensive correspondence and a visit in 2013.

13 Jane Lydon, *Eye Contact: Photographing Indigenous Australians* (Durham: Duke University Press, 2005).

14 Giglioli, *Voyage around the Globe*, 774.

15 Charles Walter, 'Tommy Hobson – age 32 – "Merrin Merrin" when born, "Drilloury" when father died Yarra Yarra Tribe (sic)', 1866, albumen silver print, Accession no(s) H91.1/7.

16 Marie Hansen Fels, *I Succeeded Once: The Aboriginal Protectorate on the Mornington Peninsula 1839–40* (Canberra: ANU E Press and Aboriginal History, 2011).

17 *Argus*, 14 June 1866, 6.

18 Frederick Starr, 'Anthropological Work in Europe', *The Popular Science Monthly* 41, no. 1 (1892): 54–72. Scholars have also noted his legacy in the form of extensive natural history and ethnographic collections in Florence and Rome, as well as the objects he gave in exchange, now housed within institutions around the world. See for example B. J. Gill, 'The Cheeseman-Giglioli Correspondence and Museum Exchanges between Auckland and Florence, 1877–1904', *Archives of Natural History* 37, no. 1 (2010): 131–49; Elvira S. Tiberini, 'Plains Indians Artifacts in the E. H. Giglioli Collection of the Pigorini Museum in Rome', *European Review of Native American Studies* 4, no. 2 (1990): 41–44. For a fuller biographical account, see Jane Lydon, '"Veritable Apollos": Aesthetics, Evolution, and Enrico Giglioli's Photographs of Indigenous Australians 1867–78', *Interventions: International Journal of Postcolonial Studies* 16, no. 1 (2014): 72–96.

19 Charles Darwin, *The Origin of Species by Means of Natural Selection* (London: John Murray, 1859).

20 In 1827, for example, naval surgeon Peter Cunningham pronounced Aboriginal people 'at the very zero of civilisation, constituting in a measure the connecting link between man and the monkey tribe'. Peter Cunningham, *Two Years in New South Wales: A Series of Letters, Comprising Sketches of the Actual State of Society in that Colony, of its Peculiar Advantages to Emigrants, of its Topography, Natural History, &c.*, vol. 2 (London: H. Colburn, 1827), 46.

21 Paul Turnbull, 'British Anthropological Thought in Colonial Practice: The Appropriation of Indigenous Australian Bodies, 1860–1880', in *Foreign Bodies: Oceania and the Science of Race 1750–1940*, ed. Bronwyn Douglas and Chris Ballard (Canberra: ANU E Press, 2008); Barry Butcher, 'Darwinism, Social Darwinism and the Australian Aborigines: A Re-Evaluation', in *Darwin's Laboratory: Evolutionary Theory and Natural History in the Pacific*, ed. Roy McLeod and Philip F. Rehbock (Honolulu: University of Hawaii Press, 1994); Henrika Kuklick, '"Humanity in the Chrysalis Stage": Indigenous Australians in the Anthropological Imagination, 1899–1926', *British Journal of the Historical Society* 39, no. 4 (2006): 535–68; Russell McGregor, *Imagined Destinies: Aboriginal Australians and the Doomed Race Theory, 1880–1939* (Carlton: Melbourne University Press, 1997).

22 *Voyage around the Globe* was based on a lengthy article he had contributed to the first volume of the *Archivio per l'Antropologia e la Etnologia* [*Archive for Anthropology and Ethnology*] in 1871, the journal of the new Società Italiana di Antropologia e di Etnologia [Italian Society of Anthropology and Ethnology].

23 Enrico Hillyer Giglioli, *La collezione etnografica del Prof. Enrico Hillyer Giglioli: geograficamente classificata* [*The Geographically Classified Ethnographic Collection of Prof. Enrico Hillyer Giglioli*] (Firenze: Tip. della S. Tipografica, 1911). Giglioli wrote: 'Dopo una diecina d'anni quella mia serie di tipi etnici aveva già acquistato notevoli proporzioni; ed oggi essa riempie venticinque grandi cartelle in-4°, più in-folio e circa una diecina di albums speciali, e consiste di oltre 10 000 fotografie, illustranti, in alcuni casi ampiamente, tutti I popoli viventi.'

24 Thomas Theye, *Der geraubte Schatten: Die Photographie als ethnographisches Dokument* [*The Stolen Shadow: Photography as Ethnographic Document*] (München: Münchner Stadtmuseum, 1989), 61.

25 Edwards, *Raw Histories*, 131–55; Phillip Prodger, *Darwin's Camera, Art and Photography in the Theory of Evolution* (Oxford and New York: Oxford University Press, 2009).

26 Giglioli began his photographic collection two years before his mentor Huxley's circular of 1869, prompting the notion that the student may have inspired the teacher; however, other schemes were in train around this time, including in India. See Edwards, *Raw Histories*; Prodger, *Darwin's Camera*.

27 T. H. Huxley, *Evidence as to Man's Place in Nature* (London: Williams and Norgate, 1863).

28 Edwards, *Raw Histories*, 131–55.

29 Ibid., 148.

30 Philippa Levine, 'States of Undress: Nakedness and the Colonial Imagination', *Victorian Studies* 50, no. 2 (2008): 191.

31 Lydon, *Eye Contact*, 1.

32 Désiré Charnay, 'Rapports sur une Mission dans L'ile de Java et en Australie' ['Report on a Journey in Java and Australia'], trans. Keith F. Davis, in *Désiré Charnay: Expeditionary Photographer*, ed. Keith F. Davis (Albuquerque: University of New Mexico Press, 1981), 148.

33 Edward Tylor, 'Dammann's Race-Photographs', *Nature* (6 January 1876): 184–5. The original German edition was titled *Anthropologisch-Ethnologisches Album in Photographien*.

34 Turnbull, 'British Anthropological Thought', 212.

35 Enrico Giglioli, E. H. (1865) Huxley Papers, Imperial College London, Series 1G – Scientific and general correspondence, Letter to T. H. Huxley from Giglioli, Enrico Hillyer, 4 April 1865. In 1874 Giglioli also translated Huxley's *Manual of the Anatomy of Vertebrate Animals*.

36 Giglioli, *Voyage around the Globe*, 776.

37 Ibid., 796.

38 Stephanie Anderson, '"Three Living Australians" and the Société d'Anthropologie de Paris, 1885', in *Foreign Bodies: Oceania and the Science of Race 1750-1940*, ed. Bronwen Douglas and Chris Ballard (Canberra: ANU E Press, 2008), 229–55.

39 Giglioli, *Voyage around the Globe*, 776.

40 Elizabeth Edwards, 'Evolving Images: Photography, Race and Popular Darwinism', in *Endless Forms: Charles Darwin, Natural Science and the Visual Arts*, ed. Diana Donald and Jane Munro (Cambridge: Fitzwilliam Museum and Yale Center for British Art, 2009), 169.

41 David Bindman, *Ape to Apollo: Aesthetics and the Idea of Race in the 18th Century* (Ithaca: Cornell University Press, 2002); Mary Cowling, *The Artist as Anthropologist: The Representation of Type and Character in Victorian Art* (Cambridge: Cambridge University Press, 1989), 11.

42 Peter D'Agostino, 'Craniums, Criminals, and the "Cursed Race": Italian Anthropology in American Racial Thought, 1861–1924', *Comparative Studies in Society and History* 44, no. 2 (2002): 319–43.

43 See for example Isobel Crombie, 'Australia Felix: Douglas T. Kilburn's Daguerreotype of Victorian Aborigines, 1847', *Art Bulletin* 32 (1991): 21–31; Dianne Reilly and Jennifer Carew, *Sun Pictures of Victoria: The Fauchery-Daintree Collection, 1858* (South Yarra: Currey O'Neil Ross on behalf of the Library Council of Victoria, 1983); Elizabeth Willis, 'Re-Working a Photographic Archive: John Hunter Kerr's portraits of Kulin people, 1850s–2004', *Journal of Australian Studies* 35, no. 2 (2011): 235–49.

44 Prodger, *Darwin's Camera*, 26.

45 Stephen Bann, *Parallel Lines: Printmakers, Painters and Photographers in Nineteenth-Century France* (New Haven: Yale University Press, 2001), 11.

46 Sheila Dillon, *The Female Portrait Statue in the Greek World* (Cambridge: Cambridge University Press, 2010).

47 J. J. Winckelmann, *History of the Art of Antiquity*, trans. Harry Francis Mallgrave (Los Angeles: Getty Research Institute, 2006 [1764]); F. Haskell and N. Penny, *Taste and the Antique: The Lure of Classical Sculpture 1500–1900* (New Haven: Yale University Press, 1981).

48 Josiah C. Nott and George Gliddon, eds, *Types of Mankind: Or, Ethnological Researches Based Upon the Ancient Monuments, Paintings, Sculptures, and Crania of Races, and Upon Their Natural, Geographical, Philological and Biblical History* (Philadelphia: Lippincott and Grambo, 1854).

49 Gwyniera Isaac, 'Louis Agassiz's Photographs in Brazil: Separate Creations', *History of Photography* 21, no. 1 (1997): 3–11; Molly Rogers, *Delia's Tears: Race, Science and Photography in Nineteenth-Century America* (New Haven: Yale University Press, 2010).

50 Charles Pickering, *The Races of Man; and Their Geographical Distribution* (London: H. G. Bohn, 1851).

51 Ibid., 139.

52 Pickering, *The Races of Man*, 142. Pickering shared Giglioli's reservations about the available image corpus of Aboriginal people, of which he concluded, 'in general, these have appeared to me simply caricatures', 140.

53 Ludwig Leichhardt, *Journal of an Overland Expedition in Australia from Moreton Bay to Port Essington a Distance of upwards of 3000 Miles, during the Years 1844–1845* (London: T. & W. Boone, 1847). London engraver, lithographer and watercolour painter Henry Melville (1826–41) lithographed the plates, and his son Harden Sidney Melville provided all other full-page illustrations. Here, Rodius's romanticizing approach contradicts Leichhardt's derogatory narrative, with this disparity in views coloured by their sometimes tense relations during the expedition. Jocelyn Hackforth-Jones, Anita Callaway and Joan Kerr, 'Charles Rodius', *Dictionary of Australian Artists Online*, last updated 2011, http://www.daao.org.au/bio/charles-rodius/biography/?.

54 Jules Sebastien Cesar Dumont d'Urville, *Voyage pittoresque autour du monde* [*Voyages around the World*] (Paris: L. Tenré, 1834); Jules Sebastien Cesar Dumont d'Urville, *An Account in Two Volumes of Two Voyages to the South Seas*, trans. Helen Rosenman (Carlton: Melbourne University Press, 1987); Jules Sebastien Cesar Dumont d'Urville, *Voyage au Pole Sud et dans l'Oceanie* [*Voyage to the South Pole and Oceania*] (Paris: Gide, 1846).

55 Nicholas Thomas, 'Dumont d'Urville's Anthropology', in *Lure of the Southern Seas: The Voyages of Dumont d'Urville 1826-1840*, ed. Susan Hunt, Martin Terry and Nicholas Thomas (Sydney: Historic Houses Trust of New South Wales, 2002), 53–66.

56 See for example Smith, *European Vision in the South Pacific*, 333; for a counter-reading, see Bronwyn Douglas, 'Art as Ethno-Historical Text: Science, Representation and Indigenous Presence in Eighteenth and Nineteenth-Century Oceanic Voyage Literature', in *Double Vision: Art Histories and Colonial Histories in the Pacific*, ed. Nicholas Thomas and Diane Losche (Cambridge: Cambridge University Press, 1999), 65–99.

57 Dumont d'urville, *An Account in Two Volumes*, 43.

58 Giglioli, *Voyage around the Globe*, 775–6.

59 Ibid., 777.

60 For a more detailed analysis, see Lydon, '"Veritable Apollos"'.

61 Giglioli, *Voyage around the Globe*, 778–9.

62 Costanza Giglioli-Casella, *Intorno al mondo: viaggio da ragazzi* [*Around the World: Travel by Children*] (Torino: G. B. Paravia, 1891), 168. Costanza wrote: 'Poveretti! Fanno anche

compassioni in quella tenuta che una volta era la loro e che ora hanno indossato cogli antichi ornamenti soltanto per prestarsi a fare il quadretto.' [English translation provided in text].

63 Bronwen Douglas, 'Foreign Bodies in Oceania', in *Foreign Bodies: Oceania and the Science of Race 1750-1940*, ed. Bronwen Douglas and Chris Ballard (Canberra, Australia: ANU E Press, 2008), 3–30.

Chapter 4

1 Historian Penny Edmonds has recently shown how the 1832 visit of Quakers travelling 'under concern' including to Bass Strait extended the language of abolition to convicts and indentured labourers, as well as Aboriginal people. Penelope Edmonds, 'Collecting Looerryminer's "Testimony": Humanitarian Anti-Slavery Thought and Action in the Bass Strait Islands', *Australian Historical Studies* 45, no. 1 (2014): 13–33.

2 Henry Reynolds, *Fate of a Free People* (Ringwood: Penguin Books, 1995).

3 Henry Reynolds, 'Arthur, Walter George (1820–1861)', *Australian Dictionary of Biography* (Canberra: Australian National University, 2005), http://adb.anu.edu.au/biography/arthur-walter-george-12775/text23047.

4 Charles Edward Stowe, *Harriet Beecher Stowe: The Story of Her Life* (Boston: Houghton Mifflin, 1911), 203.

5 Jo-Ann Morgan, *Uncle Tom's Cabin as Visual Culture* (Columbia: University of Missouri Press, 2007); Maurie D. McInnis, *Slaves Waiting for Sale: Abolitionist Art and the American Slave Trade* (Chicago: University of Chicago Press, 2011).

6 Kylie Mirmohamadi and Susan K. Martin, *Colonial Dickens: What Australians Made of the World's Favourite Writer* (Melbourne: Australian Scholarly Publishing, 2012), 2.

7 See for example, *Empire*, 6 November 1852, 1; 'European News', *The Courier*, 15 December 1852, 3.

8 'Review: Uncle Tom's Cabin (from The Times)', *Empire*, 25 December 1852, 6.

9 Ibid.

10 'American Slavery (From the Liverpool Mercury)', *Empire*, 31 December 1852, 4.

11 Richard Waterhouse, 'The Minstrel Show and Australian Culture', *Journal of Popular Culture* 24, no. 3 (1990): 147–66.

12 Jonathan Richards, *The Secret War: A True History of Queensland's Native Police* (St Lucia: University of Queensland Press, 2008); Robert Ørsted-Jensen, *Frontier History Revisited: Colonial Queensland and the 'History War'* (Brisbane: Lux Mundi Publishing, 2011).

13 Raymond Evans, Kay Saunders and Kathryn Cronin, *Race Relations in Colonial Queensland: A History of Exclusion, Exploitation and Extermination* (Brisbane: University of Queensland Press, 1988), 55–60.

14 Richards, *The Secret War*, 158; Evans, *Fighting Words*, 192.

15 Carl Adolph Feilberg, *The Way We Civilise: Black and White, the Native Police. A Series of Articles Reprinted from the Queenslander* (Brisbane: G. and J. Black, 1880), 47.

16 Feilberg, *The Way We Civilise*, 13.

17 Henry Reynolds, *This Whispering in Our Hearts* (Sydney: Allen and Unwin, 1998), 108.

18 Peter Dowling, 'Destined Not to Survive: The Illustrated Newspapers of Colonial Australia', *Studies in Newspaper and Periodical History* 3, nos. 1–2 (1995): 85–98.

19 For an excellent summary of Vogan's travels and reception drawn from the Fryer Library's

archives, see Mark Cryle, '"Australia's Shadow Side": Arthur Vogan and the Black Police', *Fryer Folios* 4, no. 3 (2009): 18–21.

20 Letter, 4 September 1891, 'Australasia: G97/A, Australia'. UQFL 2/2584, Fryer Library, University of Queensland Library.

21 Arthur James Vogan, *The Black Police: A Story of Modern Australia* (London: Hutchinson and Co., 1890), 1.

22 Cryle, '"Australia's Shadow Side"', 19.

23 John Docker, *Postmodernism and Popular Culture* (Cambridge: Cambridge University Press, 1994), 65–70.

24 *The Brisbane Courier*, 15 September 1888, 6.

25 For example, an expedition to capture Aboriginal workers is termed a 'slave-making expedition'. Vogan, *Black Police*, 96–7. Also see Vogan's other references to Aboriginal people as slaves, 149–50, 215, 223–4, 227–8, 257–8, 368, 385, 390. The prevalence of violent punishment is indicated by whips, handcuffs and leg-irons, which decorate the office of a police inspector, and were sometimes lent to neighbouring squatters to discipline 'their native slaves who are desirous of escaping from their bondage'. Ibid., 168.

26 This comparison becomes particularly stark in chapter 13, 'Claude's Letter to Dick', in which the protagonist writes of his experiences to a sympathetic relative. Vogan, *Black Police*, 220. Other references to Harriet Beecher Stowe and Whittier are made: 184, 219, 216, 223–4. Perhaps coincidentally, two of the Aboriginal people's names, Dina and Carlo, are shared with *Uncle Tom's Cabin* characters. The term 'nigger', of American derivation and which had a derogatory contemporary meaning, is used by the villains of the novel throughout, signalling their contempt for Aboriginal people. Bloodhounds are bred for squatters to pursue escaping Aboriginal workers. Vogan introduces many more general references to American colonization and the plight of the Native American, as well as frequently equating Aboriginal people with Native Americans or African Americans, using terms such as 'braves' or 'bucks'. For example, see Vogan, *Black Police*, 93, 97.

27 See especially Vogan, *Black Police*, 118.

28 A. J. Vogan, [Notes for speeches and letters], UQFL 2/2584, Fryer Library, University of Queensland Library. In another recollection, he described her as 'one of the squatter's harem at Pitchuri Creek'. A. J. Vogan, *The case for the Aborigines*, UQFL 2/2579, 11, Fryer Library, University of Queensland Library. Cryle also notes that in the margin of one of Fryer Library's copies of the book, written in Vogan's hand beside Giles's name are the words, 'Field of Acres & Field, Sandringham Station, 500,000 acres, Pitchuri Creek'. W. G. Field wrote to the Geographical Society of Australasia to defend himself, and complained that Vogan was 'biting the hand that fed him' and that Vogan's behaviour while travelling through the area was 'eccentric' and 'objectionable'. Cryle, '"Australia's Shadow Side"', 19.

29 Vogan, *Black Police*, 150.

30 Marcus Wood, *Blind Memory: Visual Representations of Slavery in England and America* (New York: Routledge, 2000), 236.

31 Wood, *Blind Memory*. Contemporary viewers were well aware of this troubling effect, as they were invited to share the male slavers' sexual frisson in a 'pornography of pain'. Karen Halttunen, 'Humanitarianism and the Pornography of Pain in Anglo-American Culture', *American Historical Review* 100, no. 2 (1995): 303–34.

32 Ian Gibson, *The English Vice: Beating, Sex and Shame in Victorian England and After* (London: Duckworth, 1978).

33 Morgan observes that British pictorial accounts could be 'outright lascivious' compared to American prints. Morgan, *Uncle Tom's Cabin*, 42–3.

34 Vogan, *Black Police*, 156.

35 Feilberg, *The Way We Civilise*, 36.

36 Judith Butler, *Frames of War: When is Life Grievable?* (London: Verso, 2010), 63–100.

37 For thoughtful discussion of this complex and troubling history, see for example Dora Apel and Michelle Wallace Smith, *Lynching Photographs* (Oakland: University of California Press, 2007); Leigh Raiford, *Imprisoned in a Luminous Glare: Photography and the African American Freedom Struggle* (Chapel Hill: University of North Carolina Press, 2011).

38 James Polchin, 'Not Looking at Lynching Photographs', in *The Image and the Witness: Trauma, Memory and Visual Culture*, ed. Frances Guerin and Roger Hallas (London and New York: Wallflower Press).

39 Richard Slotkin, *Regeneration through Violence: The Mythology of the American Frontier 1600-1860* (Norman: University of Oklahoma Press, 1973).

40 Martha Sandweiss, *Print the Legend: Photography and the American West* (New Haven: Yale University Press, 2002), 242–3. See also Peter E. Palmquist, 'Photographing the Modoc Indian War: Louis Heller versus Eadweard Muybridge', *History of Photography* 2, no. 3 (1978): 187–205.

41 Alan Trachtenberg, 'Albums of War: On Reading Civil War Photographs', *Representations* 9 (1985): 1–32.

42 Trachtenberg, 'Albums of War'.

43 Ibid., 1.

44 Ibid., 29.

45 Ken Inglis, *Sacred Places: War Memorials in the Australian Landscape* (Carlton: Melbourne University Publishing, 2008); Henry Reynolds, *Forgotten War* (Sydney: NewSouth Books, 2013). Nelson, cited in Michael Green, 'Lest We Remember: The Australian War Memorial and the Frontier Wars', *Wheeler Centre*, 20 February 2014, http://www.wheelercentre.com/notes/f261bb085eb4.

46 Green, 'Lest We Remember'.

47 Robert Manne, ed., *Whitewash: On Keith Windschuttle's Fabrication of Aboriginal History* (Melbourne: Black Inc. Publishing, 2003); Stuart Macintyre and Anna Clark, *The History Wars* (Carlton: Melbourne University Press, 2003).

48 Vogan, *Black Police*, 107.

49 Ibid., 110.

50 *Northern Territory Times and Gazette*, 20 July 1919, 4.

51 Roger Milliss, *Waterloo Creek: The Australia Day Massacre of 1838, George Gipps and the British Conquest of New South Wales* (Sydney: University of New South Wales Press, 1994). Visual depictions include *Illustrated Christian Weekly*, 24 December 1880; 'MASSACRE ILLUSTRATED. An engraving of the 1838 Myall Creek Massacre of Aboriginal people at the hands of settlers', in Camden Pelham, *The Chronicles of Crime, or, The New Newgate Calendar*, vol. 2 (London: T. Tegg, 1841), 473.

52 'Maltreatment of the Blacks', *Illustrated Christian Weekly*, 24 December 1880.

53 London-based Catherine Impey reviewed Gribble's book *Black but Comely* in her radical political magazine *Anti-Caste*. Caroline Bressey, *Empire, Race and the Politics of Anti-Caste* (London: Bloomsbury, 2013).

54 *Sydney Morning Herald*, 5 April 1892, 6. It was also the first Australian novel to have a third edition. Raymond Evans, 'Kings in Brass Crescents: Defining Aboriginal Labour Patterns in Colonial Queensland', in *Fighting Words: Writing about Race*, ed. Raymond Evans (St Lucia: University of Queensland Press, 1999), 181–2.

55 'The Recent Murder by Blacks', *Argus*, 30 May 1889, 5.

56 Vogan, *Black Police*, 199.

57 William Strutt, 'Aboriginal troopers, Melbourne police, with English corporal', pencil and watercolour, 1850, in *Victoria the Golden: Scenes, Sketches and Jottings from Nature, 1850–1862* (Melbourne: Library Committee, Parliament of Victoria, 1980), 169.

58 'Reviews', *Maitland Mercury & Hunter River General Advertiser*, 12 May 1892, 7.

59 *Brisbane Courier*, 1 April 1891, 7.

60 A. J. Vogan to the Editor, 4 September 1891, reprinted *Anti-Slavery Reporter* 11, no. 5 (1891): 234. And also see Letter, 4 September 1891, 'Australasia: G97/A, Australia', Anti-Slavery and Aborigines' Protection Society, Bodleian Library of Commonwealth & African Studies at Rhodes House, Oxford. Mss Brit Emp S22. G374. Thanks to Fiona Paisley for sharing this material with me.

61 Ibid.

62 Jane Lydon, *The Flash of Recognition: Photography and the Emergence of Indigenous Rights* (Sydney: NewSouth Books, 2012).

63 As Cryle has noted, Vogan claimed later to be a 'marked man', who 'suffered thro' advocating the cause of mercy for the aborigines'. A. J. Vogan to the Editor, 4 September 1891, reprinted *Anti-Slavery Reporter* 11, no. 5 (1891): 234.

64 Arthur Vogan, 'Open Letter. "Attack on the Cinema"', *Western Champion* (27 January 1933): 13.

65 Lynn Festa, *Sentimental Figures of Empire in Eighteenth-Century Britain and France* (Baltimore: Johns Hopkins University Press, 2006).

66 *Brisbane Courier*, 1 April 1891, 7.

67 'Aboriginal Life in Western Australia', *Newcastle Morning Herald and Miners' Advocate*, 14 July 1886, 4; 'Slavery in the North', *Kalgoorlie Western Argus*, 20 April 1899, 18.

68 David S. Reynolds, *Mightier than the Sword: Uncle Tom's Cabin and the Battle for America* (New York: W. W. Norton and Company, 2011).

69 The international photographic firm of George Washington Wilson sent a photographer to Australia during the 1890s, producing an album of Melbourne scenery and a small series of Aboriginal subjects from Grafton in northern New South Wales, showing Bandjalung people engaged in traditional activities such as camping or fishing. Bandjalung/Gumbainggirr Elder Robyne Bancroft suggests that this photograph might show local Elder King Billy Boney and his family outside a home built for them by the Aboriginal community. Personal communication, 23 June 2015.

70 Heather Goodall, *Invasion to Embassy: Land in Aboriginal Politics in New South Wales*, 1770–1972 (Sydney: Allen and Unwin, 1996).

71 John Maynard, *Fight for Liberty and Freedom* (Canberra: Aboriginal Studies Press, 2007).

72 'Timeline – History of Separation of Aboriginal and Torres Strait Islander Children from Their Families', *Australian Human Rights Commission*, accessed 12 June 2015, https://www.humanrights.gov.au/timeline-history-separation-aboriginal-and-torres-strait-islander-children-their-families-text.

73 'Torn from Parents. Serious Allegations at Grafton Treatment of Aboriginals', *Northern Star*, 8 January 1925, 4.

74 'Uncle Tom's Cabin. Classic Example at Grafton. Children Taken from Parents', *Richmond River Express and Casino Kyogle Advertiser*, 9 January 1925, 2.

75 Heather Goodall, '"Assimilation Begins in the Home": The State and Aboriginal Women's Work as Mothers in New South Wales, 1900s to 1960s', *Labour History* 69 (1995): 75–101;

Naomi Parry, '"Such a Longing": Black and White Children in Welfare in New South Wales and Tasmania, 1880–1940' (PhD Thesis, University of New South Wales, 2007).

76 I thank Robyne Bancroft for sharing this information with me. Personal communication, 23 June 2015.

Chapter 5

1 Elsie Rosaline Masson, *An Untamed Territory: The Northern Territory of Australia* (London: Macmillan and Co., 1915).

2 Masson, *An Untamed Territory*, 161.

3 Ben Dibley, 'Assembling an Anthropological Actor: Anthropological Assemblage and Colonial Government in Papua', *History and Anthropology* 25, no. 2 (2014): 263–79; Bennett, Dibley and Harrison, 'Introduction'.

4 Other popular forms of Spencer and Gillen's ethnographies include children's books such as *Queen Anne*, by Ethel Turner (London: Ward, Lock and Co., 1926).

5 Tony Bennett, Ben Dibley and Rodney Harrison, 'Introduction: Anthropology, Collecting and Colonial Governmentalities', *History and Anthropology* 25, no. 2 (2014): 137–49.

6 Helena Wayne, *The Story of a Marriage: The Letters of Bronislaw Malinowski and Elsie Masson, Volume 1, 1916–1920* (London: Routledge, 1995).

7 Richard Selleck, *The Shop: The University of Melbourne, 1850–1939* (Carlton: Melbourne University Press, 2003): 287–8.

8 Alan Powell, 'Gilruth, John Anderson (1871–1937)', *Australian Dictionary of Biography* (Canberra: Australian National University, 1983), http://adb.anu.edu.au/biography/gilruth-john-anderson-6393; D. J. Mulvaney and J. H. Calaby, 'So Much That Is New': Baldwin Spencer, *1860–1929, A Biography* (Carlton: Melbourne University Press, 1985).

9 Masson, *An Untamed Territory*, 1.

10 Key references in this substantial literature include Mulvaney and Calaby, '*So Much That is New*'; John Mulvaney, Howard Morphy and Alison Petch, eds, '*My Dear Spencer': The Letters of F. J. Gillen to Baldwin Spencer* (Melbourne: Hyland House, 1997); Henrika Kuklick, '"Humanity in the Chrysalis Stage": Indigenous Australians in the Anthropological Imagination', *British Journal for the History of Science* 39, no. 4 (2006): 535–68; George Stocking, *After Tylor: British Social Anthropology 1888–1951* (Madison: The University of Wisconsin Press, 1995); Elizabeth Povinelli, *The Cunning of Recognition* (Durham: Duke University Press, 2002); Patrick Wolfe, *Settler Colonialism and the Transformation of Anthropology: The Politics and Poetics of an Ethnographic Event* (London: Cassell, 1999); Russell McGregor, *Imagined Destinies: Aboriginal Australians and the Doomed Race Theory, 1880–1939* (Carlton: Melbourne University Press, 1997); Philip Batty, Lindy Allen and John Morton, eds, *The Photographs of Baldwin Spencer* (Melbourne: The Miegunyah Press, 2005).

11 Michel Foucault, *Security, Territory, Population: Lectures at the College de France, 1977–78*, ed. Michel Senellart, trans. Graham Burchell (London: Palgrave Macmillan, 2007); Peter Pels, 'What Has Anthropology Learned from the Anthropology of Colonialism?' *Social Anthropology* 16, no. 3 (2008): 280–99.

12 Bennett, Dibley and Harrison, 'Introduction'.

13 See especially Tony Bennett, 'Making and Mobilising Worlds', in *Material Powers: Cultural Studies, History and the Material Turn*, ed. Tony Bennett and Patrick Joyce (London and New York: Routledge, 2010), 190–208.

14 Cited in Stocking, *After Tylor*, 8.

15 A reviewer of their 1904 *The Northern Tribes of Central Australia* concluded, 'The popular impression that the Australian native is the lowest in the scale of civilisation … will be deepened by this volume.' Cited in Mulvaney et al., '*My Dear Spencer*', 9; Kuklick '"Humanity in the Chrysalis Stage"'.

16 Stocking, *After Tylor*, 96. Baldwin Spencer and F. J.Gillen, *The Native Tribes of Central Australia* (London: Macmillan, 1899).

17 Stocking, *After Tylor*: for example, *The Native Tribes of Central Australia* (1899) was mined by influential British anthropologist James Frazer, author of the classic study of comparative religion, *The Golden Bough* (1890). See also D. J. Mulvaney, 'Spencer, Sir Walter Baldwin (1860–1929)', *Australian Dictionary of Biography* (Canberra: Australian National University, 1990), http://adb.anu.edu.au/biography/spencer-sir-walter-baldwin-8606/text15031; Howard Morphy, 'More Than Mere Facts: Repositioning Spencer and Gillen in the History of Anthropology', in *Exploring Central Australia: Society, Environment and the 1894 Expedition*, ed. S. R. Morton and D. J. Mulvaney (Chipping Norton: Surrey Beatty, 1996), 135–49.

18 Bronislaw Malinowski, review of *Across Australia*, by Baldwin Spencer and F. J. Gillen, *Folk-Lore* 24, no. 2 (1913): 278–9. Baldwin Spencer and F. J. Gillen, *Across Australia* (London: Macmillan, 1912), 2 vols.

19 W. Baldwin Spencer, *Preliminary Report on the Aboriginals of the Northern Territory* (Melbourne: Under Authority of the Minister for External Affairs, Albert J. Mullett, Government Printer, July 1913), 9.

20 Spencer, *Preliminary Report*, 14.

21 Wolfe, *Settler Colonialism and the Transformation of Anthropology.*

22 Mulvaney and Calaby, '*So Much That Is New*', 308.

23 McGregor, *Imagined Destinies*, 62–86; Tony Austin, *Never Trust a Government Man: Northern Territory Aboriginal Policy 1911–1939* (Darwin: Northern Territory University, 1997). Powers to remove children had already been established by the 1897 *Aboriginal Protection and Restriction of the Sale of Opium Act* (Qld), which made the Chief Protector the legal guardian of every Aboriginal and 'half-caste' child under eighteen years old, allowing any Aboriginal person to be forced onto a mission or settlement, and the removal of children by force, and which was the model for both the *South Australian Aborigines Act* (1911) and the federal *Northern Territory Aboriginals Ordinance* (1911).

24 McGregor, *Imagined Destinies*, 79.

25 Baldwin Spencer, 'An Untamed Territory', *Argus*, 27 November 1915, 6.

26 Spencer, *Preliminary Report*, 16.

27 Masson, *An Untamed Territory*, 113–14; 9 October 1913, Letter From Patrick Cahill to Walter Baldwin Spencer Pitt Rivers Museum, 4 Cahill_03. 'Spencer and Gillen: A Journey through Aboriginal Australia' website http://spencerandgillen.net/, accessed 20 May 2015.

28 'Impressions of the Roper River Church of England Mission to Aborigines', 13 July 1913. Museum Victoria XM6167, 'Spencer and Gillen: A Journey through Aboriginal Australia' website http://spencerandgillen.net/, accessed 20 May 2015.

29 Spencer, 'An Untamed Territory'.

30 Masson, *An Untamed Territory*, 50. For a discussion of constructions of domestic servants, see Julia Martınez and Claire Lowrie, 'Colonial Constructions of Masculinity: Transforming Aboriginal Australian Men into "Houseboys"', *Gender & History* 21, no. 2 (2009): 305–23.

31 Madeleine McGuire, 'The Legend of the Good Fella Missus', *Aboriginal History* 14 (1990): 124–51.

32 Katherine Ellinghaus, 'Racism in the Never-Never: Disparate Readings of Jeannie Gunn', *Hecate* 23, no. 2 (1997): 76–94.

33 Anne McClintock, *Imperial Leather: Race, Gender, and Sexuality in the Colonial Contest* (London: Routledge, 1993), 6.

34 Victoria Haskins, 'Beyond Complicity: Questions and Issues for White Women in Aboriginal History', *Australian Humanities Review* 39–40 (2006), http://www.australianhumanitiesreview. org/archive/Issue-September-2006/haskins.html.

35 Spencer, 'An Untamed Territory'.

36 Powell, 'Gilruth, John Anderson (1871–1937)'.

37 Meaghan Morris, *Identity Anecdotes: Translation and Media Culture* (London: Sage, 2006), 58.

38 Masson, *An Untamed Territory*, 85.

39 Ibid., 62–7.

40 Spencer, *Preliminary Report*, 14; Masson, *An Untamed Territory*, 150, 154.

41 Kuklick dryly terms these 'the last word on their subject'. See her '"Humanity in the Chrysalis Stage"', 543n 37.

42 Elizabeth Edwards, *Raw Histories: Photographs, Anthropology and Museums* (Oxford and New York: Berg, 2001), 157–8; Wolfe, *Settler Colonialism*, 154.

43 Spencer, *Preliminary Report*, 12.

44 Ibid., 12–13.

45 Ibid., 13.

46 Baldwin Spencer and F. J. Gillen, *Across Australia* (London: Macmillan, 1912), 6–7.

47 Povinelli, *The Cunning of Recognition*, 85; see also Nicolas Peterson, 'Visual Knowledge: Spencer and Gillen's Use of Photography in *The Native Tribes of Central Australia*', *Australian Aboriginal Studies* 1 (2006): 12–22.

48 Masson, *An Untamed Territory*, 161.

49 I thank Tony Hughes-d'Aeth for pointing out this comparison.

50 Masson, *An Untamed Territory*, 161.

51 Julia Eckert, Franz von Benda-Beckman and Keebet von Benda-Beckman (eds) *Rules of Law and Laws of Ruling: On the Governance of Law* (Burlington, VT: Ashgate 2013), 3–4.

52 Telegram, Gilruth to Secretary External Affairs in Melbourne, Darwin 87 6/11 Section 95 10A. National Archives of Australia, Series A3, Item NT1914/808, 'C. E. Campbell, Murder of'. Barcode 49983.

53 'Riddled with Spears', *Daily Post*, 12 July1913, 3. National Archives of Australia, Series A3, Item NT1914/808, 'C. E. Campbell, Murder of'. Barcode 49983.

54 *Northern Territory Times*, 28 August 1913. National Archives of Australia, Series A3, Item NT1914/808, 'C. E. Campbell, Murder of'. Barcode 49983, 4.

55 *Northern Territory Times*, 25 September 1913. National Archives of Australia, Series A3, Item NT1914/808, 'C. E.Campbell, Murder of'. Barcode 49983, 6.

56 'News and Notes', *West Australian*, 31 December 1915, 6.

57 For further details of this case and its aftermath, see National Archives of Australia, Series A3, Item NT1914/808, 'C. E. Campbell Murder of', Barcode 49983. I thank Douglas Djalanba of Warruwi (South Goulburn Island) for his interest in his ancestor's story. It is worth noting that the Kunibidgi people now living in Maningrida do not appear to remember this event. I thank Glenn Auld for assistance in contacting this community.

58 Masson, *An Untamed Territory*, 161.

59 *Northern Territory Times*, 25 September 1913. National Archives of Australia, Series A3, Item NT1914/808, 'C. E. Campbell Murder of'. Barcode 49983, 6.

60 Spencer, *Preliminary Report*, 18–19.

61 Hansard, 18 September 1913. National Archives of Australia, Series A3, Item NT1914/808, 'C. E. Campbell Murder of'. Barcode 49983, 5.

62 November 1913, Minute Paper for the Executive Council, 'Commutation of the Death Sentences Imposed on the Australian Aborigines Daroolba, Angoodyeah, Terrendillie, Wharditt and Lemerebee' approved Governor-General, National Archives of Australia, Series A3, Item NT1914/808, 'C. E. Campbell Murder of'. Barcode 49983, 55.

63 Masson, *An Untamed Territory*, 177.

64 Ibid., 178.

65 Spencer, 'An Untamed Territory'.

66 Mark Finnane, 'The Limits of Jurisdiction: Law, Governance and Indigenous People in Colonized Australia', in *Law and Politics in British Colonial Thought: Transpositions of Empire*, ed. Shaunnagh Dorsett and Ian Hunter (Basingstoke: Palgrave Macmillan, 2010), 149–68.

67 Heather Douglas and Mark Finnane, *Indigenous Crime and Settler Law* (Basingstoke: Palgrave Macmillan, 2012).

68 Finnane, 'The Limits of Jurisdiction', 3–4.

69 Judge David Bevan, 'Trials for Murder N. T.', 3 December 1913, National Archives of Australia, Series A3, Item NT1914/426.

70 Bevan, 'Trials for Murder N. T.', 1.

71 Douglas and Finnane, *Indigenous Crime and Settler Law*, 76–9; Finnane, 'The Limits of Jurisdiction'. Bevan was able to show that criminal trials conducted in Darwin since 1884 were characterized by a pattern of sentencing Aboriginal accused to death, but often commuting their sentence to life imprisonment. No white men had been executed during that time. Gilruth wrote to Minister for External Affairs [PM Glynn], 'Trials for Murder N. T.', J. A. Gilruth to Minister for External Affairs [PM Glynn], 27 September 1913, National Archives of Australia, Series A3, Item NT1914/426.

72 Bevan, 'Trials for Murder N. T.'

73 Patrick Glynn, cited in Douglas and Finnane, *Indigenous Crime and Settler Law*, 76–9.

74 Anthropologist Adolphus Peter Elkin also noted this pattern in the 1930. See his 'Anthropology and the Future of the Australian Aborigines', *Oceania* 1 (1934): 1–18.

75 Spencer, *Preliminary Report*, 19.

76 Marilyn Lake and Henry Reynolds, *Drawing the Global Colour Line: White Men's Countries and the International Challenge of Racial Equality* (Cambridge: Cambridge University Press, 2008), 2–3.

Chapter 6

1 Western Australia, *Royal Commission on the Condition of the Natives* (Perth: Government Printer, 1905), 130. At the time, Roth was the Queensland Protector of Aborigines.

2 H. G. Wells, *A Modern Utopia* (London: Chapman and Hall, 1905); H. G. Wells, *Experiment in Autobiography*, vol. 2 (New York: Macmillan, 1934), 645.

3 Frederick Cooper, 'Conditions Analogous to Slavery: Imperialism and Free Labour Ideology in Africa', in *Beyond Slavery: Explorations of Race, Labor and Citizenship in Post-Emancipation Societies,* ed. Frederick Cooper, Thomas C. Holt and Rebecca J. Scott (Chapel Hill: University of North Caroline Press, 2000), 111–12.

4 Kevin Grant, *A Civilised Savagery: Britain and the New Slaveries in Africa, 1884–1926* (New York: Routledge, 2005).

5 Rachel Bright, *Chinese Labour in South Africa, 1902–10: Race, Violence, and Global Spectacle* (Basingstoke: Palgrave Macmillan, 2013).

6 Herbert Samuel. Britain, House of Commons, *Debates*, 16 February 1904, vol. 129, columns 1501–66.

7 Frederick Cooper, *From Slaves to Squatters: Plantation Labor and Agriculture in Zanzibar and Coastal Kenya, 1890–1925* (New Haven: Yale University Press, 1980); Howard Temperley, *After Slavery: Emancipation and Its Discontents* (London: Frank Cass Publishers, 2000).

8 John Campbell. Britain, House of Commons, *Debates*, 30 March 1905, vol. 143, columns 1742–1807.

9 Ibid.

10 Ibid.

11 Ann Curthoys and Jeremy Martens, 'Serious Collisions: Settlers, Indigenous People, and Imperial Policy in Western Australia and Natal', *Journal of Australian Colonial History* 15 (2013): 121–44.

12 Alfred Lyttelton. Britain, House of Commons, *Debates*, 30 March 1905, vol. 143, columns 1742–1807.

13 Gilbert Parker, Ibid.

14 Archbishop of Canterbury. Britain, House of Lords, *Debates*, 9 May 1905, vol. 145, columns 298–321.

15 William Roger Louis, 'Triumph of the Congo reform movement 1905–1908', in *Boston University Papers on Africa*, vol. 2, ed. Jeffrey Butler (Boston: Boston University Press, 1966), 282.

16 Cited in Grant, *A Civilised Savagery*, 70.

17 Sharon Sliwinski, *Human Rights in Camera* (Chicago: Chicago University Press, 2011), 57–81; John Peffer, 'Snap of the Whip/Crossroads of Shame: Flogging, Photography, and the Representation of Atrocity in the Congo Reform Campaign', *Visual Anthropology Review* 24, no. 1 (2008): 55–77.

18 Mark Twain, *King Leopold's Soliloquy: A Defense of His Congo Rule* (Boston: P. R. Warren Company).

19 Edmund Morel, cited in Sliwinski, *Human Rights in Camera*, 68–9.

20 Sliwinski, *Human Rights in Camera*, 59.

21 Christina Twomey, 'Severed Hands: Authenticating Atrocity in the Congo, 1904–1913', in *Picturing Atrocity: Photography in Crisis*, ed. Geoffrey Batchen, Mick Gidley, Nancy K. Miller and Jay Prosser (London: Reaktion Books, 2012), 31–50.

22 Thomas Laqueur, 'Bodies, Details, and the Humanitarian Narrative', in *The New Cultural History*, ed. Lynn Hunt (Berkeley and Los Angeles: University of California Press, 1989), 176–204.

23 Lynn Festa, *Sentimental Figures of Empire in Eighteenth-Century Britain and France* (Baltimore: Johns Hopkins University Press, 2006), 3.

24 Edmund D. Morel, *Red Rubber: The Story of the Rubber Slave Trade Flourishing on the Congo in the Year of Grace 1906* (London: T. Fisher Unwin, 1906), 212–13.

25 'Slavery in West Australia: What Our Readers Think. Letters to the Editor', *Daily News*, 4 December 1901, 8.

26 'The Aborigines Question. The Investigations by Dr. Roth', *West Australian*, 30 January 1905, 5.

27 'Editorial', *West Australian*, 25 February 1905, 5.

28 'The Aborigines Question. A Pearler's Protest in Defence of Police', *West Australian*, 9 February 1905, 3.

29 'The Aborigines Question. Dr Roth's Report: Interview with Sir John Forrest. The Difficulty of the Native Question. The Police Defended', *West Australian*, 4 February 1905, 7. See also 'Alleged Ill-treatment of Australian Natives', *Times*, 11 January 1907, 3.

30 Rev. H. Wilkinson, 'The Aboriginal Question: "A Grave Indictment – Corruption, cruelty and lust"', *West Australian*, 6 February 1905, 9. This passage was also quoted by Rev. Rentoul, 'To the Editor of the Age', Age, 12 April 1904, 3.

31 John Durham Peters, 'Witnessing', *Media, Culture and Society* 23 (2001): 707–11; James Polchin, 'Not Looking at Lynching Photographs', in *The Image and the Witness: Trauma, Memory and Visual Culture*, ed. Frances Guerin and Roger Hallas (London and New York: Wallflower Press, 2007), 207–22.

32 Chris Healy, *Forgetting Aborigines* (Sydney, NSW: UNSW Press, 2008).

33 Anupama Rao and Steven Pierce, 'Discipline and the Other Body: Humanitarianism, Violence, and the Colonial Exception', in *Discipline and the Other Body: Correction, Corporeality, Colonialism*, ed. Steven Pierce and Anupama Rao (Durham: Duke University Press, 2006), 1–35.

34 'The Aborigines Question', *Western Mail*, 18 February 1905, 12; and *Illustrated Supplement*, 24.

35 'Children Appeared "Bright and Neatly Clothed": The Other Side of the Picture: What Dr Camm Saw', *Morning Herald*, 3 February 1905, 3.

36 John Collette, 'Hermann Klaatsch's Views on the Significance of the Australian Aborigines', *Aboriginal History* 11 (1987): 98–100.

37 Hermann Klaatsch, 'Some Notes on Scientific Travel amongst the Black Population of Tropical Australia in 1904, 1905, 1906. Read at the Adelaide Meeting of the Australasian Association for the Advancement of Science, held January, 1907', *Report of the Australasian Association for the Advancement of Science*, vol. 11 (1908), 7, http://nla.gov.au/nla.aus-vn1864548.

38 Klaatsch, 'Some Notes on Scientific Travel', 15.

39 Fiona Paisley, 'Mock Justice: World Conservation and Australian Aborigines in Interwar Switzerland', *Transforming Cultures* 3, no. 1 (2008): 196–226; Hermann Klaatsch, 'Schlussbericht uber meine Reise nach Australien in den Jahren 1904–1907' ['Final Report on My Trip to Australia in the Years 1904–1907'], *Zeitschrift fur Ethnologie* [Journal of Ethnology] 39 (1907): 634–90.

40 'The Treatment of Natives in Western Australia', *The Anti-Slavery Reporter* 27, no. 1 (1907): 31. See also 'Alleged Ill-treatment of Australian Natives', *Times*, 11 January 1907, 3.

41 'The Treatment of Natives in Western Australia', *The Anti-Slavery Reporter* 27, no. 1 (1907): 31.

42 Sara Ahmed, 'The Politics of Bad Feeling', *Australian Critical Race and Whiteness Studies Association Journal* 1 (2005): 77.

43 John Campbell. Britain, House of Commons, *Debates*, 30 March 1905, vol. 143, columns 1742–1807.

44 'The Natives of Western Australia', *The Anti-Slavery Reporter* 25, no. 1 (1905): 20–1.

45 'Chief Protector of Aboriginals, Brisbane, communication to Rentoul, March 30, 1906', Notebooks re the Australian Aborigines, 1905. Notebook 1, 4. Walter Malcolmson Papers, MSS. 1131, b., Mitchell Library, State Library of NSW, Sydney, emphasis in original.

46 'The Treatment of Natives of Western Australia', *The Anti-Slavery Reporter* 25, no. 2 (1905): 39–40; 'The Treatment of Natives of Western Australia', *The Anti-Slavery Reporter* 25, no. 4 (1905): 109; 'The Treatment of Australian Natives', Times, 2 February 1905, 4.

47 Cited in 'Inferior Races', *The Anti-Slavery Reporter* 25, no. 4 (1907): 88.

48 For a detailed analysis of Wells's cosmopolitan views, see John S. Partington, *Building Cosmopolis: The Political Thought of H. G. Wells* (London: Ashgate, 2003).

49 Wells, *Experiment in Autobiography*, 645.

50 H. G. Wells, *War of the Worlds* (London: Heinemann, 1898), 2.

51 H. G. Wells, *Anticipations of the Reaction of Mechanical and Scientific Progress Upon Human Life and Thought* (London: Chapman and Hall, 1902).

52 Wells, *Experiment in Autobiography*, 643, 645.

53 Ibid., 649–51.

54 Ibid., 657.

55 H. G. Wells, *A Modern Utopia* (London: Chapman and Hall, 1905), 307.

56 Ibid., 313–14.

57 Ibid., 315–16.

58 Ibid., 316.

59 Wells, *A Modern Utopia*, 335. Wells also cited W. I. Thomas, 'The Psychology of Race Prejudice', *American Journal of Sociology* 9 (1904): 593–611, an argument for the social basis of race relations.

60 Wells, *A Modern Utopia*, 223–5.

61 Ibid.

62 Sliwinski, *Human Rights in Camera*, 1.

63 H. N. Hutchinson, J. W. Gregory and R. Lydekker, *The Living Races of Mankind. A Popular Illustrated Account of the Customs, Habits, Pursuits, Feasts, and Ceremonies of the Races of Mankind throughout the World* (New York: D. Appleton and Co., 1902), ii.

64 Ibid.

65 O. T. Mason, 'Book Reviews. *The Living Races of Mankind*', *American Anthropologist* 4 (1902): 305–6.

66 Wells, *A Modern Utopia*, 223–5.

67 Elizabeth Edwards, *Raw Histories: Photographs, Anthropology and Museums* (Oxford and New York: Berg, 2001).

68 Edward Tylor, 'Dammann's Race-Photographs', *Nature* 13 (1876): 184–5.

69 James Hannavy, ed., *Encyclopaedia of Nineteenth-Century Photography* (London: Routledge, 2013), 813–14.

70 Wells, *A Modern Utopia*, 223–5.

71 Ibid., 325.

72 Ibid., 331.

73 Michael Sherborne, *H. G. Wells: Another Kind of Life* (London: Peter Owen, 2010), 176–9.

74 A. N. Mandelstam, 'La protection international des droits de l'homme', cited in Jan Herman Burgers, 'The Road to San Francisco: The Revival of the Human Rights Idea in the Twentieth Century', *Human Rights Quarterly* 14 (1992): 447–77.

75 Burgers, 'The Road to San Francisco', 41.

76 Wells had sent his draft declaration to many people he knew, including Theodore Roosevelt, and in early 1940 he included the text of the declaration in his books *The New World Order* (London: Secker and Warburg, 1940) and *The Commonsense of War and Peace* (Harmondsworth: Penguin Books, 1940), followed by *The Rights of Man, or What Are We Fighting For?* (Harmondsworth: Penguin Special, 1940).

77 Burgers, 'The Road to San Francisco'.

78 Wells, *A Modern Utopia*, 325.

Chapter 7

1 As early as 1928 Dr William Walker had photographed conditions at the Alice Springs Bungalow home for half-caste children. By the 1930s campaigners such as the medical doctor Dr Charles Duguid used images of ill-treatment such as neck-chained Aborigines to argue for reform. For an extended analysis see Jane Lydon, *The Flash of Recognition: Photography and the Emergence of Indigenous Rights* (Sydney: NewSouth Books, 2012).

2 For example, see Lynn Hunt, 'Foreword', in *Human Rights in Camera*, ed. Sharon Sliwinski (Chicago: University of Chicago Press, 2011), ix.

3 Susie Linfield, *The Cruel Radiance: Photography and Political Violence* (Chicago: University of Chicago Press, 2011), 37.

4 For example, see Susan Sontag, *On Photography* (London: Allan Lane, 1978), 20; Barbie Zelizer, *Remembering to Forget: Holocaust Memory through the Camera's Eye* (Chicago: University of Chicago Press, 1998).

5 Constitution of the United Nations Educational, Scientific and Cultural Organization, in UNESCO, *Basic Texts, 2014 Edition* (Paris: UNESCO, 2014), 6, http://unesdoc.unesco.org/images/0022/002269/226924e.pdf.

6 Glenda Sluga, 'UNESCO and the (One) World of Julian Huxley', *Journal of World History* 21, no. 3 (2009): 393–418.

7 Jay Winter, *Dreams of Peace and Freedom* (New Haven: Yale University Press, 2006), 99–121.

8 Frederick Cooper and Randall Packard, *International Development and the Social Sciences* (Berkeley: University of California Press, 1997); Frederick Cooper, 'Modernizing Colonialism and the Limits of Empire', in *Lessons of Empire: Imperial Histories and American Power*, ed. Craig Calhoun, Frederick Cooper and Kevin W. Moore (New York: New Press, 2006); William Roger Louis, *Imperialism at Bay: The United States and the Decolonization of the British Empire* (Oxford: Oxford University Press, 1987), 104.

9 Edward Said, *Culture and Imperialism* (New York: Alfred A. Knopf, 1993), xiii; and see Jessica Whyte, 'The Fortunes of Natural Man: Robinson Crusoe, Political Economy, and the Universal Declaration of Human Rights', *Humanity: An International Journal of Human Rights, Humanitarianism, and Development* 5, no. 3 (2014): 301–21.

10 Joseph R. Slaughter, *Human Rights, Inc.: The World Novel, Narrative Form, and International Law* (New York: Fordham University Press, 2007), 53.

11 Tom Allbeson, 'Photographic Diplomacy in the Postwar World: UNESCO and the Conception of Photography as a Universal Language, 1946–1956', *Modern Intellectual History* (2015): 1–33.

12 Edward Steichen, *The Family of Man: ?An Exhibition of Creative Photography, Dedicated to the Dignity of Man, with Examples from 68 Countries* (New York: Museum of Modern Art, 1955), 4.

13 Edward Steichen, 'On Photography', in *Photographers on Photography*, ed. Nathan Lyons (Englewood Cliffs: Prentice Hall, 1966), 107.

14 Roland Barthes, *Mythologies* [Translated Annette Lavers] (New York: The Noonday Press, 1972 [1957]), 100–2.

15 Allan Sekula, 'The Traffic in Photographs', *Art Journal* 41, no. 1 (1981): 15–25, quotation, 19.

16 Louis Kaplan, *American Exposures: Photography and Community in the Twentieth Century* (Minneapolis: University of Minnesota Press, 2005).

17 Edward Steichen, 'Photography: Witness and Recorder of Humanity', *Wisconsin Magazine of History* 41 (1958): 160.

18 Kaplan, *American Exposures*, 74–6.

19 Viktoria Schmidt-Linsenhoff, 'Denied Images: The Family of Man and the Shoa', in *The Family of Man, 1955–2001: Humanism and Postmodernism, A Reappraisal of the Photo-Exhibition by Edward Steichen*, ed. Jean Black and Viktoria Schmidt-Linsenhoff (Marburg: Jonas Verlag, 2005), 81–99.

20 UNESCO, *Human Rights: Exhibition Album* (Paris: UNESCO, 1950). This exhibition was recently re-staged by Katrine Bregengaard and Eva Prag in April 2014 at Columbia University, http://home.columbia.edu/event/visualizing-universalism-unesco-human-rights-exhibition-1949-1953-71426.

21 'Australia and the Universal Declaration on Human Rights', *Australian Human Rights Commission*, accessed 21 May 2015, https://www.humanrights.gov.au/publications/australia-and-universal-declaration-human-rights; Annemarie Devereaux, *Australia and the Birth of the International Bill of Human Rights: 1946–1966* (Annandale: Federation Press, 2005).

22 Mary Ann Glendon, *A World Made New: Eleanor Roosevelt and the Universal Declaration of Human Rights* (New York: Random House, 2001), 87.

23 UNESCO, 'A Short History of Human Rights', in *Human Rights: Exhibition Album* (Paris: UNESCO, 1950), 5.

24 Allbeson 'Photographic Diplomacy', 15.

25 UNESCO, *Human Rights: Exhibition Album*.

26 'Exhibition on Human Rights', *News* (Adelaide), 12 November 1951, 20.

27 'Human Rights in Pictures', *News* (Adelaide), 6 November 1951, 3.

28 Hugh Stretton, 'Duncan, Walter George Keith (1903–1987)', *Australian Dictionary of Biography* (Canberra: Australian National University 2007), http://adb.anu.edu.au/biography/duncan-walter-george-keith-12443/text22375.

29 'Awakening Needed to Human Rights', *Advertiser*, 13 November 1951, 2. The campaign for women's suffrage led to the vote for women in South Australia in 1894. Susan Magarey, 'Why Didn't They Want to Be Members of Parliament? Suffragists in South Australia', in *Suffrage and Beyond: International Feminist Perspectives*, ed. Caroline Daley and Melanie Nolan (Auckland: Auckland University Press, 1994), 67–88.

30 'Awakening Needed to Human Rights', *Advertiser*, 13 November 1951, 2.

31 'Govt Achievements "Can Be Measured"', *News* (Adelaide), 12 November 1951, 7.

32 'Security of Family Life', *News* (Adelaide), 14 November 1951, 3.

33 Sekula, 'The Traffic in Photographs', 19.

34 Devereaux, *Australia and the Birth*, 135–6.

35 Mark Reinhardt, Holly Edwards and Erinna Duganne, eds, *Beautiful Suffering: Photography and the Traffic in Pain* (Chicago: University of Chicago Press, 2007); Arthur Kleinman and

Joan Kleinman, 'The Appeal of Experience; the Dismay of Images: Cultural Appropriations of Suffering in Our Times', *Daedalus* 125, no. 1 (1996): 1–23.

36 Cornelia Brink, 'Secular Icons: Looking at Photographs from Nazi Concentration Camps', *History and Memory* 12, no. 1 (2000): 135–50. Brink concludes that despite their dual character as reality and unreality, their ambiguities and contextual shifts in meaning nonetheless serve an important role, because such crimes demand evidence.

37 Zelizer, *Remembering to Forget*.

38 Fay Anderson, '"They Are Killing All of Us Jews": Australian Press Memory of the Holocaust', in *Aftermath: Genocide, Memory and History*, ed. Karen Auerbach (Melbourne: Monash University Publishing, 2015), 65–85. See also Lydon, *Flash of Recognition*, for discussion of comparisons between Jewish and Aboriginal victims.

39 'Awakening Needed to Human Rights', *Advertiser*, 13 November 1951, 2.

40 See for example Ravi de Costa, *A Higher Authority: Indigenous Transnationalism and Australia* (Sydney: UNSW Press, 2006), 75.

41 'Human Rights Plea for Aborigines', *Advertiser*, 20 June 1951, 3.

42 Devereaux, *Australia and the Birth*, 237.

43 Such as the prohibition of arbitrary interference and the removal of half-caste children; the right to freedom of movement and the restrictions on movement in the Territory; the right to marry and laws requiring permission for Indigenous women to marry non-Indigenous males; equal suffrage and the ban on voting; and, finally, the right to work and restrictions on Indigenous peoples working in the mining industry. Devereaux, *Australia and the Birth*, 73.

44 In 1938 the new Minister for the Interior responsible for Commonwealth Aboriginal policy, J. W. 'Blackjack' McEwan, placed before parliament proposals for a 'New Deal for the Aborigines in the Northern Territory' for economic and social assimilation. Tim Rowse, ed., *Contesting Assimilation* (Perth: API Network, 2005).

45 Rowse, *Contesting Assimilation*; Russell McGregor, *Indifferent Inclusion: Aboriginal People and the Australian nation* (Canberra: Aboriginal Studies Press, 2011).

46 Michael Courtney, 'Give Them a Chance', *Australian Magazine* (1 March 1955): 37; for a history of this process see Jane Lydon, *The Flash of Recognition: Photography and Aboriginal Rights* (Sydney: NewSouth Books, 2012).

47 Bob Boughton, 'The Communist Party of Australia's Involvement in the Struggle for Aboriginal and Torres Strait Islander People's Rights 1920–1970', in *Labour and Community: Historical Essays*, ed. Ray Markey (Wollongong: University of Wollongong Press, 2001), 263–94; Stuart Macintyre, *The Reds: The Communist Party of Australia from Origins to Illegality* (Sydney: Allen and Unwin, 1988), 143. Glendon notes that criticism of the treatment of coloured minorities in the United States had been a Soviet weapon long before the Second World War.

48 'Not imaginary Russian "slave camp" inmates, such as have Dr Evatt's sympathy, but Australian Aborigines are here pictured in chains in a real Australian slave camp', *Tribune*, 5 March 1949, 1. This theme was sustained throughout 1949, and the images were republished. See for example, 'End Scandal of Chained Aborigines', *Tribune*, 2 November 1949, 3.

49 'Protest at Chaining of Natives', *Sydney Morning Herald*, 26 October 1949, 11.

50 'Australian Move on Mindszenty case', *West Australian*, 14 April 1949, 4. 'Racial Policy Attacked: Soviet Criticises Australia', *Sydney Morning Herald*, 21 April 1949, 3.

51 'Evatt Hits at Vyshinsky', *Courier-Mail*, 14 October 1949, 1; 'UK Defends Australia: Reply to Soviet Jibe', *Sydney Morning Herald*, 14 October 1949, 3.

52 Peter Morton, *Fire across the Desert: Woomera and the Anglo-Australian Joint Project 1946–1980* (Canberra: Australian Government Publishing Service, 1989).

53 *Our Aborigines* (Canberra: Department of Territories, 1957).

54 Anna Haebich, *Spinning the Dream: Assimilation in Australia 1950–1970* (Fremantle: Fremantle Press, 2008).

55 Australian Mission to United Nations, inward cablegram to Department External Affairs, 7 October 1960, National Archives of Australia, A1838 929/5/3 Part 1.

56 National Archives of Australia, A1838 929/5/3 Part 1.

57 National Archives of Australia, A1838 929/5/3 Part 1.

58 Giorgio Agamben, *Homo Sacer: Sovereign Power and Bare Life*, trans. Daniel Heller-Roazen (Stanford: Stanford University Press, 1998), 28–9.

59 Jane Lydon, 'Young and Free: The Australian Past in a Global Future', in *Cosmopolitan Archaeologies*, ed. Lynn Meskell (Durham: Duke University Press, 2009), 28–43.

60 Sally Engle Merry, 'Human Rights Law and the Demonization of Culture (And Anthropology Along the Way)', *Polar: Political and Legal Anthropology Review* 26, no. 1 (2003): 55–77; Richard Wilson, *Human Rights, Culture and Context* (London and Chicago: Pluto Press, 1997), 13.

61 Dipesh Chakrabarty, *Provincialising Europe: Postcolonial Thought and Historical Difference* (Princeton: Princeton University Press, 2007).

62 Judith Butler, *Frames of War: When is Life Grievable?* (New York: Verso, 2010), 100.

63 'Utopias', H. G. Wells, Australian Broadcasting Commission radio address, 19 January 1939.

REFERENCES

Reports

Report from the Select Committee on Aborigines (British Settlements). Parliamentary Papers (1837), VII (425), 74–6.
Report of the Society for the Propagation of the Gospel, for 1849.
Royal Commission on the Condition of the Natives. Perth: Government Printer, 1905.

Hansard

Archbishop of Canterbury. Britain, House of Lords, Debates, 9 May 1905, vol. 145, columns 298–321.
Campbell, John. Britain, House of Commons, Debates, 30 March 1905, vol. 143, columns 1742–807.
Lyttelton, Alfred. Britain, House of Commons, *Debates*, 30 March 1905, vol. 143, columns 1742–1807.
Samuel, Herbert. Britain, House of Commons, *Debates*, 16 February 1904, vol. 129, columns 1501–66.

Periodicals

Anti-Slavery Reporter
Australian Magazine
Baptist Missionary Magazine
Colonial Intelligencer, or, the Aborigines' Friend, No. XXXVIII, June 1851
Orunodai
Photographic News
Workers' Weekly

Newspapers

Advertiser
Argus
Brisbane Courier
Courier
Courier-Mail

Daily News
Daily Post
Empire
Illustrated Christian Weekly
Illustrated London News
Maitland Mercury & Hunter River General Advertiser
Morning Herald
News (Adelaide)
Northern Star
Northern Territory Times and Gazette
Punch
Richmond River Express and Casino Kyogle Advertiser
South Australian Register
Sydney Morning Herald
Times
Tribune
West Australian
Western Champion
Western Mail

Archives

Bodleian Library of Commonwealth & African Studies at Rhodes House, Oxford. Mss Brit Emp S22. G374.
Imperial College London. Huxley Papers, Series 1G – Scientific and general correspondence.
National Archives of Australia. Series A3, Item NT1914/808; Series A3, Item NT1914/426; A1838 929/5/3 Part 1.
National Library of Australia. Rex Nan Kivell Collection NK1947.
Spencer and Gillen website. 'Spencer and Gillen: A Journey through Aboriginal Australia'. http://spencerandgillen.net/.
State Library of NSW. Mitchell Library. Walter Malcolmson Papers. MSS. 1131, b.
State Library of South Australia. Point Pearce Mission (S.A.), c. 1866–1892, Manuscript, SRG 94/W60; Private Record Group (PRG) 1131/2.
University of Bristol Library. Special Collections. Matthew Blagden Hale Papers. DM130/200-204. 'Correspondence and papers of Matthew Blagden Hale Bishop of Perth and Brisbane'; DM130/231–244. *Photographs of Aborigines*.
University of Queensland Library. Fryer Library. UQFL 2/2584; UQFL 2/2579.
Westminster Archives. Reports from various colonial dioceses mainly in Australia and New Zealand. Also a report of the Synod of the Church of England held at Goulburn. Accession BUR/F1 1866–1868.

Print and Web

Agamben, Giorgio. *Homo Sacer: Sovereign Power and Bare Life*. Translated by Daniel Heller-Roazen. Stanford: Stanford University Press, 1998.
Ahmed, Sarah. *The Cultural Politics of Emotions*. Edinburgh: Edinburgh University Press, 2004.
Ahmed, Sara. 'The Politics of Bad Feeling'. *Australian Critical Race and Whiteness Studies Association Journal* 1 (2005): 72–85.

Ahmed, Sara. 'Happy Objects'. In *The Affect Theory Reader*, edited by Melissa Gregg and Gregory J. Seigworth, 29–51. Durham and London: Duke University Press, 2010.

Allbeson, Tom. 'Photographic Diplomacy in the Postwar World: UNESCO and the Conception of Photography as a Universal Language, 1946–1956'. *Modern Intellectual History* (2015): 1–33.

Allen, Margaret. 'A "Tigress" in the Paradise of Dissent: *Kooroona* Critiques the Foundational Colonial Story'. In *Changing the Victorian Subject*, edited by Maggie Tonkin, Mandy Treagus, Madeleine Seys and Sharon Crozier-De Rosa, 59–81. Adelaide: University of Adelaide Press, 2014.

Anderson, Fay. '"They Are Killing All of Us Jews": Australian Press Memory of the Holocaust'. In *Aftermath: Genocide, Memory and History*, edited by Karen Auerbach, 65–85. Melbourne: Monash University Publishing, 2015.

Anderson, Stephanie. '"Three Living Australians" and the Société d'Anthropologie de Paris, 1885'. In *Foreign Bodies: Oceania and the Science of Race 1750–1940*, edited by Bronwen Douglas and Chris Ballard, 229–55. Canberra: Australian National University E Press, 2008.

Apel, Dora, and Michelle Wallace Smith. *Lynching Photographs*. Berkeley, CA: University of California Press, 2007.

Appiah, K. Anthony. *Cosmopolitanism: Ethics in a World of Strangers*. New York: W. W. Norton, 2006.

Atlay, James Beresford. *Sir Henry Wentworth Acland, Regius Professor of Medicine in the University of Oxford: A Memoir.* London: Smith, Elder, 1903.

Austin, Tony. *Never Trust a Government Man: Northern Territory Aboriginal Policy 1911–1939*. Darwin: Northern Territory University, 1997.

Australian Human Rights Commission. 'Australia and the Universal Declaration on Human Rights'. Accessed 21 May 2015. https://www.humanrights.gov.au/publications/australia-and-universal-declaration-human-rights.

Australian Human Rights Commission. 'Timeline – History of Separation of Aboriginal and Torres Strait Islander Children from Their Families'. Accessed 12 June 2015. https://www.humanrights.gov.au/timeline-history-separation-aboriginal-and-torres-strait-islander-children-their-families-text.

Azoulay, Ariella. *The Civil Contract of Photography*. New York: Zone Books, 2008.

Back, Jean, and Viktoria Schmidt-Linsenhoff. *The Family of Man 1955–2001: Humanism and Postmodernism. A Reappraisal of the Photo-Exhibition by Edward Steichen*. Marburg: Jonas Verlag, 2004.

Ballantyne, Tony. *Webs of Empire: Locating New Zealand's Colonial Past*. Wellington: Bridget Williams Books, 2012.

Bann, Stephen. *Parallel Lines: Printmakers, Painters and Photographers In Nineteenth-Century France*. New Haven: Yale University Press, 2001.

Barnett, Michael. *Empire of Humanity: A History of Humanitarianism*. Ithaca: Cornell University Press, 2011.

Bass, Gary J. *Freedom's Battle: The Origins of Humanitarian Intervention*. New York: Knopf, 2008.

Batchen, Geoffrey, Mick Gidley, Nancy K. Miller and Jay Prosser, eds. *Picturing Atrocity: Photography in Crisis*. London: Reaktion, 2012.

Batson, C. Daniel. 'These Things Called Empathy: Eight Related but Distinct Phenomena'. In *The Social Neuroscience of Empathy*, edited by Jean Decety and William Ickes, 3–15. Cambridge, MA: MIT Press, 2009.

Batson, C. Daniel. *Altruism in Humans*. Oxford and New York: Oxford University Press, 2011.

Batty, Philip, Lindy Allen and John Morton, eds. *The Photographs of Baldwin Spencer*. Melbourne: The Miegunyah Press, 2005.

Baughan, Emily, and Bronwen Everill. 'Empire and Humanitarianism: A Preface'. *Journal of Imperial and Commonwealth History* 40, no. 5 (2012): 727–8.

Bender, Thomas, ed. *The Antislavery Debate: Capitalism and Abolitionism as a Problem in Historical Interpretation*. Berkeley: University of California Press, 1992.

Bennett, Jill. *Empathic Vision: Affect, Trauma and Contemporary Art*. Stanford: Stanford University Press, 2005.

Bennett, Tony. 'Making and Mobilising Worlds: Assembling and Governing the other'. In *Material Powers: Cultural Studies, History and the Material Turn*, edited by Tony Bennett and Patrick Joyce, 190–208. London and New York: Routledge, 2010.

Bennett, Tony, and Patrick Joyce, eds. *Material Powers: Cultural Studies, History and the Material Turn*. London and New York: Routledge, 2010.

Bennett, Tony, Ben Dibley and Rodney Harrison. 'Introduction: Anthropology, Collecting and Colonial Governmentalities'. *History and Anthropology* 25, no. 2 (2014): 137–49.

Berlant, Lauren. 'Introduction: Compassion (and Withholding)'. In *Compassion: The Culture and Politics of an Emotion*, edited by Lauren Berlant, 1–13. New York and London: Routledge, 2004.

Bindman, David. *Ape to Apollo: Aesthetics and the Idea of Race in the 18th Century*. Ithaca: Cornell University Press, 2002.

Boltanski, Luc. *Distant Suffering: Morality, Media and Politics*. Cambridge: Cambridge University Press, 1999.

Bott, Bruce. 'Octavius Hammond of Poonindie: Medical Practitioner and Priest'. *Journal of the Historical Society of South Australia* 37 (2009): 22–40.

Boughton, Bob, 'The Communist Party of Australia's Involvement in the Struggle for Aboriginal and Torres Strait Islander People's Rights 1920–1970'. In *Labour and Community: Historical Essays*, edited by Ray Markey, 263–94. Wollongong: University of Wollongong Press, 2001.

Braithwaite, Sari, Tom Gara and Jane Lydon. 'From Moorundie to Buckingham Palace: Images of "King" Tenberry and his son Warrulan, 1845–55'. *Journal of Australian Studies* 35, no. 2 (2011): 165–84.

Brantlinger, Patrick. *Dark Vanishings*: *Discourse on the Extinction of Primitive Races, 1800–1930*. Ithaca: Cornell University Press, 2003.

Bressey, Caroline. *Empire, Race and the Politics of Anti-Caste*. London: Bloomsbury, 2013.

Bright, Rachel. *Chinese Labour in South Africa, 1902–10: Race, Violence, and Global Spectacle*. Basingstoke: Palgrave Macmillan 2013.

Brink, Cornelia. 'Secular icons: Looking at Photographs from Nazi Concentration Camps'. *History and Memory* 12, no. 1 (2000): 135–50.

Brock, Peggy. *Outback Ghettos. A History of Aboriginal Institutionalisation and Survival*. Melbourne: Cambridge University Press, 1993.

Brock, Peggy, and Doreen Kartinyeri. *Poonindie: The Rise and Destruction of an Aboriginal Agricultural Community*. Adelaide: Aboriginal Heritage Branch and South Australian Government Printer, 1989.

Broughton, William Grant. *The Counsel and Pleasure of God in the Vicissitudes of States and Communities: A Sermon*. Sydney: R. Mansfield, 1829.

Burdett, Carolyn. 'Is Empathy the End of Sentimentality?' *Journal of Victorian Culture* 16, no. 2 (2011): 259–74.

Burgers, Jan Herman. 'The Road to San Francisco: The Revival of the Human Rights Idea in the Twentieth Century'. *Human Rights Quarterly* 14 (1992): 447–77.

Butcher, Barry. 'Darwinism, Social Darwinism and the Australian Aborigines: A Re-Evaluation'. In *Darwin's Laboratory: Evolutionary Theory and Natural History in the Pacific*, edited by Roy McLeod and Philip F. Rehbock, 371–94. Honolulu: University of Hawaii Press, 1994.

Butler, Judith. *Frames of War: When is Life Grievable?* London: Verso, 2010.

Carey, Hilary M. *In God's Empire: Religion and Colonialism in the British World, c.1801–1908*. Cambridge: Cambridge University Press, 2011.

Carlyle, Thomas. 'Occasional Discourse on the Negro Question'. *Fraser's Magazine for Town and Country* 40 (1849): 670–9.

Chakrabarty, Dipesh. *Provincialising Europe: Postcolonial Thought and Historical Difference*. Princeton: Princeton University Press, 2007.

Chandler, James. 'The Politics of Sentiment: Notes toward a New Account'. *Studies in Romanticism* 49, no. 4 (2010): 553–75.

Charnay, Désiré. 'Rapports sur une Mission dans L'ile de Java et en Australie' ['Report on a Journey in Java and Australia']. In *Désiré Charnay: Expeditionary Photographer*, edited and translated by Keith F. Davis, 148–9. Albuquerque: University of New Mexico Press, 1981.

Clark, Elizabeth B. '"The Sacred Rights of the Weak": Pain, Sympathy, and the Culture of Individual Rights in Antebellum America'. *Journal of American History* 82, no. 2 (1995): 463–93.

Clutterbuck, John Bennett. *Port Phillip 1849*. London: John W. Parker, 1850.

Coleman, Deirdre. *Romantic Colonisation and British Anti-Slavery*. Cambridge: Cambridge University Press, 2005.

Collette, John. 'Hermann Klaatsch's Views on the Significance of the Australian Aborigines'. *Aboriginal History* 11 (1987): 98–100.

Cooper, Frederick. *From Slaves to Squatters: Plantation Labor and Agriculture in Zanzibar and Coastal Kenya, 1890–1925*. New Haven: Yale University Press, 1980.

Cooper, Frederick. 'Conditions Analogous to Slavery: Imperialism and Free Labour Ideology in Africa'. In *Beyond Slavery: Explorations of Race, Labor and Citizenship in Post-Emancipation Societies*, edited Frederick Cooper, Thomas C. Holt and Rebecca J. Scott, 107–50. Chapel Hill: University of North Carolina Press, 2000.

Cooper, Frederick. 'Modernizing Colonialism and the Limits of Empire'. In *Lessons of Empire: Imperial Histories and American Power*, edited by Craig Calhoun, Frederick Cooper and Kevin W. Moore, 63–72. New York: New Press, 2006.

Cooper, Frederick, and Randall Packard. *International Development and the Social Sciences*. Berkeley, CA: University of California Press, 1997.

Cowling, Mary. *The Artist as Anthropologist: The Representation of Type and Character in Victorian Art*. Cambridge: Cambridge University Press, 1989.

Crombie, Isobel. 'Australia Felix: Douglas T. Kilburn's Daguerreotype of Victorian Aborigines, 1847'. *Art Bulletin* 32 (1991): 21–31.

Cryle, Mark, '"Australia's Shadow Side": Arthur Vogan and the Black Police'. *Fryer Folios* 4, no. 3 (2009): 18–21.

Cunningham, Peter. *Two Years in New South Wales: A Series of Letters, Comprising Sketches of the Actual State of Society in that Colony, of its Peculiar Advantages to Emigrants, of its Topography, Natural History, &c.* Vol. 2. London: H. Colburn, 1827.

Curthoys, Ann, and Jeremy Martens. 'Serious Collisions: Settlers, Indigenous People, and Imperial Policy in Western Australia and Natal'. *Journal of Australian Colonial History* 15 (2013): 121–44.

D'Agostino, Peter. 'Craniums, Criminals, and the "Cursed Race": Italian Anthropology in American Racial Thought, 1861–1924'. *Comparative Studies in Society and History* 44, no. 2 (2002): 319–43.

Daly, John. '"Civilising" the Aborigines: Cricket at Poonindie, 1850–1890'. *Sporting Traditions: The Journal of the Australian Society for Sports History* 10, no. 2 (1994): 59–68.

Darwin, Charles. *The Origin of Species by Means of Natural Selection*. London: John Murray, 1859.

Davis, David Brion. *The Problem of Slavery in the Age of Revolution, 1770–1823*. Oxford and New York: Oxford University Press, 1999.

de Costa, Ravi. *A higher Authority: Indigenous Transnationalism and Australia*. Sydney: University of New South Wales Press, 2006.

Devereaux, Annemarie. *Australia and the Birth of the International Bill of Human Rights: 1946–1966*. Annandale: Federation Press, 2005.

Dibley, Ben. 'Assembling an Anthropological Actor: Anthropological Assemblage and Colonial Government in Papua'. *History and Anthropology* 25, no. 2 (2014): 263–79.

Dickens, Charles. 'The Noble Savage'. *Household Words*, 11 June 1853.

Dickens, Charles. *Bleak House*. London: Vintage, 2008.

Dillon, Sheila. *The Female Portrait Statue in the Greek World*. Cambridge: Cambridge University Press, 2010.

Dixon, Thomas. *From Passions to Emotions: The Creation of a Secular Psychological Category*. Cambridge: Cambridge University Press, 2003.

Docker, John. *Postmodernism and Popular Culture*. Cambridge: Cambridge University Press, 1994.

Douglas, Bronwen, 'Art as Ethno-historical Text: Science, Representation and Indigenous Presence in Eighteenth and Nineteenth Century Oceanic Voyage Literature'. In *Double Vision: Art Histories and Colonial Histories in the Pacific*, edited by Nicholas Thomas and Diane Losche, 65–99. Cambridge: Cambridge University Press, 1999.

Douglas, Bronwen, and Chris Ballard, eds. *Foreign Bodies: Oceania and the Science of Race 1750–1940*. Canberra: ANU E Press, 2008.

Douglas, Heather, and Mark Finnane. *Indigenous Crime and Settler Law*. Basingstoke: Palgrave Macmillan, 2012.

Dowling, Peter. 'Destined Not to Survive: The Illustrated Newspapers of Colonial Australia', *Studies in Newspaper and Periodical History* 3, nos. 1–2 (1995): 85–98.

Dumont d'Urville, Jules Sebastien Cesar. *Voyage pittoresque autour du monde* [*Voyages around the World*]. Paris: L. Tenré, 1834.

Dumont d'Urville, Jules Sebastien Cesar. *Voyage au Pole Sud et dans l'Oceanie* [*Voyage to the South Pole and Oceania*]. Paris: Gide, 1846.

Dumont d'Urville, Jules Sebastien Cesar. *An Account in Two Volumes of Two Voyages to the South Seas*. Translated by Helen Rosenman. Carlton: Melbourne University Press, 1987.

Edmonds, Penelope. 'Collecting Looerryminer's "Testimony": Humanitarian Anti-Slavery Thought and Action in the Bass Strait Islands'. *Australian Historical Studies* 45, no. 1 (2014): 13–33.

Edwards, Elizabeth. *Raw Histories: Photographs, Anthropology and Museums*. Oxford and New York: Berg, 2001.

Edwards, Elizabeth. 'Evolving Images: Photography, Race and Popular Darwinism'. In *Endless Forms: Charles Darwin, Natural Science and the Visual Arts*, edited by Diana Donald and Jane Munro, 167–93. Cambridge: Fitzwilliam Museum and Yale Center for British Art, 2009.

Edwards, Elizabeth. 'Objects of Affect: Photography beyond the Image'. *Annual Review of Anthropology* 41 (2012): 221–34.

Edwards, Elizabeth, and Christopher Morton, eds. *Photography, Anthropology and History: Expanding the Frame*. Farnham: Ashgate, 2009.

Elbourne, Elizabeth. *Blood Ground: Colonialism, Missions, and the Contest for Christianity in the Cape Colony and Britain, 1799–1853*. Montreal: McGill-Queens University Press, 2002.

Elbourne, Elizabeth. 'The Sin of the Settler: The 1835–36 Select Committee on Aborigines and Debates over Virtue and Conquest'. *Journal of Colonialism and Colonial History* 4, no. 3 (2003). doi: 10.1353/cch.2004.0003.

Elkin, Adolphus Peter. 'Anthropology and the Future of the Australian Aborigines'. *Oceania* 1 (1934): 1–18.

Ellinghaus, Katherine. 'Racism in the Never-Never: Disparate Readings of Jeannie Gunn'. *Hecate* 23, no. 2 (1997): 76–94.

Etherington, Norman, ed. *Missions and Empire*. Oxford History of the British Empire Companion Series, 1–18. Oxford and New York: Oxford University Press, 2005.

Evans, Raymond. 'Kings in Brass Crescents: Defining Aboriginal Labour Patterns in Colonial Queensland'. In *Fighting Words: Writing about Race*, edited by Raymond Evans, 181–2. St Lucia: University of Queensland Press, 1999.

Evans, Raymond, Kay Saunders and Kathryn Cronin. *Race Relations in Colonial Queensland: A History of Exclusion, Exploitation and Extermination*. Brisbane: University of Queensland Press, 1988.

Eyre, Edward. *Journals of Expeditions of Discovery into Central Australia and Overland from Adelaide to King George's Sound in the Years 1840–1*, vol. 2. London: T. and W. Boone, 1845.

Feilberg, Carl Adolph. *The Way We Civilise: Black and White, the Native Police. A Series of Articles Reprinted from the Queenslander.* Brisbane: G. and J. Black, 1880.

Fels, Marie Hansen. *I Succeeded Once: The Aboriginal Protectorate on the Mornington Peninsula 1839–40.* Canberra: ANU E Press and Aboriginal History, 2011.

Festa, Lynn. *Sentimental Figures of Empire in Eighteenth-Century Britain and France.* Baltimore: Johns Hopkins University Press, 2006.

Festa, Lynn. 'Humanity without Feathers'. *Humanity* 1, no. 1 (2010): 3–27.

Finnane, Mark. 'The Limits of Jurisdiction: Law, Governance and Indigenous People in Colonized Australia'. In *Law and Politics in British Colonial Thought: Transpositions of Empire*, edited by Shaunnagh Dorsett and Ian Hunter, 149–68. Basingstoke: Palgrave Macmillan, 2010.

Flint, Kate. *The Transatlantic Indian, 1776–1930.* Princeton: Princeton University Press, 2009.

Foucault, Michel. *Security, Territory, Population: Lectures at the College de France, 1977–78.* Edited by Michel Senellart. Translated by Graham Burchell. London: Palgrave Macmillan, 2007.

Gara, Tom. 'Wanganeen, Robert Mckenzie (1896–1975)', *Australian Dictionary of Biography.* Canberra: Australian National University, 2002. http://adb.anu.edu.au/biography/wanganeen-robert-mckenzie-11957/text21431.

Gibson, Ian. *The English Vice: Beating, Sex and Shame in Victorian England and After.* London: Duckworth, 1978.

Giglioli, Enrico Hillyer. *Viaggio intorno al globo della r. pirocorvetta italiana Magenta negli anni 1865–66–67–68* [*Voyage around the Globe on the Magenta 1865–68*]. Milano: Maisner, 1875.

Giglioli, Enrico Hillyer. *La collezione etnografica del Prof. Enrico Hillyer Gigliolo: geograficamente classificata* [*The Geographically Classified Ethnographic Collection of Prof. Enrico Hillyer Giglioli*]. Firenze: Tip. della S. Tipografica, 1911.

Giglioli-Casella, Costanza. *Intorno al mondo: viaggio da ragazzi* [*Around the World: Travel by Children*]. Torino: G.B. Paravia, 1891.

Gill, Brian J. 'The Cheeseman-Giglioli Correspondence and Museum Exchanges between Auckland and Florence, 1877–1904'. *Archives of Natural History* 37, no. 1 (2010): 131–49.

Gilroy, Paul. 'Race and the Right to be Human'. In *Inaugural Address on Accepting the Treaty of Utrecht Chair*, 5–29. Utrecht: Utrecht University, 3 December 2009.

Ginzburg, Carlo. 'Killing a Chinese Mandarin: The Moral Implications of Distance'. *Critical Inquiry* 21, no. 1 (1994): 46–60.

Glendon, Mary Ann. *A World Made New: Eleanor Roosevelt and the Universal Declaration of Human Rights.* New York: Random House, 2001.

Goodall, Heather. '"Assimilation Begins in the Home": The State and Aboriginal Women's Work as Mothers in New South Wales, 1900s to 1960s'. *Labour History* 69 (1995): 75–101.

Goodall, Heather. *Invasion to Embassy: Land in Aboriginal Politics in New South Wales, 1770–1972.* Sydney: Allen and Unwin, 1996.

Grant, Kevin. *A Civilised Savagery: Britain and the New Slaveries in Africa, 1884–1926.* New York: Routledge, 2005.

Green, Michael. 'Lest We Remember: The Australian War Memorial and the Frontier Wars'. *Wheeler Centre, Accessed 20 February 2014. http://www.wheelercentre.com/notes/f261bb085eb4.*

Gribble, John Brown. *The Warangesda Mission.* London: Wells Gardner, Darton and Co., 1884.

Gupta, Akhil, and James Ferguson. 'Discipline and Practice: "The Field" as Site, Method and Location in Anthropology'. In *Anthropological Locations: Boundaries and Grounds of a Field Science*, edited by Akhil Gupta and James Ferguson, 30–45. Berkeley: University of California Press, 1997.

Hackforth-Jones, Jocelyn, Anita Callaway and Joan Kerr. 'Charles Rodius'. *Dictionary of Australian Artists Online.* Last updated 2011. http://www.daao.org.au/bio/charles-rodius/biography/?.

Haebich, Anna. *Spinning the Dream: Assimilation in Australia 1950–1970.* Fremantle: Fremantle Press, 2008.

Hale, Mathew Blagdon. *The Aborigines of Australia: Being an Account of the Institution for Their Education at Poonindie, in South Australia.* London: Society for Promoting Christian Knowledge, 1889.

Hall, Catherine. *Civilising Subjects: Metropole and Colony in the English Imagination 1830–1867*. Cambridge: Polity, 2002.

Halttunen, Karen. 'Humanitarianism and the Pornography of Pain in Anglo-American Culture'. *American Historical Review* 100, no. 2 (1995): 303–34.

Hannavy, James, ed. *Encyclopaedia of Nineteenth-Century Photography*. London: Routledge, 2013.

Hartman, Saidiya. *Scenes of Subjection: Terror, Slavery and Self-Making in Nineteenth-Century America*. Oxford and New York: Oxford University Press, 1997.

Haskell, Francis, and Nicholas Penny. *Taste and the Antique: The Lure of Classical Sculpture 1500–1900*. New Haven: Yale University Press, 1981.

Haskins, Victoria. 'Beyond Complicity: Questions and Issues for White Women in Aboriginal History'. *Australian Humanities Review* 39–40 (2006). http://www.australianhumanitiesreview. org/archive/Issue-September-2006/haskins.html.

Healy, Chris. *Forgetting Aborigines*. Sydney: University of New South Wales Press, 2008.

Herle, Anita. 'John Layard Long Malakula 1914–15: The Potency of Field Photography', in *Photography, Anthropology and History: Expanding the Frame*, edited by Christopher Morton and Elizabeth Edwards, 241–63. Farnham, UK: Ashgate.

Hilliard, David. *God's Gentlemen: A History of the Melanesian Mission, 1849–1942*. Brisbane: University of Queensland Press, 1978.

Horton, David, ed. *The Encyclopaedia of Aboriginal Australia: Aboriginal and Torres Strait Islander History, Society and Culture*. Canberra: Aboriginal Studies Press, 1994.

Howell, Peter A. 'Poole, Frederic Slaney (1845–1936)'. *Australian Dictionary of Biography*. Canberra: Australian National University, 1988. http://adb.anu.edu.au/biography/poole-frederic-slaney-8075/text14093.

Hunt, Lynn. *Inventing Human Rights: A History*. New York: W. W. Norton and Company, 2007.

Hunt, Lynn. Foreword to *Human Rights in Camera*, by Sharon Sliwinski. Chicago: Chicago University Press, 2011, ix–xii.

Hutchinson, Henry Neville, John Walter Gregory and Richard Lydekker. *The Living Races of Mankind. A Popular Illustrated Account of the Customs, Habits, Pursuits, Feasts, and Ceremonies of the Races of Mankind throughout the World.* New York: D. Appleton and Co., 1902.

Huxley, Thomas Henry. *Evidence as to Man's Place in Nature*. London: Williams and Norgate, 1863.

Inglis, Ken. *Sacred Places: War Memorials in the Australian Landscape*. Carlton, VIC: Melbourne University Publishing, 2008.

Isaac, Gwyniera. 'Louis Agassiz's Photographs in Brazil: Separate Creations'. *History of Photography* 21, no. 1 (1997): 3–11.

Ivison, Duncan. *Rights*. Stocksfield: Acumen, 2008.

Johnston, Anna. *Missionary Writing and Empire, 1800 – 1860*. Cambridge Studies in Nineteenth-Century Literature and Culture. Cambridge: Cambridge University Press, 2003.

Johnston, Anna. 'A Blister on the Imperial Antipodes: Lancelot Edward Threlkeld in Polynesia and Australia'. In *Colonial Lives across the British Empire: Imperial Careering in the Long Nineteenth Century*, edited by David Lambert and Alan Lester, 58–87. Cambridge: Cambridge University Press, 2006.

Jolly, Margaret, and Serge Tcherkézoff. 'Oceanic Encounters: A Prelude'. In *Oceanic Encounters: Exchange, Desire, Violence*, edited by Margaret Jolly, Serge Tcherkézoff and Darrell Tryon, 1–25. Canberra: Australian National University E Press, 2009.

Joyce, Patrick and Bennett, Tony, eds. *Material Powers: Cultural Studies, History and the Material Turn*, 1–22. London and New York: Routledge, 2010.

Kaplan, Louis. *American Exposures: Photography and Community in the Twentieth Century*. Minneapolis: University of Minnesota Press, 2005.

Klaatsch, Hermann. 'Schlussbericht uber meine Reise nach Australien in den Jahren 1904–1907' ['Final Report on My Trip to Australia in the Years 1904–1907']. *Zeitschrift fur Ethnologie* [*Journal of Ethnology*] 39 (1907): 634–90.

Klaatsch, Hermann, 'Some Notes on Scientific Travel amongst the Black Population of Tropical Australia in 1904, 1905, 1906. Read at the Adelaide Meeting of the Australasian Association for the Advancement of Science, held January, 1907', *Report of the Australasian Association for the Advancement of Science*, vol. 11, 1908, 7. http://nla.gov.au/nla.aus-vn1864548.

Kleinman, Arthur, and Joan Kleinman. 'The Appeal of Experience; the Dismay of Images: Cultural Appropriations of Suffering in our Times'. *Daedalus* 125, no. 1 (1996): 1–23.

Kopytoff, Igor. 'The Cultural Biography of Things: Commoditization as Process'. In *The Social Life of Things*, edited by Arjun Appadurai, 64–94. Cambridge: Cambridge University Press, 1986.

Kuklick, Henrika. '"Humanity in the Chrysalis Stage": Indigenous Australians in the Anthropological Imagination'. *British Journal of the History of Science* 39, no. 4 (2006): 535–68.

Laidlaw, Zoë. '"Aunt Anna's Report": The Buxton Women and the Aborigines Select Committee, 1835–37'. *Journal of Imperial and Commonwealth History* 32, no. 2 (2004): 1–28.

Lake, Marilyn, and Henry Reynolds. *Drawing the Global Colour Line: White Men's Countries and the International Challenge of Racial Equality*. Carlton: Melbourne University Press, 2008.

Lang, John Dunmore. *An Historical and Statistical Account of the New South Wales*, vol. 6. London: Forgotten Books, 1875.

Langton, Marcia. 'The Edge of the Sacred, the Edge of Death: Sensual Inscriptions'. In *Inscribed Landscapes: Marking and Making Place*, edited by Bruno David and Meredith Wilson, 253–69. Honolulu: University of Hawaii Press, 2002.

Lansbury, Coral. *Arcady in Australia: The Evocation of Australia in Nineteenth-Century English Literature*. Carlton: Melbourne University Press, 1970.

Laqueur, Thomas. 'Bodies, Details, and the Humanitarian Narrative'. In *The New Cultural History*, edited by Lynn Hunt, 176–204. Berkeley and Los Angeles: University of California Press, 1989.

Lauren, Paul Gordon. *The Evolution of International Human Rights: Visions Seen.* Philadelphia: University of Pennsylvania Press, 1998.

Leichhardt, Ludwig. *Journal of an Overland Expedition in Australia from Moreton Bay to Port Essington a Distance of upwards of 3000 Miles, during the Years 1844–1845*. London: T. and W. Boone, 1847.

Lester, Alan. 'Humanitarians and White Settlers in the Nineteenth Century'. In *Missions and Empire*. Oxford History of the British Empire Companion Series, edited by Norman Etherington, 64–85. Oxford and New York: Oxford University Press, 2005.

Lester, Alan, and Fae Dussart. *Colonization and the Origins of Humanitarian Intervention*. Cambridge: Cambridge University Press, 2014.

Levine, Philippa. 'States of Undress: Nakedness and the Colonial Imagination'. *Victorian Studies* 50, no. 2 (2008): 189–219.

Linfield, Susie. *The Cruel Radiance: Photography and Political Violence*. Chicago: University Press, 2011.

Lorimer, Douglas A. *Colour, Class, and the Victorians: English Attitudes to the Negro in the Mid-Nineteenth Century*. Leicester: Leicester University Press, 1978.

Louis, William Roger. 'Triumph of the Congo Reform Movement 1905–1908'. In *Boston University Papers on Africa*, vol. 2, edited by Jeffrey Butler, 267–302. Boston: Boston University Press, 1966.

Louis, William Roger. *Imperialism at Bay: The United States and the Decolonization of the British Empire*. Oxford and New York: Oxford University Press, 1987.

Lydon, Jane. *Eye Contact: Photographing Indigenous Australians*. Durham: Duke University Press, 2005.

Lydon, Jane. 'Young and Free: The Australian Past in a Global Future'. In *Cosmopolitan Archaeologies*, edited by Lynn Meskell, 28–43. Durham: Duke University Press, 2009.

Lydon, Jane. *The Flash of Recognition: Photography and the Emergence of Indigenous Rights*. Sydney: NewSouth Books, 2012.

Lydon, Jane. '"Veritable Apollos": Aesthetics, Evolution, and Enrico Giglioli's Photographs of Indigenous Australians 1867–78'. *Interventions: International Journal of Postcolonial Studies* 16, no. 1 (2014): 72–96.

Lydon, Jane. '"The Colonial Children Cry": Jo the Crossing-Sweep Goes to the Colonies'. *Journal of Victorian Culture* 20, no. 3 (2015): 1–18

Lydon, Jane, and Sari Braithwaite, '"Cheque Shirts and Plaid Trowsers": Photographing Poonindie Mission, South Australia'. *Journal of the Anthropological Society of South Australia* 37 (2013): 1–30.

MacDonald, Charlotte. 'Between Religion and Empire: Sarah Selwyn's Aotearoa/New Zealand, Eton and Lichfield, England, c.1840s–1900'. *Journal of the Canadian Historical Association* 19, no. 2 (2008): 43–75.

McClintock, Anne. *Imperial Leather: Race, Gender and Sexuality in the Colonial Contest.* New York: Routledge, 1993.

McGregor, Russell. *Imagined Destinies: Aboriginal Australians and the Doomed Race Theory, 1880–1939.* Carlton: Melbourne University Press, 1997.

McGregor, Russell. *Indifferent Inclusion: Aboriginal People and the Australian Nation.* Canberra: Aboriginal Studies Press, 2011.

McGuire, Madeleine. 'The Legend of the Good Fella Missus'. *Aboriginal History* 14 (1990): 124–51.

McInnis, Maurie D. *Slaves Waiting for Sale: Abolitionist Art and the American Slave Trade.* Chicago: University of Chicago Press, 2011.

Macintyre, Stuart. *The Reds: The Communist Party of Australia from Origins to Illegality.* Sydney: Allen and Unwin, 1988.

Macintyre, Stuart, and Anna Clark. *The History Wars.* Carlton: Melbourne University Press, 2003.

Magarey, Susan. 'Why Didn't They Want to Be Members of Parliament? Suffragists in South Australia'. In *Suffrage and Beyond: International Feminist Perspectives*, edited by Caroline Daley and Melanie Nolan, 67–88. Auckland: Auckland University Press, 1994.

Malinowski, Bronislaw. Review of *Across Australia*, by Baldwin Spencer and F. J. Gillen. *Folk-Lore* 24, no. 2 (1913): 278–9.

Manne, Robert, ed. *Whitewash: On Keith Windschuttle's Fabrication of Aboriginal History.* Melbourne: Black Inc. Publishing, 2003.

Marriott, John. *The Other Empire: Metropolis, India and Progress in the Colonial Imagination.* Manchester: Manchester University Press, 2003.

Martinez, Julia, and Claire Lowrie. 'Colonial Constructions of Masculinity: Transforming Aboriginal Australian Men into "Houseboys"'. *Gender & History* 21, no. 2 (2009): 305–23.

Mason, Otis T. 'Book Reviews. *The Living Races of Mankind*'. *American Anthropologist* 4, (1902): 305–6.

Masson, Elsie Rosalie. *An Untamed Territory: The Northern Territory of Australia.* London: Macmillan and Co., 1915.

Mattingley, Christobel, and Ken Hampton, eds. *Survival in Our Own Land: 'Aboriginal' Experiences in 'South Australia' since 1836.* Adelaide: Wakefield Press, 1988.

Maynard, John. *Fight for Liberty and Freedom.* Canberra: Aboriginal Studies Press, 2007.

Meredith, Mary. *Koorona.* London: Simpkin, Marshall: 1871.

Merry, Sally Engle. 'Human Rights Law and the Demonization of Culture (and Anthropology Along the Way)'. *Polar: Political and Legal Anthropology Review* 26, no. 1 (2003): 55–77.

Milliss, Roger. *Waterloo Creek: The Australia Day Massacre of 1838, George Gipps and the British Conquest of New South Wales.* Sydney: University of New South Wales Press, 1994.

Mirmohamadi, Kylie, and Susan K. Martin. *Colonial Dickens: What Australians Made of the World's Favourite Writer.* Melbourne: Australian Scholarly Publishing, 2012.

Moorhouse, Matthew. 'Quarterly report for period ending 30 September 1850'. *Register* (1 September 1850): 3–4.

Morel, Edmund D. *Red Rubber: The Story of the Rubber Slave Trade Flourishing on the Congo in the Year of Grace 1906.* London: T. Fisher Unwin, 1906.

Morgan, Jo-Ann, *Uncle Tom's Cabin as Visual Culture*. Columbia: University of Missouri Press, 2007.

Morphy, Howard, 'More Than Mere Facts: Repositioning Spencer and Gillen in the History of Anthropology'. In *Exploring Central Australia: Society, Environment and the 1894 Expedition*, edited by S. R. Morton and D. J. Mulvaney, 135–49. Chipping Norton: Surrey Beatty, 1996.

Morris, Meaghan. *Identity Anecdotes: Translation and Media Culture*. London: Sage, 2006.

Morton, Christopher. 'Double Alienation: Evans-Pritchard's Zande and Nuer photographs in Comparative Perspective'. In *Photography in Africa: Ethnographic Perspectives*, edited by Richard Vokes, 33–55. Woodbridge and Rochester: Boydell and Brewer, 2012.

Morton, Peter. *Fire across the Desert: Woomera and the Anglo-Australian Joint Project 1946–1980*. Canberra: Australian Government Publishing Service, 1989.

Moyn, Samuel. *The Last Utopia*. Cambridge: Belknap Press of Harvard University Press, 2010.

Mullan, John. *Sentiment and Sociability: The Language of Feeling in the Eighteenth Century.* Oxford: Clarendon Press, 1988.

Mulvaney, Derek John. 'Spencer, Sir Walter Baldwin (1860–1929)'. *Australian Dictionary of Biography*. Canberra: Australian National University, 1990. http://adb.anu.edu.au/biography/spencer-sir-walter-baldwin-8606/text15031.

Mulvaney, Derek John and John Henry Calaby. *'So Much That is New': Baldwin Spencer, 1860–1929: A Biography*. Carlton: Melbourne University Press, 1985.

Mulvaney, John, Howard Morphy and Alison Petch, eds. *'My Dear Spencer': The Letters of F. J. Gillen to Baldwin Spencer*. Melbourne: Hyland House, 1997.

Murdoch, Lydia. *Imagined Orphans: Poor Families, Child Welfare, and Contested Citizenship in London*. Chapel Hill: Rutgers University Press, 2006.

Nettelbeck, Amanda. '"Seeking to Spread the Truth": Christina Smith and the South Australian Frontier'. *Australian Feminist Studies* 16, no. 34 (2001): 83–90.

Nietzsche, Friedrich. *On the Genealogy of Morals*. Translated by Walter Kauffman and Reginald John Hollingdale. New York: Vintage, 1989.

Nord, David Paul. *Faith in Reading: Religious Publishing and the Birth of Mass Media in America* (Oxford and New York: Oxford University Press, 2004).

Nott, Josiah C., and George Gliddon, eds. *Types of Mankind: Or, Ethnological Researches Based Upon the Ancient Monuments, Paintings, Sculptures, and Crania of Races, and Upon Their Natural, Geographical, Philological and Biblical History.* Philadelphia: Lipincott and Grambo, 1854.

Nussbaum, Martha. *Poetic Justice: The Literary Imagination and Public Life*. Boston: Beacon, 1996.

Ørsted-Jensen, Robert. *Frontier History Revisited: Colonial Queensland and the 'History War'*. Brisbane: Lux Mundi Publishing, 2011.

Palmquist, Peter E. 'Photographing the Modoc Indian War: Louis Heller versus Eadweard Muybridge'. *History of Photography* 2, no. 3 (1978): 187–205.

Paisley, Fiona. 'Mock Justice: World Conservation and Australian Aborigines in Interwar Switzerland'. *Transforming Cultures* 3, no. 1 (2008): 196–226.

Parry, Naomi. '"Such a Longing": Black and White Children in Welfare in New South Wales and Tasmania, 1880–1940'. PhD Thesis, University of New South Wales, 2007.

Partington, John S. *Building Cosmopolis: The Political Thought of H.G. Wells*. London: Ashgate, 2003.

Patton, Barry. 'Aboriginal Child Separations and Removals in Early Melbourne and Adelaide'. In *Evangelists of Empire? Missionaries in Colonial History*, edited by Amanda Barry, Joanna Cruickshank, Andrew Brown-May and Patricia Grimshaw. Melbourne: University of Melbourne eScholarship Research Centre, 2008. http://msp.esrc.unimelb.edu.au/shs/missions.

Peffer, John. 'Snap of the Whip/Crossroads of Shame: Flogging, Photography, and the Representation of Atrocity in the Congo Reform Campaign'. *Visual Anthropology Review* 24, no. 1 (2008): 55–77.

Pelham, Camden. *The Chronicles of Crime, or, The New Newgate Calendar*, vol. 2. London: T. Tegg, 1841.

Pels, Peter. 'What Has Anthropology Learned from the Anthropology of Colonialism?' *Social Anthropology* 16, no. 3 (2008): 280–99.

Peters, John Durham. 'Witnessing'. *Media, Culture and Society* 23 (2001): 707–11.

Peterson, Nicolas. 'Visual Knowledge: Spencer and Gillen's Use of Photography *in The Native Tribes of Central Australia*', *Australian Aboriginal Studies* 1 (2006): 12–22.

Pickering, Charles. *The Races of Man; and Their Geographical Distribution*. London: H. G. Bohn, 1851.

Polchin, James. 'Not Looking at Lynching Photographs'. In *The Image and the Witness: Trauma, Memory and Visual Culture*, edited by Frances Guerin and Roger Hallas, 207–22. London and New York: Wallflower Press, 2007.

Porter, Andrew. 'Trusteeship, Anti-Slavery and Humanitarianism'. In *The Oxford History of the British Empire, Volume III The Nineteenth Century*, edited by Andrew Porter, 198–221. Oxford and New York: Oxford University Press, 1999.

Porter, Bernard. *Critics of Empire: British Radicals and the Imperial Challenge*. London: I. B. Tauris, 2008.

Povinelli, Elizabeth. *The Cunning of Recognition*. Durham: Duke University Press, 2002.

Powell, Alan. 'Gilruth, John Anderson (1871–1937)', *Australian Dictionary of Biography*. Canberra: Australian National University, 1983. http://adb.anu.edu.au/biography/gilruth-john-anderson-6393.

Powerhouse Museum. 'Ambrotypes'. Accessed 16 October 2013. http://www.powerhousemuseum.com/collection/database/theme,1306,Ambrotypes.

Prodger, Phillip. *Darwin's Camera, Art and Photography in the Theory of Evolution*. Oxford and New York: Oxford University Press, 2009.

Rai, Amit. *Rule of Sympathy: Sentiment, Race and Power, 1750–1850*. New York: Palgrave, 2002.

Raiford, Leigh. *Imprisoned in a Luminous Glare: Photography and the African American Freedom Struggle*. Chapel Hill: University of North Caroline Press, 2011.

Rao, Anupama, and Steven Pierce. 'Discipline and the Other Body: Humanitarianism, Violence, and the Colonial Exception'. In *Discipline and the Other Body: Correction, Corporeality, Colonialism*, edited by Steven Pierce and Anupama Rao, 1–35. Durham: Duke University Press, 2006.

Raynes, Cameron. *A Little Flour and a Few Blankets: An Administrative History of Aboriginal Affairs in South Australia, 1834–2000*. Gepps Cross: State Records of South Australia, 2002.

Reddy, William M. *The Navigation of Feeling: A Framework for the History of Emotions*. Cambridge: Cambridge University Press, 2001.

Reilly, Dianne, and Jennifer Carew. *Sun Pictures of Victoria: The Fauchery-Daintree Collection, 1858*. South Yarra: Currey O'Neil Ross on behalf of the Library Council of Victoria, 1983.

Reinhardt, Mark, Holly Edwards and Erinna Duganne, eds. *Beautiful Suffering: Photography and the Traffic in Pain.* Chicago: University of Chicago Press, 2007.

Reynolds, David S. *Mightier than the Sword: Uncle Tom's Cabin and the Battle for America*. New York: W. W. Norton and Company, 2011.

Reynolds, Henry. *Dispossession: Black Australians and White Invaders*. Sydney: Allen and Unwin, 1989.

Reynolds, Henry. *Fate of a Free People.* Ringwood: Penguin Books, 1995.

Reynolds, Henry. *This Whispering in Our Hearts.* Sydney: Allen and Unwin, 1998.

Reynolds, Henry. 'Arthur, Walter George (1820–1861)'. *Australian Dictionary of Biography*. Canberra: Australian National University, 2005. http://adb.anu.edu.au/biography/arthur-walter-george-12775/text23047.

Reynolds, Henry. *Forgotten War.* Sydney: NewSouth Books, 2013.

Richards, Jonathan. *The Secret War: A True History of Queensland's Native Police*. St Lucia: University of Queensland Press, 2008.

Rizzolatti, Giacomo, and Corrado Sinigaglia. *Mirrors in the Brain: How Our Minds Share Actions and Emotions*. Translated by Frances Anderson. Oxford and New York: Oxford University Press, 2008.

Robin, A. De Q. 'Hale, Mathew Blagden (1811–1895)'. *Australian Dictionary of Biography*. Canberra: Australian National University, 2013. http://adb.anu.edu.au/biography/hale-mathew-blagden-3689/text5771.

Rorty, Richard. 'Human Rights, Rationality, and Sentimentality'. In *On Human Rights: The Oxford Amnesty Lectures*, edited by Stephen Shute and Susan Hurley, 111–34. New York: BasicBooks, 1993.

Rogers, Molly. *Delia's Tears: Race, Science and Photography in Nineteenth-Century America*. New Haven: Yale University Press, 2010.

Rose, Deborah Bird. *Dingo Makes Us Human: Life and Land in an Aboriginal Australian Culture*. Cambridge: Cambridge University Press, 1992.

Rosenwein, Barbara. 'Worrying about Emotions in History'. *American Historical Review* 107 (2002): 921–45.

Rowse, Tim, ed. *Contesting Assimilation*. Perth: API Network, 2005.

Said, Edward. *Culture and Imperialism*. New York: Alfred A. Knopf, 1993.

Sandweiss, Martha. *Print the Legend: Photography and the American West*. New Haven: Yale University Press, 2002.

Sekula, Allan. 'The Traffic in Photographs'. *Art Journal* 41, no. 1 (1981): 15–25.

Sekula, Allan. *Photography against the Grain: Essays and Photo Works 1973–1983*. Halifax: Nova Scotia University Press, 1984.

Selleck, Richard. *The Shop: The University of Melbourne, 1850–1939*. Melbourne: Melbourne University Press, 2003.

Sharma, Jayeeta. 'Missionaries and Print Culture in Nineteenth-Century Assam: The Orunadoi Periodical of the American Baptists Mission'. In *Christians and Missionaries in India: Cross-Cultural Communication since 1500*, edited by Robert Frykenberg, 256–73. Grand Rapids: Wm E. Erdmans Publishing Co., 2003.

Sherborne, Michael. *H. G. Wells: Another Kind of Life*. London: Peter Owen, 2010.

Short, Augustus. *The Poonindie Mission, Described in a Letter from the Lord Bishop of Adelaide to the Society for the Propagation of the Gospel*. London: Society for the Propagation of the Gospel, 1853.

Short, Augustus. *A Visit to Poonindie: and Some Accounts of That Mission to the Aborigines of South Australia*. Adelaide: William Kyffin Thomas, 1872.

Skinner, Rob, and Alan Lester. 'Humanitarianism and Empire: New Research Agendas'. *Journal of Imperial and Commonwealth History* 40, no. 5 (2012): 729–47.

Slaughter, Joseph R. *Human Rights, Inc.: The World Novel, Narrative Form, and International Law*. New York: Fordham University Press, 2007.

Slaughter, Joseph R. 'Humanitarian Reading'. In *Humanitarianism and Suffering: The Mobilization of Empathy*, edited by Richard Ashby Wilson and Richard D. Brown, 88–107. Cambridge: Cambridge University Press, 2009.

Sliwinski, Sharon. *Human Rights in Camera*. Chicago: Chicago University Press, 2011.

Slotkin, Richard. *Regeneration through Violence: The Mythology of the American Frontier 1600–1860*. Norman: University of Oklahoma Press, 1973.

Sluga, Glenda. 'UNESCO and the (One) World of Julian Huxley'. *Journal of World History* 21, no. 3 (2009): 393–418.

Smith, Adam. *The Theory of Moral Sentiments*. Edited by David Daiches Raphael and Alexander Lyon Macfie. Indianapolis: Liberty Fund, [1759] 1984.

Smith, Bernard. *European Vision in the South Pacific*. Oxford: Clarendon Press, 1960.

Smith, Mrs James [Christina]. *Caroline and Her Family: With, The Conversion of Black Bobby*. Mt Gambier: Watson & Laurie, 1865.

Smith, Mrs James [Christina]. *The Booandik Tribe of South Australian Aborigines: A Sketch of their Habits, Customs, Legends and Language*. Mount Gambier: South East Book Promotions Inc., 2001.

Smith, Lindsay. 'The Shoe-Black to the Crossing Sweeper: Victorian Street Arab and Photography'. *Textual Practice* 10, no. 1 (1996): 29–55.

Solomon-Godeau, Abigail. *Photography at the Dock: Essays on Photographic History, Institutions, and Practices*. Minneapolis: University of Minnesota Press, 1991.

Sontag, Susan. *On Photography*. London: Allan Lane, 1978.

Spencer, Stephanie. *O. G. Rejlander: Photography as Art*. Ann Arbor: UMI Research Press, 1985.

Spencer, Walter Baldwin. *The Native Tribes of Central Australia*. London: Macmillan and Co. 1899.

Spencer, Walter Baldwin. *Across Australia*. London: Macmillan and Co. 1912.

Spencer, Walter Baldwin. *Preliminary Report on the Aboriginals of the Northern Territory*. Melbourne: Under Authority of the Minister for External Affairs, Albert J. Mullett, Government Printer, July 1913.

Starr, Frederick. 'Anthropological Work in Europe'. *The Popular Science Monthly* 41, no. 1 (1892): 54–72.

Steichen, Edward. *The Family of Man: ?An Exhibition of Creative Photography, Dedicated to the Dignity of Man, with Examples from 68 Countries*. New York: Museum of Modern Art, 1955.

Steichen, Edward. 'Photography: Witness and Recorder of Humanity'. *Wisconsin Magazine of History* 41, no. 3 (1958): 159–67.

Steichen, Edward. *A Life in Photography.* Garden City: Doubleday, 1963.

Steichen, Edward. 'On Photography'. In *Photographers on Photography*, edited by Nathan Lyons, 107–12. Englewood Cliffs: Prentice Hall, 1966.

Stocking, George. *After Tylor: British Social Anthropology 1888–1951*. Madison: The University of Wisconsin Press, 1995.

Stowe, Charles Edward. *Harriet Beecher Stowe: The Story of Her Life*. Boston: Houghton Mifflin, 1911.

Stowe, Harriet Beecher. *Uncle Tom's Cabin; or, Life among the Lowly*. Boston: John P. Jewett and Co., 1852. British edition reprinted London: C. H. Clarke, 1852.

Stretton, Hugh. 'Duncan, Walter George Keith (1903–1987)'. *Australian Dictionary of Biography*. Canberra: Australian National University 2007. http://adb.anu.edu.au/biography/duncan-walter-george-keith-12443/text22375.

Strong, Rowan. *Anglicanism and the British Empire, c.1700–1850*. Oxford and New York: Oxford University Press, 2007.

Strutt, William. *Victoria the Golden: Scenes, Sketches and Jottings from Nature, 1850–1862*. Melbourne: Library Committee, Parliament of Victoria, 1980.

Stueber, Karsten. 'Empathy'. *Stanford Encyclopedia of Philosophy*. Last revised 14 February 2013. http://plato.stanford.edu/archives/win2014/entries/empathy/.

Tagg, John. *The Burden of Representation: Essays of Photographies and Histories.* Minneapolis: University of Minnesota Press, 1993.

Temperley, Howard. *After Slavery: Emancipation and Its Discontents*. London: Frank Cass Publishers, 2000.

Theye, Thomas. *Der geraubte Schatten: Die Photographie als ethnographisches Dokument* [*The Stolen Shadow: Photography as Ethnographic Document*]. München: Münchner Stadtmuseum, 1989.

Thomas, Nicholas. *Entangled Objects: Exchange, Material Culture, and Colonialism in the Pacific*. Cambridge, MA and London: Harvard University Press, 1991.

Thomas, Nicholas. 'Dumont d'Urville's Anthropology'. In *Lure of the Southern Seas: The Voyages of Dumont d'Urville 1826–1840*, edited by Susan Hunt, Martin Terry and Nicholas Thomas, 53–66. Sydney: Historic Houses Trust of New South Wales, 2002.

Thomas, William I. 'The Psychology of Race Prejudice'. *American Journal of Sociology* 9 (1904): 593–611.

Thorne, Susan. *Congregational Missions and the Making of an Imperial Culture in Nineteenth-Century England*. Stanford: Stanford University Press, 1999.

Thornton, Katharine. *The Messages of Its Walls & Fields: A History of St Peter's College, 1847 to 2009*. Adelaide: Wakefield Press, 2010. http://www.stpeters.sa.edu.au/#history.

Tiberini, Elvira S. 'Plains Indians Artifacts in the E. H. Giglioli Collection of the Pigorini Museum in Rome', *European Review of Native American Studies* 4, no. 2 (1990): 41–4.

Trachtenberg, Alan. 'Albums of War: On Reading Civil War Photographs'. *Representations* 9 (1985): 1–32.

Turnbull, Paul. 'British Anthropological Thought in Colonial Practice: The Appropriation of Indigenous Australian Bodies, 1860–1880'. In *Foreign Bodies: Oceania and the Science of Race 1750-1940*, edited by Bronwen Douglas and Chris Ballard, 205–28. Canberra: Australian National University E Press, 2008.

Turner, Ethel. *Queen Anne*. London: Ward, Lock and Co., 1926.

Twain, Mark. *King Leopold's Soliloquy: A Defense of His Congo Rule*. Boston: P. R. Warren Company, 1906.

Twomey, Christina. 'Severed Hands: Authenticating Atrocity in the Congo, 1904–1913'. In *Picturing Atrocity: Photography in Crisis*, edited by Geoffrey Batchen, Mick Gidley, Nancy K. Miller and Jay Prosser, 39–50. London: Reaktion Books, 2012.

Tylor, Edward. 'Dammann's Race-Photographs'. *Nature* (6 January 1876): 184–5.

UNESCO. *Human Rights: Exhibition Album* (Paris: UNESCO, 1950).

UNESCO. 'Constitution of the United Nations Educational, Scientific and Cultural Organization'. In *Basic Texts, 2014 Edition*. Paris: UNESCO, 2014. http://unesdoc.unesco.org/images/0022/002269/226924e.pdf.

Vogan, Arthur James. *The Black Police: A Story of Modern Australia*. London: Hutchinson and Co., 1890.

Wall, Alfred. 'Photographic Pictures and Illustrations'. *Photographic Journal* (15 September 1863): 359.

Wall, Alfred. 'Rejlander's Photographic Art Studies'. *Photo News* (24 September 1886): 619–20.

Wallace, Maurice O., and Shawn Michelle Smith, eds. *Pictures and Progress: Early Photography and the Making of African American Identity*. Durham: Duke University Press, 2012.

Waterhouse, Richard. 'The Minstrel Show and Australian Culture'. *Journal of Popular Culture* 24, no. 3 (1990): 147–66.

Watson, Frances. *Text, Church and World: Biblical Interpretation in Theological Perspective*. Grand Rapids: Eerdmans, 1994.

Wayne, Helena. *The Story of a Marriage: The Letters of Bronislaw Malinowski and Elsie Masson, Volume 1, 1916–1920*. London: Routledge, 1995.

Wells, Herbert George. *War of the Worlds*. London: Heinemann, 1898.

Wells, Herbert George. *A Modern Utopia*. London: Chapman and Hall, 1905.

Wells, Herbert George. *Experiment in Autobiography*, vol. 2. New York: Macmillan, 1934.

Wells, Herbert George. *The Commonsense of War and Peace*. Harmondsworth: Penguin Books, 1940.

Wells, Herbert George. *The New World Order*. London: Secker and Warburg, 1940.

Wells, Herbert George. *The Rights of Man, or What Are We Fighting For?* Harmondsworth: Penguin Special, 1940.

Westgarth, William. *Australia Felix; or, a Historical and Descriptive Account of the Settlement of Port Phillip*. Edinburgh: Oliver and Boyd, 1848.

Westgarth, William. *The Colony of Victoria: Its History, Commerce and Gold Mining*. London: S. Low, Son, and Marston, 1864.

Whitington, Fred T. *Augustus Short, First Bishop of Adelaide: The Story of a Thirty-Four Years' Episcopate*. London: Wells Gardner, Darton and Co.,1888.

Whyte, Jessica. 'The Fortunes of Natural Man: Robinson Crusoe, Political Economy, and the Universal Declaration of Human Rights'. *Humanity: An International Journal of Human Rights, Humanitarianism, and Development* 5, no. 3 (2014): 301–21.

Wickberg, Daniel. 'What Is the History of Sensibilities?' *American Historical Review* 112, no. 3 (2007): 661–84.

Willis, Deborah, and Barbara Krauthamer. *Envisioning Emancipation: Black Africans and the End of Slavery*. Philadelphia: Temple University Press, 2013.

Willis, Elizabeth. 'Re-Working a Photographic Archive: John Hunter Kerr's Portraits of Kulin People, 1850s–2004'. *Journal of Australian Studies* 35, no. 2 (2011): 235–49.

Wilson, Richard Ashby, and Richard D. Brown, eds. *Humanitarianism and Suffering: The Mobilization of Empathy*. Cambridge: Cambridge University Press, 2009.

Wilson, Richard Ashby, and Richard D. Brown. 'Introduction'. In Richard Ashby Wilson and Richard D. Brown, *Humanitarianism and Suffering: The Mobilization of Empathy*. 1–30. Cambridge: Cambridge University Press, 2011.

Wilson Richard, *Human Rights, Culture and Context*. London and Chicago: Pluto Press, 1997.

Winckelmann, Johann Joachim. *History of the Art of Antiquity*. Translated by Harry Francis Mallgrave. Los Angeles: Getty Research Institute, [1764] 2006.

Winter, Jay. *Dreams of Peace and Freedom*. New Haven: Yale University Press, 2006.

Wolfe, Patrick. *Settler Colonialism and the Transformation of Anthropology: The Politics and Poetics of an Ethnographic Event*. London: Cassell, 1999.

Wood, Marcus. *Blind Memory: Visual Representations of Slavery in England and America*. New York: Routledge, 2000.

Zelizer, Barbie. *Remembering to Forget: Holocaust Memory through the Camera's Eye*. Chicago: University of Chicago Press, 1998.

INDEX

Note: Page numbers in italics refer to images or captions.